Video Art

Video Art

A Guided Tour

CATHERINE ELWES

WITH A FOREWORD BY
SHIRIN NESHAT

I.B. TAURIS
LONDON · NEW YORK

in association with

UNIVERSITY OF THE ARTS
LONDON CAMBERWELL COLLEGE OF ARTS
CENTRAL SAINT MARTINS COLLEGE OF ART
AND DESIGN CHELSEA COLLEGE OF ART AND
DESIGN LONDON COLLEGE OF COMMUNICATION
LONDON COLLEGE OF FASHION

Reprinted in 2006 by I.B.Tauris & Co Ltd
6 Salem Road, London W2 4BU
175 Fifth Avenue, New York NY 10010
www.ibtauris.com

In the United States of America and in Canada distributed by
Palgrave Macmillan, a division of St Martin's Press
175 Fifth Avenue, New York NY 10010

First published in 2005 by I.B.Tauris & Co Ltd
Copyright © Catherine Elwes, 2005

ISBN 1 85043 546 4
EAN 978 1 85043 546 4

A full CIP record for this book is available from the British Library
A full CIP record for this book is available from the Library of Congress

Library of Congress catalog card: available

Typeset in ITC Slimbach
Printed and bound in India by Replika Press Pvt Ltd

Contents

Illustrations

Foreword

Over the past few decades the moving image has, perhaps inevitably, become a crucial aspect of contemporary art. One could analyse artists' initial draw to the moving image in many different ways, but primarily, I think, it reflects artists' collective response to their time – to the powerful presence of media and technology, of television and cinema in mainstream culture. But perhaps this development equally represents artists' frustration with the exclusivity of art and its audience; their desire to bring art closer to popular culture and to engage more closely with real social and political issues.

It is fair to say, then, that the generation of artists from the 1960s and 1970s such as Nam June Paik, Vito Acconci and Bruce Nauman, and David Hall, Tamara Krikorian and Stuart Marshall in the UK – amongst numerous others internationally – not only challenged the art world by breaking its conventions, but also succeeded in taking art outside of its normal perimeter, making art more accessible and bringing it closer to the general public.

This fusion between visual art, new technologies and the moving image has been transformed over time by both movements within video art and individual artists. Perhaps the biggest development has been that artists are finally relieved of the task of making 'objects', and can now conceive their ideas in a way that becomes 'experiential'. I remember the first time I experienced the work of Bill Viola: I was mesmerized by how he managed to remain faithful to the vocabulary of visual arts, as his installations became painterly and sculptural, yet retain the magic, the intangibility and the transparency, of the moving image.

Naturally, as artists expand the vocabulary of art, they redefine the relationship of the spectator to the artwork. It appears that in such work the viewer is challenged to be an 'active' participant, no longer the 'passive' observer. We find video artists frequently choosing to isolate their viewers in a dark room, perhaps partially to avoid distraction from other works of art, and to demand more in-depth attention (the same attention required of a feature film in a movie theatre), but most importantly to create environments in which, through

the combined use of image, sound and physical elements, art can immerse the viewer on emotional, intellectual and physical levels.

Whilst much early video work was primarily made in relation to the medium of television and in response to its ubiquity, as this book demonstrates, since the 1990s, many artists, it seems, have become preoccupied with a careful study of the language of cinema and how it might be incorporated into the visual art vocabulary. The greatest discovery for some of us has been that cinema is a 'total' art form, simultaneously embodying media from photography, painting and sculpture to performance, theatre and music. The use of 'narrative' in video art has been of immense interest and is still in development. Many artists have grown ambitious in the formulation of their concepts, no longer satisfied with expressing their ideas in a single image, but in a group of images and in a way that allows them to tell a 'story'. The incorporation of narrative into the medium of video art can be tricky as there are important distinctions between the language of cinema or of television and that of visual art. However it can be successful, as the 'New Narrative' movement of the 1980s has shown, and Matthew Barney comes to mind as a contemporary artist who has uniquely crossed that boundary without taking the risk of mimicking conventional film.

Finally, one of the greatest impacts of the moving image in visual arts has been to encourage artists to be more ambitious – by abandoning 'studio art', by stepping into the world, by blurring boundaries between mediums and by working collaboratively. *Video Art, A Guided Tour* beautifully chronicles the evolution and development of the movement, showing how artists have ultimately established and defined an unprecedented connection between the experience of the moving image and that of visual art.

Shirin Neshat

Acknowledgements

In the course of writing this book, I have consulted many individuals and those who have patiently answered my questions include Rod Stoneman, David Curtis, John Wyver, Ben Cook and Gary Thomas. A.L. Rees, Laura Mulvey, Julia Knight, Malcolm le Grice and Michael Newman have, in different ways, helped towards the AHRB research leave that gave me time to do the work. Oriana Baddeley and the research team at Camberwell College of Arts offered invaluable advice and support throughout. Many artists contributed their memories and insights to fill the gaps in my own.

I am particularly indebted to David Hall, David Critchley, Tom Sherman, Steve Hawley, Mike Stubbs, Mick Hartney, Roland Denning, Kate Meynell and Chris Meigh-Andrews, whose own research in the field provided an invaluable resource. Kathy Battista and Jackie Morreau kept me in touch with what was going on outside my scholarly prison while Susan Lawson lent me all the difficult books and asked the pertinent questions. Mike Stanfield cooked above and beyond the call of friendship while Uwe Ackermann and Bruno Muellbauer allowed me to become a drain on family patience and goodwill. I appreciate the generosity of all the artists who have allowed me to reproduce images of their work and I offer this volume as a testament to their vision, imagination and determined interrogation of the culture, their persistent worrying of 'the edges of what is known'.

The research for this book was carried out with the support of the Arts & Humanities Research Board and the University of the Arts London.

Introduction

From the Margins to the Mainstream

Perhaps, in some darkened viewing room somewhere, there exists an indefatigable art historian prepared to spend the four and twenty years of monitor watching necessary to emerge with a definitive overview of video art.

Mick Hartney

Video is the default medium of the twenty-first century. It is everywhere, trapped on monitors and computer screens and projected, cinema-style, onto pristine gallery walls, across public spaces and onto the hallowed surfaces of national museums. The prominence of the moving image in contemporary art hides a forty-year history in which video played a vital role on the margins of the avant-garde. It began life in the mid 1960s, screening to small groups of aficionados in obscure, 'alternative' spaces. Then, in the 1990s, video art broke through into the mainstream of the museum and gallery system, taking up a central position as the twentieth century came to a close. The early history of the medium is only now coming to light and the present volume is devoted to reintroducing the work of pioneering video-makers while positioning their ideas as a prism through which to offer an understanding of contemporary video. I hope that my guided tour of the medium will prove an appropriate travelling companion to the reader's own discovery of video art and its sometimes baffling but always intriguing history.

The tour is, of necessity, a personal one. Dispassionate judgement is particularly difficult for me, given that I lived through and played a modest part in that story as it manifested in the UK. Everything I re-view is to a greater or lesser extent filtered through my own political affiliations, my aesthetic preferences and the personal and professional trajectory I followed throughout the period in which video art emerged and flowered. Rather than manufacture

some spurious objectivity, I have elected to tell the story as I witnessed it, read about it, gossiped about it, added to it and, in my capacity as a critic, attempted to make it accessible to a wider audience. Although my research has thrown up many interesting discoveries, I also encountered certain difficulties along the way. I have noticed striking similarities in works occurring simultaneously in different parts of the world. Mindful of the fact that great minds often think alike, I have chosen those videos that best illuminate the distinctive chronology I have tried to represent. The modest length of this tour is disproportionate to the size of the ever-growing archive of video art and I have been forced to become more selective than I would wish in the works I discuss. I occasionally lapse into contradiction, as I always do when I can see two sides of an argument. For example, I will never reconcile the desire to critique the mainstream with the temptation to reproduce what one set out to subvert. Sometimes, I speak from the inside where the passions I felt in the early days are still simmering, sometimes I step outside in search of a broader picture with continuities of formal and tactical strategies traceable across the generations. My tour is necessarily partial, analytical, engaged, informed and still fired by the excitement I felt in 1978 when I produced my first, flickering monochrome image of what I had trapped in the 'unblinking stare' of the viewfinder.

The tour begins in the euphoric iconoclasm of the 1960s when, on both sides of the Atlantic, artists questioned social and political institutions as well as the traditions of fine art, regarded as ossified around the practices of painting and sculpture. Once the plastic arts had been reduced to the blank canvas and the minimalist slab of concrete, there seemed nothing more to be said. Video, along with performance and experimental film, offered a way out of the conceptual impasse of high art practices. As the newest technology, video was soon harnessed to the counter-cultural imperatives of the age. Although predominantly exploited as an agent of change, early video shared formal concerns with mainstream painting and sculpture, then dominated by modernism and minimalism. Broadly speaking, video art in the USA concentrated on a kind of pared-down, self-reflexive investigation of the technology and its functions. In the UK, video artists were also embroiled in an examination of the specificities of the apparatus, or the tools of their trade, but saw the monolith of television as their main adversary. They concentrated on deconstructing televisual narrative conventions that were felt to produce a passive cultural consumer.[1] The empowerment of that spectator and viewer involvement in the creation of meaning became a key issue in both monitor-based, sculptural work and multi-screen installations and led to the electronic interactivity that we see today. Almost without exception, every generation and nationality has used video as a personal medium, an electronic mirror with which to investigate social identity – femininity, masculinity, ethnicity, and sexuality. The formation of identity has been linked to the influence of social

stereotypes promoted by television, print media and the cinema. These popular cultural forms produced a narrowly defined human typology that promoted social prejudice – racism, sexism and homophobia. Video artists from the 1980s onwards, appropriated and manipulated those same stereotypical images as a deconstructive strategy for exposing the distortions and iniquities of media representations. But in the 1990s popular cultural imagery was integrated into video art as part of a celebration of contemporary visual culture and superseded the traditional themes and preoccupations of fine art as well as the more political, deconstructive approach to the moving image.

The evolution of video technology remains the backbone of the story, with new developments such as colour processing, digital editing and image layering leading aesthetic and stylistic trends. From the beginning, video has been in dialogue with the institutions with which it shares its technology: television, surveillance, video games, promotional video and, latterly, the Internet. In this respect, the social dimension is always at play, however aestheticised the work may have become. This is the case even in video's new gallery-projected form, which recreates the spectacular and immersive experience of cinema. With the convergence of film and video in contemporary gallery art, it is interesting to see that many of the characteristics of video history still survive: the playfulness, the irreverence for art history and the commercial mainstream, the technical trickery as well as the social and political engagement. It has also preserved many of its earlier forms: the performance documentary, the auto-portrait and the polemical text. This volume is designed to put contemporary work into its historical context. I do so, not to denigrate the newer artists in the field with implications of plagiarism, but to show how continuities and commonalities exist across the generations. With the speed of technological development and a changing social and political landscape, video as an art form and discursive arena is constantly being renewed.

IN THE BEGINNING • MARKING OUT THE TERRITORY

Like many technologies, video was born of an alliance between military and industrial concerns in the West. The first portable equipment was developed in the early 1960s by the US army for surveillance purposes in Vietnam. The medium already existed in the form of broadcast television, an institution that was increasingly dominated by commerce and subjected to political pressures. Shot through with thinly disguised ideological messages such as the ultimate desirability of consumer goods and the 'natural' place of women in the kitchen, the new 'opiate of the people' was looking more like an agent of social control than a form of family entertainment. Video art came into being deeply opposed to both its progenitors and, when Sony Portapaks went on sale in the mid 1960s, artists decisively reclaimed video as a creative medium capable of challenging

the military, political and commercial interests from which it sprang.[2] The aesthetic possibilities of the medium were crucial to the development of video as an art form, but like the artists of the Russian Revolution, North American and European practitioners in the 1960s saw the potential for their art to become an instrument of social and political transformation. They took up an oppositional stance vis-à-vis the dominant culture situating video art in the swell of a highly politicised avant-garde. Operating on the radical fringes, video-makers sought to expose not only the manipulations of mainstream entertainment but also the definitions and orthodoxies of traditional fine art practices to which video was now uneasily annexed.

Nam June Paik can claim the distinction of being one of the first artists to acquire a Sony portable recorder and camera when they went on sale to the general public in 1965.[3] Paik's historic purchase coincided with Pope Paul VI's visit to New York. Armed with his new Portapak, the artist followed the crowds in a taxi and witnessed the papal procession, simultaneously recording everything he saw. Since the first recorders were reel-to-reel machines with a maximum recording time of one hour and no facility for editing, Paik just left the machine running. The work ended when he ran out of tape. That evening, at the Café a Go Go, Paik screened the unedited black and white video on a monitor, alongside the broadcast TV version of the same event.

Paik's video was a 'real time' work. It took the same stretch of time to view the Pope's procession in the gallery as it took to record the original occasion. Where the television coverage was heavily mediated by broadcast conventions, Paik's tape involved no editing, no dramatisation, no voice-overs, studio discussions, flashbacks or commercial breaks. Neither was there any attempt to disguise the technological process that was creating this *vidéo vérité* record of the procession. The work was determined only by the artist's eye and the serendipity of finding himself in the right place at the right time with the appropriate equipment.

Paik worked deliberately outside the Hollywood-dominated film industry and independently of the television networks and, at least initially, without commercial funding. In contrast to the briefly credited but essentially anonymous cameraman of the television broadcast, Paik and his reputation as an avant-garde artist were important elements in the work. His status as an artist allowed him to take a strong moral and oppositional stand, directly challenging the monopoly of mainstream media and what he saw to be the bourgeois values embedded in their programming. Paradoxically, he was only able to do this by calling on the privileged status of the artist and the singularity of vision, the lone voice of genius that was enshrined in post-war American art. In the context of fine art, he was able to lay claim to what his camera saw as an autonomous, creative agent in defiance of the invisible, corporate forces that silence the individual whilst homogenising humanity into a narrow

range of stereotypes for the television screen. The video was proof that Paik, the irreducible individual, the free creative agent had been there and made an authentic record of what he saw. This Korean artist did so while using the very same technology that would render him invisible in broadcasting owing to his membership of an ethnic minority.

THE SOCIAL CONTEXT

Television has been attacking us all our lives, now we can attack it back.

Nam June Paik

Paik's seminal work was perfectly in keeping with the interventionist climate of the 1960s when young people across North America and Europe believed they could effectively oppose and transform existing social structures. The hippie generation rejected the narrow aspirations and middle-class values of their parents and refused to participate in the capitalist treadmill that condemned the boys to white- and blue-collar servitude while the girls stayed at home in the prison of domestic drudgery and childcare. The liberation movements of the period gave us civil rights, black power, feminism and gay politics. The sexual revolution helped to cast off the social mores of the older generation and a new interest in eastern mysticism promised spiritual fulfilment and self-improvement. The most visible and unifying causes centred on the anti-war movement, with its 'Ban the Bomb' crusade and refusal to endorse the war in Vietnam. Environmental issues were soon as heatedly debated as militarism and western imperialism. The 1960s became the era of protest and Paik's work represented the first challenge to the hegemony of the mainstream media, controlled by its oligarchy of commercial, political and military interests. Following Marshal MacLuhan's vision of global communication, Paik and his contemporaries believed that they could harness the tools of mass media to awaken a new, alternative social and political consciousness. Video art was born at a time of high personal and political faith. Artists and activists alike believed that their actions could make a difference to society. Individual initiatives were framed by a recognition that everyone belonged to local and global communities. A collective identification was coupled with an individual sense of responsibility towards the future shape of the world, both social and ecological. In the radical ferment of the avant-garde, individuals were more interested in revolutionising art and society than pursuing personal success. However, the romance of poverty had a tendency to wear off in time and many artists, like Paik himself, saw the advantages of promulgating their views from a position of high visibility as opposed to crying in the wilderness on the fringes of the avant-garde. But Paik's sincerity is not in question and the early pioneers

of video art were intent on transforming both society and what they saw as the outdated conventions of the high art establishment.

THE ART CONTEXT • THE DEATH OF THE ART OBJECT

Video has the unique potential of conveying the aesthetic aspirations
of an entire generation.
Willoughby Sharp

For neither the first nor the last time, young voices rose up and announced that art was dead. Easel art, that is. By the mid 1960s, both painting and sculpture in the grand manner appeared to have run their course. Artists rejected the mediating role of what they regarded as an obsolete art object. Being once removed from the artist – its generating source – the conventional work of art was now accused of blocking the free flow of the artist's creative intentions towards a newly receptive audience. It was time to jettison the ponderous demands of museum patronage for large-scale canvases and monumental bronzes, even minimalist ones. Artists wanted to create an encounter with the viewer that was as immediate as the inter-personal and political upheaval going on outside the galleries, as instantaneous as Paik's encounter with the Pope's procession in New York. The dematerialisation of the art object had begun and artists looked for new forms of expression that reflected the urgency of their revolutionary ideas and the new direct relationship they were seeking with their audiences. They found video and performance art.

Performance art offered possibly the most perfect medium of artistic communion because life and art came together in a shared event or collective 'happening'. In live art, no artefact stood between the artist and audience and no object remained after the event to be collected, sanctioned and sanctified by the critics, historians and collectors controlling the art establishment. However, the cannier 1960s artists carefully kept the detritus of their live work whilst protesting their leftist disinterest in the objects of performance, which are now increasingly collectable.

Video was also approved as a suitably ephemeral medium, existing only when animated by an electric current and capable of being copied, recopied and disseminated like any other mass-produced merchandise. In spite of now having to negotiate the more recent traditions of broadcast media, video artists felt they were working on a clean sheet of paper. Film too was caught up in the net of avant-garde experimentation along with dance and music, which were similarly appropriated from popular culture and reinvented as 'movement' and 'sound' by a new generation of radical artists. The very categories of the arts were dissolving with the creation of hybridised works involving any number

of media, technologies and performance disciplines. As well as evolving into an art form in its own right, video had the ability to pull together many of these disparate elements combining performance, sound and duration into documentary or fictionalised representations of artistic events. Video both crystallised and witnessed the proliferation of new ideas in the expanding landscape of cultural practice and reflected the revolutionary changes taking place in society at large. In its role as monitor to the avant-garde, video helped to fill the gaps left by the slow, but inexorable eviction of painting and sculpture from their dominant position in contemporary art.

THE NEW ROLE OF THE VIEWER

... art that allows us to enact our own closures, and not an art that is closed upon
arrival.
Jeremy Millar

Now that it was no longer possible to hide behind the reassuring buffer of the 'dead' art object, what did the living arts demand of the 1960s cultural consumer? Within the Enlightenment model, popularised in the eighteenth century by Kant and sanctified in the twentieth by modernist criticism under Clement Greenberg and Michael Fried, the art object contained intrinsic aesthetic properties that could only be discovered by the refined sensibilities and trained eyes of the art cognoscenti. Art lovers would enter the hallowed space of the museum and, isolated from the messy social realities outside, attempt to unlock the secrets of the art object. Once correctly tuned in, the viewer could use the work of art as a talisman and be transported to higher levels of aesthetic experience. The perceptual processes and particularised interpretations of the viewer based on individual history, experience, gender and other variables were not part of the picture. A visitor to the gallery needed to leave all idiosyncratic responses at the door and work towards a state of high cultural grace from which it was possible to access the essential meaning and beauty locked inside the unique art object. In the process, timeless and universal aesthetic principles would be grasped and the gallery visitor could go home safe in the knowledge of belonging to that section of the human race in which reason dominates and all baser animal impulses are safely under control. Invariably, it was the collectors, critics, commentators and other doyens of the art establishment who determined the precise nature of those universal aesthetic principles and the particular meaning of a work. This established a single, authoritative, 'correct' viewing and interpretive position that could be used as a touchstone to separate good art from bad and high art from lowly crafts and popular culture. Within a modernist conceptual framework, the art object was held to embody not only

higher, transcendental meaning, but also the intentions of the artist – what the cultural theorist Roland Barthes called the 'theological meanings'.

All this changed when Barthes published his influential book *Image, Music, Text* in 1977.[4] Barthes argued that the meaning of a text or image lay as much with the viewer as it did with the creation, its creator and its advocates. The democratic principles underlying Barthes' analysis encouraged performance and video artists to dispense with the unique art object and transform the role of the viewer from passive recipient of received ideas to active participant in the creation of aesthetic meaning. However, rather than abdicate entirely the active role to the viewer, 1960s and 1970s time-based artists working in film, video and performance relocated the meaning of a work to the creative space opened up by the encounter between artist, technology, performance props and the audience. This constituted a unique socially and historically cohesive moment. No single element or individual held the key to the meaning of the 'text' or occupied the definitive point of view. Within a live performance, there were as many 'true' interpretations of the work as there were witnesses and participants. A non-hierarchical live event always contained the possibility that an individual could override the artist's intentions and directly influence the direction and outcome of the performance. In practice, this rarely happened although, in theory, artists were giving up their directorial powers and enlisting the audience in full participation. In a peculiar twist of logic, some performance artists took it upon themselves to democratise all works of art and specialised in hijacking other artists' events. This was perhaps a form of resistance to Barthes' notion that the birth of the active reader/viewer could only take place pursuant to the death of the author. At least within a new performance idiom, the artist could still be an active participant. In video, an unconscious fear of becoming eclipsed by the newly emancipated viewer may have been responsible for the widespread practice of the artist becoming the subject of her/his own work.

Whether literally active or active in the contribution of a creative imagination, the new role of the viewer in the production of meaning exploded the modernist myth of universality in aesthetic appreciation. The interpretation of art was now seen to be contingent on social, political and historical factors being brought to bear on individuals at the moment of reception as well as the intrinsic qualities of a set of objects or pictorial effects. Peter Kardia has observed that the central problem of cultural production was now 'the interaction between the position and place of the witnessing subject and the imaginative project embodied in the work'.[5] The newly democratised space of art challenged the established authorities that had determined aesthetic value in art. At the same time, dialogic practices broadened the range of activities that could be considered art. Video and performance were now accepted as legitimate art forms.

With the person of the viewer now in a constitutive position, the canonical edicts of art history might be banished forever and everyone could make

art, each one of us become a critic. At least that was the theory. Artists were reluctant to give up their privileges and although they acknowledged the important role of the audience, they remained the principal instigators and directors of artistic events laying claim to authorship of the work for the cultural record. Even amongst the newly awakened audiences, some viewers remained more equal than others – critics, curators and funders taking precedence over the ordinary punter. The hegemony of the art marshals could not be broken so easily. Then as now, artists needed to be sanctioned by historians and critics to maintain visibility and ensure sponsorship, state, private and corporate. In spite of artist-run spaces and distribution networks offering alternatives to commercial galleries, performance and artists' film and video were never able to escape entirely their dependence on the art establishment and some, like Paik, always courted wide recognition. In recent years, the picture has changed again and the relationship between artist and audience has become more complex with commercial forces and popular culture claiming a stake in art and offering another source of funding. In the new century, there is little appetite for survival outside the various institutions that support the arts, but back in the 1960s, an honest attempt was made to break free and amplifying the role of the ordinary viewer was consistent with a determination to democratise art.[6] In many of the strategies adopted by performance and video artists, the one-way flow of information in both fine art and broadcast television was reconstituted as a two-way process. The meaning of a work now lay in the creatively charged relationship between 'witnessing subjects', the materials in play and the imagination of the artist – that self-appointed visionary who speaks through the medium of art.

IN VIDEO VERITAS • VIDEO AS A DOCUMENT OF PERFORMANCE

There continues to be a strong link between performance art and video. In the early days, both courted a direct and democratic encounter between the artist and audience and both rejected the material and institutional traditions of fine art. In spite of their disdain for the art object, performance artists were also looking for ways of recording their work for posterity and the more immediate problem of disseminating their ideas beyond the performance itself, not to mention collecting support material for the next funding application. Documentary photography is capable only of capturing a series of frozen moments and is inadequate to the task of recreating a time-based event that is founded on flux, change and multiple points of view. With its ability to record long events and its status as a factual medium, video now took on the job of fixing performances that were, in essence, ephemeral. By the mid sixties, American artists like Eleanor Antin, Peter Campus, Linda Montano and Terry Fox began to use video as their chief medium of documentation. In Canada, Ian Baxter and the N.E.

Thing Co., Gerry Gilbert and Michael Snow were similarly enshrining their live work in moving image records. In former Yugoslavia, Abramovićand Ulay made performances to camera and in the UK, Stuart Brisley, Rose Finn-Kelcey and Gilbert and George all taped their work.

These early performance tapes would rarely be seen in public and were regarded as documents, residues of the live events, though they were briefly collected by galleries along with other photographic and material by-products of live work.[7] The aesthetic value was secondary to the videotape's ability to accurately record the events in real time. Commentators like the historian Amelia Jones have argued that the meaning of live performance is retrospectively formed by the documentation and the interpretations that historians and critics formulate.[8] However, this view is contrary to the intentions of performance artists working in the late 1960s and early 1970s. For them, the experience of the event was the primary objective, with its cathartic and transformative potential mobilised in a live confrontation between artist and audience. They chose to use video to document their work because it came closest to establishing the time-based facts of an event. However, video had its own limitations. The picture quality was poor and with the technology pushed out of the way to avoid interfering with the performance, much of the detail was lost. To make matters worse, the camera was often restricted to a fixed, distant position and microphones were often placed so far away from the action that they were unable to filter out extraneous sounds. The resulting sequences took in everything and yet conveyed little of the impact of the live event in which the senses could be selectively tuned to elements that, at a given moment, were charged with meaning. It was too easy for writers like Amelia Jones to mythologise or impose their own interpretations on events that they sometimes hadn't seen and that were experienced quite differently at their point of origin.

Aware of the distorting lens of available methods of documentation and its interpreters, many artists now began to create actions and live events specific-ally for the video camera and monitor. Artists like Tina Keane and Sonia Knox in the UK and Vito Acconci and Joan Jonas in the USA began to use the video technology as part of the performance itself. The discrepancies between the mediated video image and the live presence of the artist created what Jonas called a 'parallel narrative'. In Germany, Ulrike Rosenbach made performances in which the camera was strapped to her body, the resulting image representing her point of view in what she called 'live video performances'. In *Dynamic Field Series Part 1* (1971), the American Peter Campus attached the camera to the ceiling by way of a pulley, so that he could make his image recede and expand by pulling or releasing the rope. Campus contrived to be both in front of and behind the camera simultaneously. These live video-performances combined the role of video as a recording device with its participation as an essential component of the work itself. The mechanism of video image generation and

the process of performance art documentation were laid bare and contrasted with the invisibility of technology in mainstream broadcasting.

Many of the early performance-to-camera works were held within the frame and three-dimensional container of a monitor, which served to heighten the sense of a shared vulnerability with the artist. The scaled-down human form, the miniature theatre of the box and the prison of the technology all served to endow the artist with the poignancy of a trapped animal. Without the filter of entertainment, character and plot, the compassionate realism of performance to camera is surprisingly powerful. In spite of the degraded resolution of early video, and the often-visible charade of artists' performances, it was possible for an emotional, corporeal connection to be made between two subjectivities across the time-lapse separating recording and viewing.

In 1970, Bruce Nauman made the most famous and minimal performance to camera. At first sight, *Stamping the Studio* is an unedited record of Nauman prowling his studio in a shuffling gait, a brooding evocation of the artist in the grip of creative frustration. Looking much like present day surveillance footage, the video (originally shot on film) is also a kind of mapping of the artist's agency within his chosen environment, unadorned by narrative and other forms of television fabulation. His neurotically repetitive action deviates substantially from socially accepted behaviour and questions ideas of madness and normality. The seeming artlessness of the performance is deceptive. The camera is carefully positioned, and Nauman's actions precisely orchestrated so that the path he treads delineates both the space he occupied in the past and the square boundary of the video monitor we are looking at in our present. In *Wall-Floor Positions* (1968), the artist's body, in more direct proportions to the monitor, seemingly struggles to move around inside the box. With the help of an invisible monitor, Nauman makes sure that he does not breach the edges of the picture frame and break the illusion of his containment in its actual, three dimensional prison.

Nauman used the authenticity of a pared down, performative action to point up the artificiality of television realism but also the constructed nature of art – any art. Anticipating Bill Viola, and the UK artist, Sam Taylor-Wood's later depictions of artificial emotion projected by actors, Yugoslav artists Abramović and Ulay made *AAA-AAA* (1978), a tape in which they screamed at each other to the limits of their vocal endurance. The American Teddy Dibble produced a persistent cough that never seemed to satisfy an off-camera instructor or doctor. In *Cough* (1986), we witness Dibble's repeated failures to produce the ideal cough. The artist looks straight into the camera whilst an out of frame director-doctor insistently corrects his coughing: 'No, make it harder. No, louder. Again. Again.' Like Abramović and Ulay's vocal excesses, Dibble's cough is clearly manufactured but the duration of the piece and the obvious physical discomfort suffered by the artist, induce in the viewer a somatic empathy. Clearly, the

success of this physical identification depends on duration. The coughing and screaming are agony to listen to only if they don't stop. If the tapes are turned off or can be walked away from before the action builds up sufficient empathetic agony in the viewer, the works cannot act upon the senses. We could not, in this case, suspend disbelief sufficiently to internalise the plight of the artists.

I once made a tape about a crying baby.[9] It played on a looped compilation along with tapes by other artists. Each time my work came around, the gallery staff turned it down because they couldn't stand the crying. They got the point of the work and nullified it. This use of performed, embodied experience to induce a somatic response in the viewer finds an echo today in a recent video from Canada. In *Heaven* (2000), Lloyd Brandson and Jack Lauder point a fixed camera at an expanse of frozen lake separated from a dull sky by a thin, barely visible horizon line. This is Lake Winnipeg gripped by sub-zero temperatures in the depths of winter. The two artists run past the camera, naked but for some roughly made boots. They gradually disappear into the white horizon and nothing happens for an agonising 60 seconds. Just as we become convinced that they have died of exposure, the painfully vulnerable figures reappear and slowly grow back into men who have somehow survived the cold.

The ability of the viewer to both imagine and enter the bodily predicament of the artist depends on a shared time-space and a common physiology. It is the recognition of both similarity and a narrow difference that makes the empathetic process possible. The artist is me, and not-me simultaneously. With a widening of the species gap, the effect diminishes. If it had been an animal suffering from the cold in *Heaven*, we would have felt it less except possibly in England where animal suffering often inspires greater feeling than human distress. An insect depicted as a shivering spot on the horizon would be unlikely to cause any real anxiety in the viewer. Through a shared time-space, it is a species-specific empathy that video is capable of creating.

One could argue that, in its ability to conjure up another human being, video seeks to restore to mechanical reproduction what Walter Benjamin called the lost 'aura' of the unique art object. In video, the authenticating imprint of the artist's hand is evident and refers to the originating moment in which the subject interacted with the technology. In spite of being only a ghostly replica of what was once there, in its organisation around realism, video betrays the artist's and indeed the viewer's need to retrieve the severed connection with 'the absolutely unique and even magical quality... of his subject'.[10] In videos like *Heaven* and *Stamping the Studio*, the artist and the subject are one and the same, the artist's uniqueness embodied in his electronic mark making. More than with any other medium, we are momentarily convinced that we are witnessing the moment of creation. And yet, video is the most duplicitous of all the media of mechanical reproduction.

WORKING WITH THE TECHNOLOGY • FICTION AND THE
SUSPENSION OF DISBELIEF

In terms of single-screen, pre-recorded sit-and-watch video art, this sense of auratic presentness and direct involvement are, of course, an optical illusion. There is no real-time, face-to-face encounter with the artist nor can the viewer physically access the world the artist is revealing through the video image. In fact, neither the artist, nor the illusory world s/he inhabits exists at all in any concrete sense. The video image is a simple confidence trick. For many artists working at the dawn of video art, the fundamental illusionism of the image became a source of scrutiny, fascination and, in the UK in particular, of political analysis.

All pre-recorded moving image depends on viewers activating an irrational denial of absence. They suppress the obvious fact that the apparent presence of a person on the screen is nothing but an electronic fabrication. In spite of the clever mimesis, there is clearly nobody there. Through the suspension of disbelief, viewers ignore the apparatus that creates the illusion and, instead, imaginatively read the flickering screen as a faithful representation of reality. The audience and artist enter into a kind of credulity pact. The artist pretends to speak directly to the viewer from another space and time and the viewer tacitly agrees to accept the message as a concrete manifestation in the here and now. It is sometimes a shock to discover to what extent we enter into this game of fake-for-real. We have been doing it since childhood when fairy stories allowed us to take imaginative flight into fables that gave form to the chaos of feelings and conflicts that maturation blows in. As the psychologist Bruno Bettleheim pointed out, we have little need for more 'useful information about the external world' but respond instead to imaginative equivalents for 'the inner processes taking place in an individual'.[11] As Bettleheim observed, children generally know the difference between what is real and what is an illusion. They enter into the world of the imagination without letting go of reality. The process was once perfectly demonstrated to me when I spent some time at the BBC working as a make-up artist. The popular puppet character Basil Brush was available to meet his audience in his dressing room after the show. The puppeteer greeted the children in his shirtsleeves with the cloth fox sheathing the end of his arm. Making no attempt to throw his voice, the puppeteer slipped into character and animated the puppet to match his speech. The children ignored the man and spoke to the ersatz fox. It is a feature of our communication age that our ability to tell the difference between fiction and reality deteriorates with age. Within the conceptual ferment of the 1970s, the credulity pact we enter into both as children and as adults was itself interrogated by artists just as the verisimilitude of video was systematically undermined. As we have seen, artists attempting to recreate with video the immediacy of performance art have not been shy to exploit the credulity pact we make with the small screen. They took advantage of our gullibility even when their aim was to deconstruct our

notions of televisual authenticity. Performative artists have always capitalised on video's ability to imaginatively re-create the one-to-one encounter between an individual artist and a viewer who tacitly agrees to be truly foxed by an electronic optical illusion.

THE SPECIFICITIES OF THE MEDIUM • LIVE RELAY

You can take a picture and put it through a wire and send it to another place...
Woody Vasulka

If the verisimilitude of early pre-recorded video was not altogether convincing, then its credibility was dramatically enhanced by the medium's unique ability to deliver to an audience a live-relay image of an event happening elsewhere. The power of television to convince was based partly on the transmission of live images across great distances to millions of people simultaneously. By the mid 1960s, the technology became available to artists who could now make direct contact with viewers over short distances with cameras linked to monitors by long cables and eventually over greater distances with small transmitters. Today, this function of video technology has expanded exponentially on the Internet giving artists instant visual and auditory access to all four corners of the earth.

The first adventures with live transmission were more modest. One of the earliest examples is Yoko Ono's *Sky TV* (1966) in which she confronted the audience, not with her own body as she often did in her performances, but with the vastness of the sky above the museum. From a camera mounted on the roof of the building, a live image of the heavens was continuously beamed down to a monitor in the gallery. Viewers enjoyed the sense of being simultaneously inside and outside the space and the novel experience of contemplating an image that rarely emerged from its role as a backdrop to conventional narratives. Simultaneity had arrived in video bringing it even closer to performance art and the presence of the artist or the natural phenomenon being transmitted to the gallery was almost, but not quite, palpable.

THE TIME FRAME

In live relay, the image and the audience occupy the same time frame, and unless the video component is being recorded, neither would materially survive the event other than in individual memories and other documentation of the event. In the context of live relay, video is as ephemeral as performance. But a pre-recorded tape aspires to the condition of permanence. However evanescent it is in its electronic specificity, the video image represents a moment of history frozen in the aspic of the oxide coating on the surface of the tape. It exists in

suspended animation, in a continuous present that can be retrieved at any point in the future for the life of the tape or in reduced form, from copies. Like photography, but with the added verisimilitude provided by sound and motion, video acts as a time machine giving the past life in the present and allowing those occupying the present to travel back to recent and more distant historical moments. For the image of the artist, early video recording also offered a modest immortality – about 20 years depending on the quality of the tape and the conditions in which it was kept. Nam June Paik believed that video most resembled life in its material mortality: 'Video art imitates nature, not in its appearance or mass, but in its intimate "time-structure"... which is the process of AGING (a certain kind of irreversibility)'.[12]

Video has the ability to travel across space and time as well as offering a short-term, anti-ageing aid to vanity. It can also bring space and time together. In 1980, the American artist Ira Schneider showed 24 tapes on a circle of monitors. Each tape was shot in a different location in the 24 time zones that make up the geographical time frame of the earth. Where broadcast television has the capability of sending a single image to destinations throughout the world, *Time Zone* anticipated the ability of the Internet to do the opposite, that is, bring together lives that are separated nationally and geographically but, in ignorance of each other, are experienced simultaneously across the globe. The Canadian Lawrence Spero decided to witness the dawn of the new millennium as a continuous Internet present by visiting a succession of webcam-linked cities around the world as each time zone hit midnight. Trapped in a kind of groundhog day new year, it took Spero twenty-four hours to experience the first second of the new millennium with everyone on earth.

Before the advent of the Internet, both television and early video were able to link geographically disparate representations of the present in simultaneous recordings and live broadcasts. The present could be launched into a projected future through recording what the camera saw onto tape. With later technological advances, video matched the ability of film to speed up apparent time and slow it down almost to the point of a dreamlike stasis. Then it became possible to combine images shot at different times and places into a montage of simultaneously experienced realities on one screen. Even with old and new variations on simultaneity, the most consistently captivating trick of time that both film and video can play is undoubtedly their ability to play back, to summon the past into the present with the apparent effortlessness of a crystal ball.

However, in the crystal depths of video magic, things are not always what they seem. Since the medium was invented, it has been difficult to tell the difference between a pre-recorded tape and an image relayed live from another space. In the 1970s, time had not yet eroded the quality of the tape nor aged the people and places depicted. Video history was very recent. The American artist

Vito Acconci cleverly played on the almost identical quality of pre-recorded and live video. In *Claim Excerpts* (1971), Acconci mounted a monitor at the top of a spiral staircase. On it, viewers could see the artist climbing the stairs, cursing and brandishing an iron bar. An instantaneous judgement had to be made. Was Acconci really approaching or was this a pre-recorded joke on the viewer? Records suggest that most people erred on the side of caution and fled. The work exposed our unquestioning belief in the veracity of media information and the psychological process that enables audiences to routinely suspend disbelief before the flickering falsehoods of the video monitor. In Acconci's clever deception, the line between the real and the simulated became frayed, our sense of time past and present was unsettled. Believing ones eyes no longer seemed a reliable strategy for survival.

INSTANT FEEDBACK IN THE PRIVACY OF YOUR OWN STUDIO

> Video was a medium for rehearsal.
>
> **Vito Acconci, 2003**

In terms of audience reception and manipulation, video offered both advantages and disadvantages. As far as the working practices of moving image artists were concerned, the most revolutionary aspect of the technology was the instant access it provided to the image – something that film could not do. With the camera hooked up to a monitor and feeding back what it saw, an artist could work directly with the image, arranging elements in the picture frame to satisfaction before committing anything to tape. The American-born artist Dan Reeves still celebrates the plasticity and spontaneity of the medium, 'and the very smallish gap between inspiration and execution' that video allows.[13] Writing in a recent issue of the UK journal *Filmwaves*, the artist Marty St. James vividly describes how he could never give up the immediacy of video in favour of the uncertainties of film: 'It would be like making a sculpture in a bucket, sending it off to the foundry and waiting for it to come back already fixed to the floor.'[14] St. James further emphasises the existential experience of video: 'With video, there is no delay. As in a performance, you work in the present... With film, you wait for the postman to bring you something you made in the past, something you haven't seen for two weeks, something that's dead.' As St. James testifies, performance lives in the present, but at the moment of creation, it is a one-off, one-shot enterprise. If you get it wrong on the night, you can't press rewind and start again. The beauty of the first video recordings was that they could disappear without a trace, discretely disposing of many false starts. Sequences could be discarded by recording over them with a new version or erasing them with continuous black – 'blacking the tape'. It was like working

with a pencil and rubber where film and performance demanded the courage to create with indelible ink. Once the performance had taken place or the film exposed, the work was set and took on a certain material permanence. Even if it had been buried at the bottom of the garden, a film constituted evidence of the artist's activities that could not be denied in a court of law. An artistic statement that in St. James' terms would be nailed to the floor.

Like many of the plastic arts, pre-recorded video could be continually deferred. It was the ideal medium for the indecisive, the perfectionist and those who favoured the slow materialisation of an idea in the privacy of a painting or sculpture studio. The traditionally spontaneous medium could be highly rehearsed and constructed. Video was also the perfect medium of self-contemplation and offered views of the body that were normally inaccessible, such as the back of the head. This proved particularly useful to Vito Acconci who, in *Corrections* (1970), was able to burn away unwanted hairs on the back of his neck with the help of an off-screen monitor. The video also allowed the artist to stare into his own face, watch his own gestures, hear his own voice and observe those indefinable messages we all unwittingly transmit with our bodies. By means of live feedback, the video artist was able to see the self as it appeared to others. Gazing into the mirror of the feedback loop allowed entry into a locked-in world of self and self as other in the reflecting pool of the technology. No other crew or machinery was needed to create the image and natural light was sufficient to illuminate a scene. The camera would then record the encounter with the self without the pressures of having to negotiate the expectations and input of collaborators or the reactions of a live audience. As we will see in Chapter 3, feminists later exploited the ability of the video closed-circuit system to act as mirror-confessor in the autobiographical work they made under the principle that the Personal was Political. Other 'minority' groups, particularly gay men, found the intimacy and domestic nature of video the ideal vehicle for the exploration of social, racial and sexual identity.

THE ELUSIVE MEDIUM

Analogue video is capable of an apparently unassailable realism in spite of the crudity of the image in the early days, its harsh contrasts and its myopic, poor depth of field. However, this fugitive image doesn't materially exist other than as a series of invisible electronic impulses encoded on a magnetic tape that will disintegrate within 20 years or less. Its material base bears no resemblance to the image it produces and it depends for its existence on the smooth running of machines and electricity. In the early days of video art, the unreliability of video equipment gave the medium the reputation of being the only art form that was truly dematerialised. Owing to repeated technical breakdown, it frequently failed to materialise at all. When it did, its sensitivity to misalignment meant that it was often reduced to pulsating abstractions and visual 'noise'.

In spite of the clever tricks it can play, video has always been an ephemeral and delicate medium, susceptible to being wiped, destroyed by heat, moisture, trauma and vibration. Although it can be manipulated in the present through the closed-circuit system, video is essentially a hands-off medium. Videotape cannot be held up to the light like film, or painted and scratched to produce an image. Nothing is learned from handling videotape; in fact, it can only be damaged by touch. It is even susceptible to magnetic forces including those created on electric subway trains, or so we were told. When I was a student in London, Mike Stubbs, a fellow student at the Royal College of Art, failed to come up with any work for a tutorial and claimed that his tapes had been destroyed by the magnetic forces pursuing the tube train to Kensington. Whether or not the underground was capable of wiping tapes, the vulnerability of the video image to magnetic forces was not in doubt and was perfectly demonstrated by Nam June Paik in 1965. *Magnet TV* consisted of a black and white monitor crowned by a powerful horseshoe magnet. The force field created by the magnet derailed the image from its scan lines and drew it towards the top turning a representational image into sweeping, veil-like abstractions. If the magnet was moved, the patterns flowed into new configurations following the shifting magnetic field.

Paik's *Magnet TV* demonstrated the vulnerability of the video image to outside interference. Paik, among others, was to prove that the video signal could be accessed and transformed at the point of manufacture. For other artists, the remoteness of the image is the very quality to which they are attracted. Marty St. James finds video an ideal form of expression for an abstract mind that doesn't want to deal with the physicality of the world. Video offers a point of convergence where his thoughts and ideas can find immediate expression and be relayed to a local, then later with the development of the Internet, to a global audience. As Hervé Fisher wrote, 'a thought laid upon a videotape is a thought capable of being broadcast everywhere at once in naked communication.'[15] This sense of the unpolluted artistic concept embodied in the ephemeral medium of video has been reiterated throughout its history. Like a thought, the video image is essentially an abstraction, a mirage that cannot be captured and held to account. Its workings are underground, transatlantic, global, unbounded. Contemporary Meme theory comes close to describing the elusive power of thought communicated in electronic phantasms. They pass through electronic systems and are replicated the way Meme theory describes cultural ideas spreading like forest fires from individual to individual across time and space. In common with thought, video is free of a permanent material host. And this sense of impermanence, of the fleeting, but occasionally profound effect of the video image is what drew the 1960s generation to the medium. In spite of their attempts to capture the image in short-lived recordings, the transitory nature of video reflected their philosophies of the here and now, the existential moment

of change and the spreading resistance to the certainties and grand narratives that art, religion and science had used to construct the narrow world-view of their parents' generation.

THE MILLION-DOLLAR PAINTBRUSH • A NOTE ON THE TECHNOLOGY

Apart from the philosophical appeal of this illusive medium, the easy appearance and sometimes-convenient disappearance of video had its practical advantages. Unlike film, tapes could be recycled and with small or one-person crews, video had relatively low production costs. Relative to film, that is. Even in the late 1970s, the basic video equipment was still very expensive for the average artist to buy and most people relied on colleges and artist-run production centres to lend or rent them the equipment at favourable rates. In 1981, with the help of several grants, Dan Reeves spent $100,000 (US) on a top of the range three-tube camera and recorder. In the ensuing decade, with rapid improvements in the technology, he went on to spend a small fortune on the newest machines, each item virtually obsolete by the time it reached him.[16] In 1982, my own bottom of the range Sony camera cost £1,000, the Portapak, a further £2,000. Editing equipment was beyond my budget. But 16 mm film was also very expensive in the 1960s and 1970s and most artists worked with cheaper, and lighter, super 8 equipment. The disadvantage of super 8 was that it allowed only three minutes of continuous recording time, where video extended the scope to 20 minutes in a portable system and an hour for the desktop variety. The technology has now evolved to the point of general affordability. Extended battery life, miniaturisation and portability have meant that video has overtaken super 8 as the preferred home-movie medium. In the increasingly popular realm of reality TV, subjects are now given small digital cameras to reinvent their life stories for public consumption.

Those early black and white recorders may have offered considerable advantages for real-time recording, but the machines themselves were not as portable as they are now. The combined weight of a Portapak recorder and camera was over 18lb. The now familiar image of Bill Viola facing the desert like some techno-cowboy, the equipment casually slung across his shoulders, was magnificent, but unrealistic for those of us blessed with female musculature. Even relatively strong men needed assistants to run with the equipment and, as a result, many pioneers of video either collaborated or chose to work with a tripod from static positions in a controlled studio environment.

ENTER THE IMAGINARY • THE IMPACT OF VIDEO EDITING

Nam June Paik's recording of the Pope's cavalcade was made in real time, partly because no editing was available to the artist at that stage. Later, in the

1970s, simple assemble-editing became accessible and video changed from a raw, performance-based medium to a vehicle of psychological and imaginative play. Editing also made possible experiments in fractured, non-linear narratives, compressing or extending time at will. The more accurate the editing, the faster the edits became and with the advent of digital editing, artists experimented with rapid-fire cutting that tested the edges of perceptual coherence. Slow motion heralded contemplative works aspiring to a spiritual dimension that in the work of Bill Viola was also a meditation on the cycle of life and death. When an array of special effects was introduced in the 1980s, there emerged a new painterly tendency that was built on early experiments with image processing that Paik and others had pioneered in the 1960s. Images became layered, surreal and the focus shifted to the tactile and mesmeric qualities of abstraction and surface patterning. The technology available to artists became progressively more sophisticated and production values soared in the late 1980s and early 1990s. Artists like Sam Taylor-Wood and Matthew Barney now use digital video and create works that deliberately reproduce the high gloss and shallow ennui of adverts and fashion photographs. But there have been frequent nostalgic returns to the grunge aesthetics, the raw immediacy of early video. In the late 1980s, the American artist Sadie Benning chose a Fisher-Price toy video camera to record the trials and tribulations of a young lesbian growing up in middle America, while in the late 1990s the UK artist Richard Billingham used a light-weight digital camera to produce subjective, fly-on-the wall portraits of his dysfunctional, alcoholic family. The brief, forty-year history of video can be written in terms of the rapidly evolving technology available to artists and, later, to the general public. Video artists have exploited each technological development and many of the aesthetic, political and philosophical ideas underpinning their work saw the light because, at a given moment, the technology made it possible.

In the following chapters, we will look in more detail at the various tendencies and movements that make up the story of video art. Woven into the narrative will be the progression of video from an unwieldy one-take, black and white recording medium, to an infinitely flexible means of social, political and personal documentation. Video, with its increasingly sophisticated digital manipulations, has also evolved into the vehicle for the most elaborate flights of the artistic imagination. As the story unfolds, we will see a shift away from the counter-cultural aspirations of political work in the early years towards a more complex relationship to popular culture coinciding with a renewed involvement in the commercial gallery system.

2

The Modernist Inheritance

Tampering with the Technology,

and Other Interferences

Some day artists will work with capacitors, resistors and semi-conductors as they work
today with brushes, violins and junk.

Nam June Paik

Artists emerging from the revolutionary ferment of the late 1960s were quick
to explore the potential of portable video technology, the first new moving
image format to emerge since the invention of film. Over the years, this
flexible and enduring medium was to be used by artists for a range of social,
political and aesthetic practices. Although driven by revolutionary politics and
a determination to dissolve established categories and definitions of art, at
the point of conception, video art was profoundly marked by the modernist
aesthetic concerns that dominated post-war American and later European
painting and sculpture.

WHAT HAPPENED TO PAINTING AND SCULPTURE?

Once the nineteenth-century French Impressionists and their epigones had
disrupted the smooth surface of representational painting and Picasso, Braque and
the Surrealists defied the conventions of pictorial realism, artists began to explore
the intrinsic qualities of traditional art materials and became less concerned with
transforming paint, wood and bronze into faithful copies of the external world.
By the mid 1950s, realism in art came under renewed attack and a modernist
campaign for 'truth to materials' was launched – with an emphasis on surface,
texture and the optical effects of pure pigment. Marble, wood and paint were no

longer required to represent anything other than an ontological declaration of self or in the case of Expressionist painting, the phenomenological, gestural results of the artist's hand scattering coloured fluids onto virgin canvas. Instead of pursuing universal aesthetic principles in a Kantian appreciation of art, the discerning gallery-goer was now to be immersed in the phenomenology of material and discover its essence in an almost transcendental communion with wood as wood and paint as paint. For many, this derived as much from eastern mysticism as from a modernist insistence on truth to materials. These two ideologies could be combined and art reconfigured as a stripped-down evocation of material as being-in-itself. Beyond the material and its imaginative transcendence, the most minimal of modernist art also contained elements that aspired to the condition of pure thought, of thought in a closed circuit of self-contemplation.

Although individually, post-war artists – Americans in particular – enjoyed considerable notoriety and success, within their work they pursued anonymity, or a generalised, archetypal human presence in deference to the new ascendancy of material as the subject of art. Even the neurotic gesturing of Jackson Pollock and his fellow abstract expressionists offered a pared-down vision of creativity, an explosive meeting of wordless angst and paint. In three dimensions, minimalism also came to dominate as Carl Andre invited us to contemplate the dumb regularity of bricks arranged as a shallow platform. Donald Judd created immaculate, but non-functional metal boxes and Richard Serra installed precariously balanced slabs of steel in public spaces. In colour field and minimalist painting, any evidence of the artist's hand was considered a distraction from the pure appreciation of colour and surface and the highly tuned sense of essential presence a purely abstract painting could evoke. As minimalist abstraction headed for its logical conclusion, the traditional fine arts seemed to be set on a course of auto-destruction. By the mid 1950s, Ellsworth Kelly had produced the 'Black Square' canvases, nothing but expanses of dusty grey paint. The works, in a gesture of ultimate self-exposure, referred only to themselves, narrowing the viewer's attention to minute traces of the artist's hand in the unwitting bleeding of one colour into another or broadening readings into metaphysical speculations. In terms of the language of art, these endgame minimalists elaborated what Stuart Marshall described as 'the play of pure signifiers free of any signifieds beyond the realm of aesthetics itself'.[1]

Thus, video emerged at a time when modernism decreed that the material specificities of paint, wood, metal and later film were to be explored for their own sake. Where modernist sculpture and easel art unveiled the material base of the plastic arts, film and video added a preoccupation with process already evident in the 'action' paintings of the abstract expressionist, Jackson Pollock. Film lent itself well to this project owing to the different stages that needed to be completed to create the image – performing, lighting, filming, developing, printing, editing and projecting the result. Across the duration of the film,

the means of production could be revealed within the image itself.[2] Film also offered a surface to be painted, scratched and otherwise tampered with in a game of double exposure. In this way it could, even as a projected, illusional image, constantly insist on its non-representational, material condition. Stuart Marshall has suggested that this self-reflexivity was more difficult to achieve with early video technology. Although artists like Nam June Paik later invented machines that interfered with the mechanical and electronic processes that create the video image, the medium offered no surface to work on directly. The birth of the image took place deep in the technology where the artist could not gain access without breaking the machine and extinguishing the signal. Marshall further suggested that the overriding realism of the image meant that video artists tended to work with issues of representation and narrativity where film-makers, painters and sculptors were able to pursue abstraction and the modernist engagement with material.

Here it might be legitimate to claim for video another antecedent in the linguistic investigations of conceptual art. Once Marcel Duchamps had successfully convinced the 1917 art world that a urinal was art, conceptual artists could turn their attention to the representational systems that classify objects, people and places and fix their meaning, use and value. They showed how these categories translated into the realm of aesthetics and revealed the cultural taxonomy that defined what was art and what was not. In their own practices, conceptual artists sought to unsettle the apparently natural marriage of meaning and material especially when the result was elevated to the status of art. Much conceptual art delighted in absurdism and illogical juxtapositions and transpositions of materials, precipitating in their objects a glorious obsolescence. In the 1930s, Meret Oppenheim had exhibited an unusable furry teacup while the 1960s saw the American Claes Oldenburg constructing a giant Mickey Mouse. By the 1980s, in the UK, Amikam Toren was making paintings of chairs with pigment made from those same chairs ground down. Art and Language marked the logical endgame of conceptual art by replacing the art object with elaborate and largely incomprehensible theoretical propositions.

As we will see later, this concern to unravel linguistic conventions rather than commune with process and material was more a feature of video in the UK than elsewhere. In fact, all video involved a relationship with a set of machines and processes, regardless of the maker's stated objectives. The image itself had to be created electronically, at a distance as a set of mechanical and electronic instructions. Like film, the material specificity of early video technology did, in fact, offer many points of access and interference, and many more as knowledge of the medium grew. In the same way that the philosopher Michel Foucault recommended examining criminals in order to understand better the workings of the law, early video artists triggered malfunctions in the technology to explore its fundamental nature. In the process, they discovered some of the

medium's expressive potential once it was liberated from the realist imperatives of broadcast television.

THE SPECIFICITIES OF THE MEDIUM

In 1962, the French artist César exhibited an operating TV mounted on a pedestal and threatened it with a gun. This memorable gesture marked the first assault on the technology of television and its popular offspring, portable video. A growing understanding of the technical properties of the televisual image soon allowed artists to launch attacks on the delivery of its flickering realism at its point of reception, on the television set and later at the moment of its creation in the camera. Those who acquired the requisite technical expertise were able to dismantle and adapt the apparatus itself. A brief look at how television technology worked in the mid 1960s will help locate the points of entry that artists discovered. It was by interfering with those bewildering networks of cables, wires and components that artists began their search for the truth of the materials and the key to the mimetic lies that tele-vision magically conjures up.

TELEVISIONS

Early television sets contained a vidicom tube onto which an image was scanned through 525 lines in the USA and 625 lines in Europe and the UK. The 'tube' was a glass envelope the inside of which was coated with tightly packed clusters of phosphor. The picture was activated by an electron gun that bombarded the phosphor clusters with electrons in a controlled sequence. The picture was made up of two 'fields' created by the electron beam scanning first the odd, then the even lines on the screen in quick succession. These were calibrated to create 24 frames per second, each one made up of two interlocking fields. These were not true frames in the filmic sense since the scanning process was continuous, more fluid than mechanical.

Early televisions delivered a black and white image synchronised to mono sound. In spite of the initial crudity of the result, they created sufficiently compelling visions to hold their viewers' collective attention and confirm a new social role for the TV set within suburban family life. Television design soon abandoned any pretence to be concealing an amusing new gadget in an item of elegant furniture. Instead, televisions brazenly flaunted sleek industrial casings that helped establish the up to date modernity of the families to which they belonged.

The bland narratives and establishment views of broadcasters now replaced the cohesive function of family interactions and storytelling. This displacement offered artists the first point of exposure and disruption. In 1962, the German artist Wolf Vostell called on audiences to hijack the evening's TV entertainment

by repeatedly changing channels, wrapping the TV in barbed wire, burying it or eating it as an indigestible 'TV Dinner'. Through his instruction to channel-hop continuously, Vostell was shattering the pervasive narratives of television and his absurd injunction to destroy what were then very expensive sets highlighted the consumerism that dominated cultural production and reception. He was also taking a swipe at the cupidity of individuals whose seemingly limitless appetite for novelty was beginning to feed the burgeoning television industry. If viewers were foolish enough to follow Vostell's instructions, the logistical problems involved in wrapping the TV in barbed wired and finding a way of converting it into an edible form, would certainly reinstate family cooperation, if not laughter and conversation.

Like a child dismantling a new toy, Vostell began to interfere with the television set itself. He invented his *TV Decollages* in which he used the vertical and horizontal hold adjustments to throw the picture out of kilter and distort the broadcast image to the point of incoherence. In this way, the artist interrupted the continuous flow of mass, one-way cultural production. By artificially creating faults in the image reception, Vostell revealed the electronic source of the televisual illusion. These works were of their technological time. Contemporary television sets have dispensed with the need for vertical or horizontal hold adjustments thereby closing an avenue of intervention in the image. Artists soon exhausted the available opportunities to intervene provided by television manufacturers on the outside of the set and embarked on more invasive surgery.

We have already seen how Nam June Paik used powerful magnets to create distortions of the television image. Paik also began to tamper with the internal workings of the TV set. Following the tradition of modified instruments that had been pioneered by the contemporary composer John Cage, Paik began adapting TV sets to create what he called 'Electronic Television', a new visual equivalent of Electronic Music. His first experiments showed the mark of the Zen Buddhism that had triggered John Cage's pursuit of silence and chance. Where Cage had reduced the audience to listening to their own breathing, Paik emptied out the television image into meditative, minimalist abstractions.[3] In 1963, he created *Zen for TV*, a television set on which only a single line of light appeared. He achieved this by modifying the scanner in such a way as to prevent the electron beam from scanning the lines above and below the visible line of light. The slender electronic horizon line demonstrated a technological process but also invited the viewer to abandon the shallow pleasures of television consumerism and embark on a process of transcendental meditation. The line suggested deeper interpretations of infinity, of the division between sky and land, heaven and hell as well as the natural and the man-made and whatever meanings are prompted in the individual when gazing at a horizon. The simple division of the picture surface into two equal parts also emphasised the geometry of the three-

dimensional box that is a television set, an object that viewers quickly forget as they are drawn into the illusionistic scenes playing on its glassy surface.

In *Moon is the Oldest TV* (1965), one of his most poetic 'prepared' television works, Paik modified a series of TV monitors to produce another minimalist shape, a circle of white light. By moving the scanner further back into the television housing, the pool of light that was visible on the screen was reduced in size and with its bluish tint, took on the eerie aspect of the moon. In later versions of the work, Paik used a series of magnets fixed to the necks of each tube to distort the moon-shape into its various phases from full to crescent to virtual obliteration with the new moon. The twelve monitors represented each month of the year, although strictly speaking there should have been thirteen since there were thirteen lunar months in the year when the moon was first used as a measure of time. Paik reinstated the moon as one of the original sources of light, as a navigational aid and object of religious contemplation. At the same time, he deconstructed the technology, not simply as a dry reminder of how the tricks of the eye fool us into accepting a televisual image as reality, but as a means of creating a new aesthetic with wider social and cultural meanings. Above all, Paik wanted to 'get the audience in a oneness of consciousness, so they could perceive more'.[4]

Up to this point, artists had made physical interventions into the technology by retuning, misaligning and derailing the normal functioning of televisions and monitors. But Paik soon discovered that he could adapt the output of a television set by intervening in the signal at the point of input. Back in the 1950s, Ben Laposky had produced his *Oscillons*, elaborate, filmy abstractions created by distorting sound waves with deflector plates attached to an oscilloscope. Like a television set, the oscilloscope used a cathode ray tube to visualise electrical signals and was susceptible to magnetic interference. In 1963, Paik adapted this technique by feeding the output of a radio into a television set which then interpreted the audio signal as a single point of light. When the volume on the radio was turned up, the point of light expanded. Turning the sound down again caused the light to recede in the same way that early television images vanished into a point of light when the set was switched off. As in Paik's work with external magnets, *Point of Light* incorporated the interactive principle that characterised contemporary performance art, by depending on the cooperation of the audience to turn the knob on the set and demonstrate its potential. This embraced the aleatory principle, the element of chance that was central to John Cage's musical experiments and Paik's own commitment to indeterminacy. Each new manipulation by a member of the audience remained unpredictable, unique and unrepeatable.

The modernist imperative to dismantle the images of cultural production and reveal their component parts remained a strong element in Paik's early work. As well as making visible the internal workings of the technology, Paik was

executing a gesture of defiance at the monolithic omnipresence of television. In his terms, broadcast media were mounting a constant onslaught on their audience's sensibilities and he had taken it upon himself to launch a counter-offensive. But his work was also reflective of the domestic setting in which television weaves its spell. There is a playful element in his prepared sets. Like a precocious son of the household, Paik pulls the box apart and takes a certain delight in spoiling it for everyone else. He even offers his audience a chance to take part in his subversive play, defying both the new conventions of suburban domesticity and the media monster that was infiltrating every aspect of private and public life.

CAMERAS

Once artists gained access to affordable and portable cameras and recorders in the mid sixties, they soon subjected them to the same modernist tampering that Paik and Vostell had inflicted on television sets. The camera did not escape their forensic curiosity and in parallel with Vostell's treatment of television sets, Douglas Davis buried a camera, then smashed it into a mirror and finally lowered it out of a window, with the machine being forced to record its own fate. More subtle forms of torture were devised once a rudimentary understanding of the internal workings of the camera was acquired.

The technical make up of early video cameras reversed the process whereby a television receiver decoded broadcast signals into a scanned image. Light focused through a lens fell on the camera tube and the information was encoded into a set of electronic pulses that were routed to a television or monitor, decoded and reconstituted as an image. Artists discovered that the phosphor coating in early camera tubes had a memory and manufacturers warned that it was inadvisable to point the camera at intense sources of light for extended periods. 'Hot spots' in the image would 'burn' onto the tube and remain as indelible ghosts to be superimposed on any subsequent footage recorded with the same camera.

In 1975, the US artist Mary Lucier used this property of the technology to make *Dawn Burn*. Pointing the camera directly at the sun, she exposed the tube to its concentrated rays of light as it rose over the East River in New York. The passage of the sun was thus burnt into the tube as an arcing trace creating a perfect record of the sunrise but ruining the camera for other users. In Germany, Jochen Gerz demonstrated the sensitivity of the tube to light in *Prometheus. Greek Piece no.3* (1975). For the duration of the twenty-minute tape, Gerz reflected sunlight back into the lens of the camera with a small mirror. Standing some fifty meters away, the figure of the artist gradually disappeared under the spreading burn marks of the sun.

By intensifying and concentrating the input of light, these works created a fault that exposed a flaw in the technology. They also demonstrated the series of alchemical transformations that begin with the natural phenomenon of light

falling on the lens, its conversion to an analogue signal that subsequently metamorphoses into visual information emitted by the luminous phosphor hidden in the monitor. Gerz made the process starkly visible by creating then destroying the mimetic illusion in which the artist was illuminated and then effaced by the light that first revealed him. This could be seen as a cautionary tale about technology, nature taking its revenge when left to its own devices, or it could be a meditation on the ephemeral nature of human life. However, *Prometheus. Greek Piece no.3* is primarily a modernist conceit in which television technology is thwarted in its aim to faithfully replicate the world.

CAMERA TO MONITOR, VIDEO FEEDBACK

Artists soon pounced on another fault line in the technology, one that continues to fascinate art students to this day. By pointing a camera directly at the monitor to which it is connected, artists like Bill and Louise Etra and Ben Tatti discovered that video feedback creates the perfect closed-circuit manifestation of the video process. The image repeats and disappears into a vortex of ever-receding replicas of itself. It continually feeds upon itself like a ravenous mythological creature consuming its own tail. In its self-contemplation, the video image symbolically interrupts the continuous one-way flow of broadcast information. Looped back, the signal finds no destination and disrupts the forward propulsion of narrative time on which television depends. Any object placed between the camera and its multiple mirror becomes subject to the same distortions and is sucked into the oubliette of the technological malfunction. The distinction between object and ground is lost as is the separation of discrete objects. Foreground and background dissolve into vertiginous surface patterns. The electro-visual acrobatics that video feedback performs were popular at the time of their discovery. Although it was initially regarded as a deconstructive device, feedback captured something of the drug-induced 'trips' of the 1960s, the hallucinogenic blurring of senses and boundaries that LSD could cause.

Notwithstanding its psychedelic potential, video feedback was exploited for its ability to dramatise the imaging function of the camera as well as the perceptual processes of the artist. Stephen Partridge in the UK used feedback and time delay to create a three-dimensional domino effect of monitors being turned by hand. *Monitor 1* (1974) shows a tiny monitor within a slightly larger monitor within another larger monitor, increasing in size until the monitor on which the tape is playing is reached. Each monitor turns a second after the other in a Russian Doll demonstration of video feedback. In 1971, the Canadian Michael Snow developed his installation *De La* in which a video camera mounted on an elaborate mechanical tripod scanned its environment through 360 degrees at variable speeds. The image was delivered to two monitors and as the camera swung past, the infinite recession of video feedback filled the screens. Pierre Théberge

observed that, 'although it can point at the television screens and multiply their images indefinitely, the machine (camera) itself, is absent from all the images it can produce.'[5] The feedback loop being produced by the camera and monitor may not reproduce the external appearance of the machines, but it is an accurate visualisation of the internal workings of both and their structural interaction.

SOUND FEEDBACK

The American artist Richard Serra made it possible for an audience to experience the physiological equivalent to what Ernest Gusella described as 'tape echo'. *Boomerang* (1974) recorded on video the reactions of Nancy Holt speaking into a microphone whilst hearing her words fed back through headphones and subject to a slight delay. This phenomenon also pertained to long distance telephone calls and occasionally still happens with mobile phones causing, in this writer at least, a slight feeling of nausea. Serra observed that in this situation, speakers became conscious of the processes whereby thoughts are formed, translated into words, uttered and apprehended by a listener, but in *Boomerang* the participant was both the source and destination of the vocalisation. Attempting to react appropriately to each phase, the work provoked a 'revolving, involuting experience, because parts of the words coming back in on themselves stimulated a new direction for thoughts'.[6] In my experience those new directions take the form of an alarming awareness of the external social markers that are contained in my own voice. I can hear myself as others hear me at the moment of my own utterance. The intended effects of my words do not match my judgement of the result and I frantically realign my tone to produce the public image I fondly imagine I project through my voice. Like the visual delirium of video feedback, the auditory feedback of *Boomerang* can produce in the speaker/listener an instant psychosis. As Nancy Holt describes it in the tape, 'I am surrounded by *Me*, my mind surrounds me, goes out into the world, then comes back inside me… no escape.' There is a retreat from reality because the reality of being consciously trapped in representation produces a functional and sensory overload that becomes quickly unbearable.

SYNCH SOUND

For its participants, one of the many disturbing aspects of Richard Serra's *Boomerang* was the disruption of the synchronisation of sound to visual events within the picture frame. Words have to match lip movements in order for television realism to function effectively. This realism replicates our understanding of cause and effect, and confirms the health of our perceptual systems. To disrupt the logic of spoken language is profoundly damaging to both conventional narrative structures and the position of the individual within a system of communication that he thought he understood. In 1969, the

American artist Bruce Nauman slowly separated speech from lip movement in his hypnotic tape *Lip Sync*. By turning the camera upside down, he created an inverted close up of his chin and lips. In the tape, he repeats the term 'lip sync' for the duration, the words gradually slipping out of sync with his lip movements and just as gradually falling back into step with the image. As I have mentioned, in *Stamping the Studio* (1968), Nauman is seen shuffling around his studio and, once again, the sound of his footsteps drifts out of sync and slowly returns to make sense of the image. In video, sound is always recorded simultaneously with the image and Nauman's ability to achieve the separation was dependent on a small technical advance in Portapaks towards the end of the 1960s. The recorders now offered two channels of sound, the first of which was synchronised to the picture while the second could be recorded independently as an audio dub superimposed on the original recording. Artists could now play with a voice-over commentary after the event or, as in Nauman's case, use the second channel of sound to subvert the first.

Some years later the logical relationship between sound and picture was disrupted further by the American artist Gary Hill whose tape *Why do things get in a muddle?* (1984) contrived to make speech and picture run in opposite directions. Two actors playing a learned academic and questioning Alice figure learnt their lines backwards and when the tape was itself played in reverse motion, the words, coming out breathy and syncopated, made syntactical sense but the action ran backwards. The process was most obvious when the bearded academic appeared to ingest and blow smoke into his pipe while his speech remained coherent, if a little strange. This disjuncture of words and the perceived forward march of time created an unsettling spectacle and drew attention to the familiar match of sound, picture and temporal direction that television and film rely on. Once again, the transparency of the medium was challenged by a modernist tampering with the conventional association of word and picture and a curious dream-like discursive world rose up in the linguistic gaps.

FURTHER MALFUNCTIONS

The most famous work of early modernist video exploited a familiar television malfunction of the period. The first television sets were prone to lose the synchronisation of the picture scanning and begin to drift between frames with the usually invisible black band marking the transition from one frame to another scrolling through the picture. Vertical and horizontal roll buttons were helpfully provided on old sets to steady the picture. The New York artist Joan Jonas deliberately misaligned the vertical roll so that the black band rhythmically scrolled through the picture. In *Vertical Roll* (1972) she made a recording of her hand repeatedly slamming down on a table and played it through the faulty monitor. The unevenness of her action meant that, from time

to time, her hand appeared to hit the black bar and push it to the bottom of the frame. It looked as though the self-styled 'electronic sorceress' was achieving the impossible, that is, reversing the immateriality of the video image by climbing inside the technology and touching a physical component. However, both the black band and the artist's hand were clearly illusions created by electronic signals. Together with the components facilitating their movements, they constituted the only material dimensions of the work. The video image and its artful deconstruction existed in this and any other work in video only as a change in electrical potential, entirely dependent on the supply of electricity to the system for it to exist.

SCRAMBLING THE MESSAGE

The credulity of early television and video audiences, their willingness to suspend disbelief and read a hazy black and white or washed out colour image as a form of reality became the concern of many British video-makers in the early 1970s. David Hall, a pioneer of UK video, was determined to expose the lie and destabilised the codes of television realism by illuminating another defect of the technology thereby creating what is probably the definitive television deconstruction. *This is a Television Receiver* (1971–1976) featured the well-known newsreader Richard Baker facing the camera in a steady, if tight, frame. This familiar figure began to speak, delivering not the prescribed evening bulletin packaged for the delicate palate of the British viewing public, but a self-reflexive statement that fractured the credulity pact, then as now voluntarily entered into with broadcasters. 'This is a television receiver,' Baker begins, 'which is a box made of wood, metal or plastic. On one side, most likely the one you are looking at, there is a large rectangular opening that is filled with a curved glass surface that is emitting light... in a variety of shades or hues... these form shapes that often appear as images, in this case the image of a man, but it is not a man.' Baker goes on to describe the mechanism by which sound is created matching the man's lip movements, 'but it is not a man's voice'. Hall is using the verisimilitude of television to declare its fraudulence and call into question the official view of the world that Baker's calm and authoritative BBC voice transmitted to millions every night of the week in the 1970s. But in case we should be in any doubt that both the image and the texts of television are artful constructs, the artist goes on to prove his point by copying and replaying the sequence several times, bringing into play a defect that has only now been solved by the advent of digital video. Even today, analogue video still exists in the form of domestic VHS and we all know that copying videotapes involves a deterioration of the signal. In Hall's tape, the image of the newsreader goes down through the generations, copies are made of copies until Baker and his voice have disintegrated beyond recognition. All we are left with is the box, the

1. David Hall, *This is a Television Receiver* (1976). Commissioned by BBC TV as the unannounced opening piece for their *Arena* video art programme, first transmitted 10 March 1976. Courtesy of the artist.

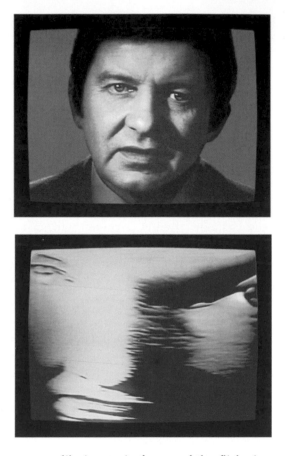

three-dimensional object that we so readily ignore in favour of the flickering illusions playing nightly on its deceptive surface. Clearly, in the digital age, it would be possible to make perfect replicas of the original and no deterioration would take place. But in the era of analogue video, *This is a Television Receiver* demonstrated the illusionism at the heart of cultural production and, by exploiting a fundamental flaw in the technology, Hall revealed the material base of that electronic *trompe l'oeil* to which so many of us are addicted.

COMPUTERS

In the early days of video, the technology was adapted and dismantled to malfunction (Paik, Jonas, Hall), to function without synchronisation (Nauman), independently of a recording process (Paik, Lucier) and free of a camera (Vostell). Video artists now attempted to create images without recourse to broadcast television or indeed the observable world. With the advent of

computers, video broke its dependence on external reality to create an image and evolved a visual language generated entirely from the internal workings of the technology. Stephen Beck and Eric Siegel built the first video synthesizer with which they created slowly moving colour abstractions that flowed and merged as pleasingly as Rothko's oceanic colour field paintings. As in video feedback, the results were closer to the drug induced psychedelic abstractions beloved of contemporaneous hippies and discotheque light shows: 'Watch the colours, man...' As Mick Hartney has pointed out, these non-narrative retinal feasts were quickly taken up by the rock industry, by promotional video-makers and, more recently, by youth TV.[7]

Today's computers have made the generation of electronic abstraction more complex and faster-paced, with a high turnover of visual stimuli taking the spectator up to and beyond the point of sensory overload. Many artists have seen computer space as a value-free, transparent electronic domain in which their creativity might expand without the baggage of artistic traditions that burden painting, sculpture and even televisual imagery. By the late 1980s, artists like William Latham were exploiting the benefits of high resolution, creating disquieting abstract mutations and surreal animations. Like computer animation and Hollywood special effects, these works were the result of functioning and discreet technologies and did not seek to indicate the means of production beyond the image.

Other artists used computers and simple homemade or commercially available vision mixers and switchers to intervene in the smooth passage of the signal from camera to monitor. Through these devices, the image could be hijacked and superimposed or juxtaposed or mixed with other images or replaced altogether with video sources from other cameras. Off-air broadcast material could be altered or combined with images generated by the artist. With the advent of computer image processing, the possibilities for aesthetic and conceptual intervention rose exponentially and technological wizardry will emerge at various points as this account of video unfolds.

Nam June Paik built a computer that could mix images, and he used Chromakey techniques (colour separation overlay) to superimpose parts of one image over another creating bizarre montages. Chromakey works by selecting a colour from the first image, usually blue, that is then replaced by an image from another source. This process is familiar to us on television when the weather reporter stands in front of a computer-generated graphic and points to different areas of the country that magically sprout clouds and suns to illustrate the story. The weather reporter is in fact standing in front of a blue screen. In the early 1970s, the UK artist Peter Donebauer built what he considered to be a 'video instrument', in its commercial form a *Videokalos Colour Synthesizer*. With some experience behind him in creatively realigning studio cameras within a multi-camera set up at the Royal College of Art, Donebauer developed the

Videokalos as an electronic painter's palette. As well as offering five possible layers of images, the video instrument separated the colour elements of a broadcast composite signal into its constituent red, green and blue. In this way, the artist could work with the colours directly and combine them with images generated by cameras and other sources. For Donebauer, the machine was like an instrument and needed to be portable so that he could use it to perform live with musicians and dancers.

The performative potential of video synthesizers was also explored by the Czech artists Steina and Woody Vasulka who worked in both Europe and the USA. They became fascinated with the magic of the invisible electronic signal and began working with audio, then videotape, in the late 1960s. At first, the Vasulkas shared Paik's desire to obviate the need for a camera to produce an image by feeding an audio signal directly into the video recorder. Once they began to mix the sound-generated patterns with another originating from a camera, it became hard to define the point at which the sound ended and the picture began. The Vasulkas contrived to channel the sound of Steina's violin directly into the video signal so that each time her bow came into contact with the strings, the notes she played interacted with and distorted the image of her

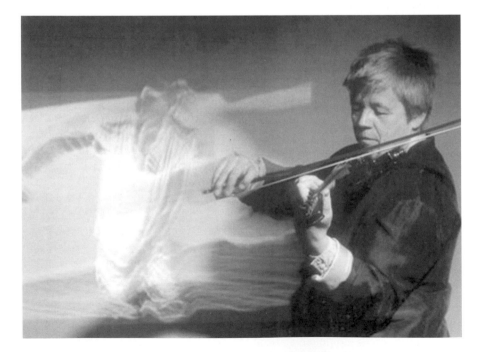

2. Steina Vasulka, *Violin Power: The Performance* (1992 to present), video performance. Courtesy of the artist.

performance on the screen. Like Bruce Nauman, the Vasulkas were reminding us that unlike most film, video comes with a built-in synchronised soundtrack. They devised a new relationship between sound and image, one in which the sound we could hear and see being produced by the performer took on a visual form of its own and disturbed the logic of the representational image.

In later works, with the aid of computers, the Vasulkas were able to employ Steina's violin to manipulate video images more precisely. Taking the role of both editor and vision mixer, Steina could use her bow to scroll forwards and backwards and repeat pre-recorded sequences at will. At times Steina performed retrospectively with dancers, musicians and actors, controlling their music, speech and movements from her instrument. Like a puppeteer with invisible strings, Steina directed her collaborators from the violin now rigged up in such a way that certain strings controlled the speed of the sequence whilst individual notes called up specific images. Vasulka had both people and machines dancing to her tune and was performing as much in the technology as with it. These works became a model for much subsequent computer-based music/video performance and the Vasulkas have made the transition into popular culture by designing software that is used by the current generation of VJs (video jockeys).

It is clear from these accounts that modernist interventions into video technology depended on the image surviving long enough for the defects and distortions to make their deconstructive points. A simple break at any point in the circuitry would easily eclipse a video image altogether, whereas a strip of film could survive a fair bit of surface damage as long as it could still pass though the gate of the projector. While modernist video attempted to precipitate the faults that television was careful to conceal, it still had to avoid total loss of the picture – the blank screen that would, in fact, be the ultimate modernist statement, but was actually the nightmare of every artist who depended on unreliable video equipment in the early years. Painters and sculptors, feeling threatened by the new media, liked to taunt video-makers with the joke that what they enjoyed most about their screenings was that nothing ever happened. Early video-makers had to perfect a delicate balancing act between sabotage and rescue in order to communicate their radical messages and the sometimes-incidental poetry of their deconstructions.

... AND, FINALLY

I use technology in order to hate it more properly.

Nam June Paik

As picture quality has improved over the forty-odd years of video's existence, most of the technical anomalies in both cameras and monitors have been

ironed out. Today's televisions and video recorders offer few points of entry or opportunities to act directly upon the image other than by employing the limited pre-set effects provided by the manufacturers. There has been a concomitant weakening of interest in the technology itself and with some notable exceptions, few contemporary artists maintain the modernist impulse to take the machines apart.[8] Nowadays the focus has shifted to what computers can do with the image and programming knowledge has taken over from the earlier training in basic electronic and engineering sabotage. In spite of the video trickery now at our disposal, the language of the moving image has reverted to its pre-modernist transparency and on the whole, the machines work.

In the early years, Paik and Hall were clear in their objective of disrupting the smooth surface of televisual illusionism. Where modernist painters and sculptors searched for essences and noumenal truths in their communion with materials, pioneers of modernist video appeared to court the failure of the technology as an end in itself. Edith Decker-Phillips has noted a distinction between John Cage's intentions to liberate sound and Nam June Paik's more radical goal, which was to 'eliminate traditional music and performance practices altogether'.[9] The most radical artistic ambitions cannot progress without the technology and in spite of Paik's claim to hate machines, modernist video was based on an intimacy with the apparatus that was prompted as much by enchantment with technological toys as by political analysis. Such fascination with technology has become a feature of our age.

As well as offering a challenge to broadcast media and artistic convention, modernist video-makers like Jonas and the Vasulkas colonised video as a habitable physical and psychological space for creative individuals. They also symbolically returned to a mimetic medium the mark of the individual, bestowing on artists' video Walter Benjamin's 'aura', that talismanic essence of the unique object that reproductive media have banished. Later on, postmodern thinking would erode the notion of both the individual and the primacy of the art object. It would also challenge the pursuit of originality in a world dominated by networks of interchangeable information, circulating in pre-packaged forms. However, in its earliest manifestations, video art was marked by a counter-cultural impulse, an insistence on the agency of the individual as an antidote to the hegemony of television. It offered an independent vision against television's tendency to homogenise and package human subjectivities into a bland pabulum of pick 'n' mix stereotypes.

3

Disrupting the Content

Feminism

Video is a bullet in the landscape.

Anne Course

TELEVISION, THE ALTERNATIVE VIEW

Deconstructing televisual verisimilitude represented one oppositional strategy; another was to attack television at the level of content. On the strength of camera-credible news-gathering, networks have always claimed a privileged relationship with reality and objective truth. However, their impartiality has proved elastic, mediated as it is by the political and commercial interests of their paymasters. The representation and interpretation of events on television is, in fact, several steps removed from lived reality. The packaging devices that include judicious editing, cosy voice-overs and commercial breaks have the effect of normalising official news coverage for mass audiences. In spite of the occasional hard-hitting broadcasts by investigative journalists like the UK's John Pilger, the controls on reporting remain stringent. They are enforced in peacetime as in times of war and with good reason. During the Vietnam War in the 1960s, television learned that the realism from which it drew its powers of persuasion could also work against establishment interests characterised as 'national interest'. Vietnam was the first war to enter our sitting rooms via a television screen. Politicians were unable to counter the effects of exposing the horrors of military conflict to ordinary American citizens who increasingly doubted the moral justification for sacrificing their sons to a nebulous cause, miles from home. The negative outcomes of this inadvertent TV exposure were compounded by the alternative views of the conflict that the anti-war movement was successfully disseminating through literature, song, mass demonstrations

and art. Even today, we rarely see the human costs of US or UK foreign policy on our television screens. We mainly witness the horrors perpetrated by the current enemies of the state.

Since the Vietnam War, the reporting of world affairs on television has remained as much a matter of political expediency as of fact. To balance the unitary world-view promulgated by the networks, artists have used the credibility of video as a factual medium to present their own, alternative experiences of reality, their version of history. In Chapter 7 we will see how groups of artists and activists produced campaign tapes to counter what they saw to be the misrepresentation of events on television. For the moment, I will concentrate on the singular point of view that individuals contributed to problematising the narrow understanding of the world created by corporate broadcasting. The Vietnam War was the inspiration for one of the earliest examples in which an artist undertook to tell his truth, some years after the event. Dan Reeves drew on his own experiences as a conscript in Vietnam to create a moving account of the deaths of his compatriots, an aspect of the war the media came to play down. *Smothering Dreams* (1981) was a dramatised reconstruction of an ambush in which many of Reeves' fellow marines were trapped, wounded and killed. The scenes of confusion, blood and despair are interspersed with memories of childhood games, of Cowboys and Indians teaching the boys to accept violent conflict as a given of their masculine condition. Reeves appropriated a narrative structure and the realism of Hollywood cinema to expose the realities of war free from the jingoistic commentaries with which television attempted to sanitise this episode in American history.

In the UK, war was both close to home in Northern Ireland and distant in parts of the world where hostilities drove asylum seekers to other shores. Mona Hatoum's *Measures of Distance* (1988) recorded one woman's experiences of the Arabic Diaspora, made all the more distressing by separation from her parents who were left to survive the dangers of war-torn Beirut while she sought refuge in London. The tape revolves around letters from home that form a dense mesh of Arabic script superimposed on images of her mother's naked body while the measured voices of mother and daughter speak the words in both Arabic and English. The minutiae of daily life under siege, the marital tensions and niggling worries a mother has for her daughter form a matrix of anxieties into which historic events intrude. This mother, like hundreds of others, was in danger of being reduced to a cold statistic by destructive forces beyond her control. Her death would constitute a barely perceptible blip in the figures that may or may not be deemed newsworthy that week. Through the unique pattern and detail of her mother's embattled existence, Hatoum insisted on the importance of individual lives caught up in armed conflicts. The specificities of her story rose above the babble of tendentious generalisations and propaganda that have long marred reporting from the Middle East.

To some extent, the impact of Reeves' and Hatoum's very personal accounts of war depended on their contrast with television equivalents in the 1970s and 1980s in which individual, non-professional voices were largely absent. Up until the 1990s, television generally excluded the experiences of ordinary soldiers or citizens and certainly had little truck with artists. The notion of reality TV did not exist and such representations of humanity as reached the screens took the form of celebrity personae or fictional characters reflecting the experience, aspirations and desires of the white, heterosexual middle-class males that ran the networks. Women, ethnic minorities, gays and ordinary folk were reduced to stereotypes or simply did not appear. The liberation movements of the 1960s and 1970s made what David Ross called 'the personal attitude' a potent counter-cultural weapon. Ross observed that television, as an institution and a grammar, was well established by the time artists got hold of video cameras and contended that the personal attitude was the one thing that artists could usefully contribute.[1] Video auto-portraiture, the artist's individual perceptions resisting the hegemony of broadcast television, found its natural home in feminist video.

FEMINISM – THE PERSONAL IS POLITICAL

Over the centuries, most western societies and virtually all third-world countries have been patriarchal in structure, that is, organised around social and political institutions dominated by men serving the interests of men. The 'stronger' sex has wielded power in the public arena while women's sphere of influence has been restricted to the domestic domain. In spite of the activities of the Suffragettes early in the twentieth century and the advent of universal suffrage, women in the 1960s and 1970s were still under-represented in almost all walks of life, including the art world. Feminists now challenged the whole gamut of gender inequalities that had persisted on the shaky grounds of sexual difference, on men and women's divergent procreative roles, on biology as destiny. Politics in general and Patriarchy in particular were seen to have infiltrated, indeed created, the private realm, a bounded territory where the majority of women lived out their lives. The film-maker Sally Potter expressed it in these terms: 'Ideology is not merely reflected but produced in the context of the family and in personal relationships... political structures are not just "out there" but are manifest in the most seemingly insignificant actions, words and conditions.'[2] In order to mobilise women to rise out of oppression and win equality in public life, feminists employed a method that politicised women in the heart of their domestic confinement, in the family home. From the 1960s to the 1980s, consciousness-raising as a non-hierarchical process brought women together, often in one anothers' kitchens, to exchange stories of their lives and re-interpret them, not as a product of their individual failings or neuroses, but as a function

of collective oppression under Patriarchy. This was the 'Personal as Political', a slogan that became a feminist rallying-cry for activists and artists alike.

Women artists began to use the 'private' narratives of consciousness-raising as material in their work. The hidden experiences that women had suppressed now entered the public realm of art and these stories were offered, not as monuments to individual artistic egos, but in the hope that other women would be inspired to add their own accounts and promote the process of political awakening. However, it was not enough simply to raise consciousness and enjoy the comradeship of other oppressed women in public or in private. The stories were told for a political purpose that is significantly absent from the personal outpourings we now witness every day on afternoon TV. Within feminist art, as in the wider movement of women's liberation, the aggregate of these myriad voices enabled a common feminist analysis to be made from which political initiatives were forged on issues ranging from abortion to equal pay, domestic violence to childcare, nuclear disarmament to family planning. In contemporary terms, a consciousness-raising collective could be seen as an early form of focus group, but with political rather than commercial objectives. In contrast to the communion with materials and processes that was required of a modernist audience, feminist art was designed to promote political enlightenment and inspire activism that might eventually lead to social change. Feminists no longer conceived of the audience as heterogeneous and aimed the thrust of their arguments principally at other women. In terms of a subterranean female culture running alongside a patriarchal mainstream, this was nothing new. Women had always engaged in multi-layered conversations, one-to-one exchanges in which ideas travelled laterally, by osmosis, periodically crystallising into oral histories that have been passed down through the ages from mother to daughter. But these exchanges no longer took place underground and came to light within the visual arts in general and video in particular, where the investigation of personal identity was fast becoming a key concern.

Feminist art urged activism in the wider world, but it also embarked on a redefinition of femininity itself at the level of representation. Under Patriarchy, images of women were limited to a range of stereotypes classifiable as either negatively or positively charged erotic objects – desirable or undesirable. This system of classification was complemented by the virgin-whore dichotomy with the sexually voracious woman opposed to the ubiquitous image of maternal and domestic devotion on which society turned and reproduced. With television now one of the major vehicles for the dissemination of cultural images of women, video was an obvious medium with which to begin dismantling stereotypical representations and assert the political, psychic and aesthetic evolution of women's newly raised consciousness. With growing audiences and a cultural environment conducive to liberation politics, women could begin to use the association of video with facticity to develop political campaigns.

Video facilitated the exploration of new territories in feminine experience and mobilised the feedback mirror of the technology to search for a viable identity as well as alternative ways of appearing and acting in the world.

FEMINIST VIDEO – INSTANTANEITY

As with any emergent political movement, feminism was marked by a sense of urgency born of centuries of relative silence. Women were impatient to speak, to visualise and to become visible. They gravitated towards performance and video because of their confrontational nature and their ability to deliver an immediate message to an audience. With these direct forms of address, women were able to convey, almost instantly, the various doctrines of feminism. Following the practice of consciousness-raising, women were initially concerned with speaking directly to other women as they had always done on a one-to-one basis – what men liked to call gossip. In this respect, video already carried the possibility of this form of exchange within its inherited vocabulary. Television established the device of eye-to-eye contact with the viewer through the ubiquitous presenter and newsreader. The manufactured intimacy of this direct address to an audience was a useful precedent, but in the context of avant-garde practices, video as a medium was wide open. The writer David Ross pointed out that video was born of the pre-existing disciplines of film, theatre and television. However, the rules of performance and video were still being hammered out; in fact their only convention was that there were no conventions. For women developing a new taxonomy of feminine subjectivity, a nascent video language, unburdened by centuries of patriarchal precedents, seemed to offer relatively virgin territory for the exploration of the feminine.

As we have seen, the instantaneity of video was attractive to those who favoured a representational language of wide currency, but it was video's unique ability to mirror back the image of the artist to herself that most attracted feminist artists working with autobiographical material. A video image could be worked on directly in the privacy of home or studio with the monitor as a guide. The results could be made public or deleted at will. In spite of being heavy and cumbersome, portable video equipment was relatively easy to operate. Women could quickly master the technology and embark on the difficult business of introspection and experimentation without the intrusive presence of camera crews and generally male technicians. With erasure as easy as making a mark, the medium allowed artists unprecedented control over both the substance and the terms of their visibility.

The instantaneity of video was a feature of its production, but also of its dissemination. With the advent of the VHS format, large numbers of copies could be made from the master tape and distributed cheaply to groups and individuals through artist-run organisations, alternative viewing spaces, media

festivals and community groups. The possibility of mass communication through broadcast was also of considerable interest for the campaigning purposes of feminism, but the early days of video were characterised by an understandable suspicion of mass media and artists preferred to use alternative art and community-based distribution networks.

DOMESTICITY AND FAMILY RELATIONS

In terms of content, many artists began with the traditional arena of women's private lives. As Sally Potter implied, domestic life and personal relationships have long formed the foundation of women's identities. The images of domesticity promoted by television in the late 1960s and 1970s reflected the post-Second World War campaign to pressure women back into the home to make way for the returning soldiers who wanted their jobs back. Childrearing and domestic work were reinvented as women's destiny and advertising between television shows portrayed a smiling homemaker whose sole aim in life was to bring up baby and achieve the brightest wash. In the early days of feminism, many women artists deconstructed this image of domestic drudgery. One of the most incisive was Bobby Baker whose entertaining performances in London produced cooking as art and elevated the products of a seemingly worthless female activity, 'the budget meal for two, the supper party for four' into marketable high art. Martha Rosler's classic video *Semiotics of the Kitchen* (1975) recreated a cookery programme, but made no attempt to entertain. In the tape, the aproned artist stands behind a table on which an array of kitchen utensils is laid out. She selects each one in turn, holding them up to the camera and dully speaking their name. Dish, tenderiser and plate are enumerated like a school roll call whilst their function is briefly demonstrated but without ingredients. When it comes to knife, fork and ice pick, Rosler turns these familiar objects into domestic weapons and beats the air like a cool-headed murderess dispatching an invisible victim. When it is the turn of the ladle, she flings aside the imaginary contents creating a nightmare mess that would mark her as a failed housewife. The underlying threat of Freudian castration, of losing both the symbol and member of manhood, is grimly laboured as Rosler hacks out the inventory of women's repetitive domestic slavery serving up her anger in carefully measured culinary gestures.

Some years later, Vivienne Dick made a wry, one-minute protest at the entrapment of women in the home and the unforeseen selflessness that maternal and wifely duty demands. *It's 3 a.m.* (1991, BBC television) reveals the artist smoking and drinking in the early hours because the baby is awake and crying – again. As she lights up another cigarette, her voice-over bemoans her condition. Tied to the bottomless pit of need that is an infant, all she really wants to do is 'smoke and drink and stay out late with men'. The disappearance

of generations of young women into motherhood and domestic servitude remains the greatest brain drain of Western Europe, even in these supposedly post-feminist days when women have become superwomen and maintain a career as well as run a home. These are relatively recent developments and in the early days of feminism and up to the late 1980s, the majority of women still vanished into the phantom army of unpaid mothers and housekeepers who traded their freedom for a man's name and the promise of financial security.

FATHERS, HUSBANDS, LOVERS, STRANGERS

Traditionally, women were expected to find fulfilment in domestic roles and gain status in the public realm by association with their male relatives, trading on the achievements of their fathers, husbands, brothers and sons. Within the new terms of a publicly declared personal, every family relationship was now open to examination. Often, the powerlessness and abuse that women suffered at the hands of men behind closed doors was exposed, as in the UK artist Louise Forshaw's *Hammer and Knife* (1987). The tape opens with the artist standing in the middle of a field. She quietly describes the rape that resulted in her, thereafter, sleeping with a hammer and a knife under her pillow. At times, sexual abuse was overtaken by even greater violence as was revealed by Pratibha Parmar's *Sari Red* (1988). Using the direct vocabulary of documentary overlaid by a rich tapestry of colour, Parmar charts the brutal murder of Kalbinder Kaut Hayre by white youths in a northern English town. The exposure of violence against women in these tapes coincided with a political campaign in England resulting in the creation of women's shelters that also arranged legal protection and representation for battered wives.

It was certainly important to expose the violence of a culture that so frequently breaks out in individual acts of violence against women and children. But women's relationships with their male relatives were often complex and led to less Manichean evocations of female identity that were defined by proximity to men with whom they shared a genetic inheritance. Within a family, difference and sameness can constitute shifting polarities even when subject to the gendering forces of the external cultural order. In *The Ballad of Dan Peoples* (1976), the Canadian Lisa Steele sits on a stool with the photograph of an old man on her lap. In a lilting chant, Steele takes on the character of the old-timer, and sings his oft-repeated stories of a country childhood. Anticipating Gillian Wearing's transposition of voices from children to adults, Steele adopts the memories and thus the identity of the old man. He proves to be a key to her own identity – the man whose voice she throws is that of her grandfather, his perceptions and prejudices internalised as her own. The sharp distinction between male and female is also dissolved in a vocal transposition that the performance artist Laurie Anderson affected around this time. By means of

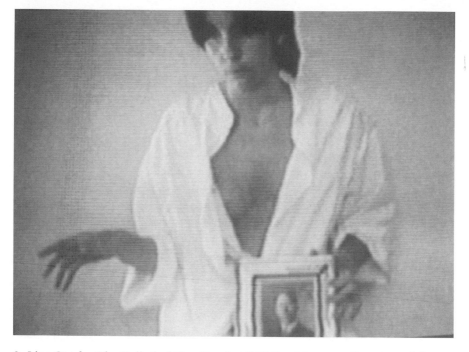

3. Lisa Steele, *The Ballad of Dan Peoples* (1976), videotape. Courtesy of the artist and Vtape, Toronto.

a vocoder, Anderson was able to change the pitch of her voice during her performances so that she intermittently spoke as a man. In appropriating men's voices, Anderson embodied the masculine attributes and traditions that would normally be credited only to the men in her family. The taking on of masculine garb and masculine identity by women artists has a long history and many have used the performative potential of video to annex other powerful cultural identities. Eleanor Antin impersonated a king and, through actors, Max Almy explored the image of the contemporary 'Perfect Leader' – the male politician. Others have worked closely with male artists, often blurring the distinctions between their identities. Abramović and Ulay, Katharina Sieverding and, in the 1990s, Smith and Stewart have explored interdependent but often combative relationships with male relatives, lovers and collaborators. Such relationships have formed the basis of many works investigating femininity through the prism of masculinity, both external and internalised.

Women often introject the repressed emotions of men and throughout history have been left to mourn the consequences of male violence on those they love, whether criminal, military or institutional. Occasionally, they are left to grieve the violence that men do to themselves. The image of the *Mater Dolorosa* was

invoked by the American Linda Montano in her video *Mitchell's Death* (1976). Shrouded in deep chiaroscuro, Montano's face embodies the trauma of loss as she chants the story of her husband's suicide while acupuncture needles hang from her cheeks in lieu of tears. The artist creates a deliberately artificial representation of grieving with these ersatz tears and fake Gregorian chant and she heightens the effect with a shift in synchronisation that dislocates the words from her lip movements. In this way, the emotions are shown to be borrowed, her husband's despair internalised and reproduced, while her own grief is expressed in the content of her chanting: a reconstruction of the banal details of the day he died. Her lament charts her own attempt to normalise the unthinkable.

DAUGHTERS AND SONS

Steele and Montano negotiated the troubled psychic and social territory between self and a male other with whom one shares a common humanity, emotional ties and/or a genetic inheritance. The bonding between mother and daughter, united not only genetically, but also by a shared cultural and biological gender, is just as fraught with conflict. The maternal bond is nonetheless capable of operating outside cultural norms as well as within the dictates of the social order. The UK artist Tina Keane has examined the oral histories in which, over the centuries, mothers have passed on knowledge and her-stories to successive generations. Working with her own daughter, Emily, Keane has created films, videos and installations that explore the marginal but fertile discourses of childhood songs and games. Over the centuries, the relationship between mother and daughter has been troubled by the mother's conflicting desires to protect her child from the brutalities of Patriarchy whilst succumbing to the pressure to groom her for a secondary role in the social order. The daughter for her part has sought from her mother clues for how to break the rules whilst condemning her for being instrumental in imposing them. Tina Keane's work in the 1970s and beyond was an attempt to break the cycle of learned subservience and rebellion by reinstating the unauthorised, marginal forms of expression: the songs, rhymes, games and nonsense that allow what Hélène Cixous called the 'single-grooved mother tongue' to tell another story. It is this supplementary narrative that has united mothers and daughters across the centuries.

The work of UK artist Katharine Meynell, made in collaboration with her daughter Hannah Kates Morgan, similarly emphasises the symbiotic relationship between mother and daughter. *Hannah's Song* (1986) is a sensual portrait of the infant Hannah that begins with the evocation of a mother's gaze and ends with the child's discovery of her own image in a mirror. What Meynell describes as the 'slippage of roles' constitutes a fusion of identities, the mother heralding her daughter's future and the child echoing her mother's

4. Katharine Meynell, *Hannah's Song* (1986), with Hannah Kates Morgan, videotape. Courtesy of the artist.

past. Theirs is a continuum and continually interchangeable experience of femininity seemingly sidestepping the psychoanalyst Jacques Lacan's theory of the mirror phase in which the self is split into subjective knowledge of itself and the image it presents to the world. The pre-linguistic sensuality that Meynell explores seems to question the necessity for either the trauma of separation in language or the intrusion of the 'third term', the phallic regulatory principle that underlies the organisation of both language and individual social positioning. In *Hannah's Song*, mother and daughter seem oblivious to the fact that they lack the magic wand of masculine power. They luxuriate in their own closed circuit of identification, sensuality and emotion that offers respite from the divisive phallic organisation of the psyche and of language.

The transgressive sensuality of a 'polymorphous and perverse' infancy was explored in my own work *There is a Myth* (1984). As the tape opens, the image of an engorged breast fills the screen and an infant's hand, that of my son Bruno, repeatedly pummels the breast eventually teasing a stream of milk from the nipple. The male is depicted here, not in his masterful role as the signifying

principle of patriarchal culture, but in his most helpless state, wholly dependent on the Kleinian breast to fulfil his needs and confirm his agency in the world. What was a simple involuntary action common to all mammals took on the symbolic aggression that infects the psyche, particularly the male psyche, when confronted by difference and the enforced separation from undifferentiated communion with the mother. For men, this separation is a necessary caesura that guarantees entry into the symbolic order, into masculinity and society at large. In *There is a Myth*, the body of the mother, so often reduced to an image of sentimental and selfless bounty in the canon of western art, is reclaimed as a source of desire and fear. It is a place dominated by the power of female biology and its ability to withhold as well as satisfy creates in the male imagination a fear that, one day, woman will take revenge for her subjugation.

WOMEN IN LOVE

There is surprisingly little work from the early days of feminism that tackles heterosexual eroticism, perhaps because, for many, that would have been tantamount to sleeping with the enemy. The eroticism women explored was more likely to follow a divergent path. Where Kate Meynell and Tina Keane celebrated the sensuality of their daughters' bodies, other women have attempted to exclude the constitutive force of male sexuality by taking as their own objects of desire a body like their own. Over the years, lesbian erotica has explored every permutation of woman-to-woman interaction from sadomasochism to tender meditations on spiritual union through poetry, music and dance. The American Sadie Benning used a Fisher-Price toy video camera to create grainy soap operas of adolescent love on the fringes of the rock culture. In Canada, Dara Gellman showed girls kissing and kissing as if any loss of body contact would break the spell of 'doubling, queer readings and other strolls through the woods of lasting pleasures'.[3] Over on the West Coast, the Cree artist Thirza Cuthand spun wry anecdotes about a young lesbian subjected to the desires and projections of older women. Whether women came together as mothers, daughters or lovers, their exclusion of any image of the 'third term', what psychoanalysis likes to call the dominant male principle, created a physical and discursive space that abounded with conflicts, but offered resistance to the monolith of a man-made culture.

THE BODY IN PROXIMITY

The works of Kate Meynell, Linda Montano and Thirza Cuthand have all renegotiated the cultural, emotional and political territory of personal relations. They also stand as examples of the ways in which feminists set out to rescue the body of woman, of the mother, from being mapped and marked as re-productive, sexual, and ideological territory by a masculinist culture. In the new iconography

of feminist art, the salvaging of the female body as a creative domain, as what Barbara Fisher dubbed the 'speaking body', took place at the level of experience as well as at the level of representation. Some women celebrated the liberation of women's sexuality. The unleashing of women's repressed desire ignited videos that echoed Carolee Schneemann's now iconic performances of physical excess, 'hippy' events involving naked bodies, animals and the visceral panoply of nature's products. In keeping with the sexual revolution of the times, the liberation of the body in these works concentrated on freeing women's sexual energy in concert with their creative energies. There were artists who placed the body beyond the confines of assimilable experience, beyond the linguistic terms of reference that pertained in the early 1960s. Through Dionysian excess and extremes of pain and endurance, the language of women's bodies could no longer be contained by what was known, what was already mapped.

In the UK, feminist art was divided between the unbridled celebrations and reclamations that Schneemann pioneered in the USA and a more circumspect approach that regarded language, visual as well as textual, as fundamentally resilient to feminist takeover. Being one of the most highly charged and over-determined images in our culture, a woman's body was seen to be particularly hard to return to its owner. Many feminist commentators warned of the dangers inherent in creating images that emphasised women's sexuality and biology. As Rozsika Parker and Griselda Pollock pointed out, these images 'are easily retrieved and co-opted by a male culture because they do not rupture radically meanings and connotations of woman in art as body, as sexual, as nature, as object for male possession'.[4] For many women working in England, even the slightest glimpse of a feminine presence in moving image art was rife with the danger of falling into reiterative patterns of sexual objectification. This led many to abandon the image of woman altogether. These artists were convinced that the gaze and, by extension, the film or video camera were constructed to reflect only a masculine subjectivity. All that passed before the lens would necessarily fall into its rightful place within patterns of desire that conferred on men the privilege of looking while women would always remain the object of the gaze.[5] Peggy Phelan later recycled this view and advocated an 'active vanishing' to avoid patriarchal recuperation. However, neither of these positions was appropriate to performance and video artists' work, which was largely dependent on seeing and being seen. Unwilling to return to obscurity, but aware of the pitfalls of sexual representation, women this side of the Atlantic looked for ways of problematising the appearance of the female body whilst negotiating new forms of visibility. The first thing they observed was that the female form, whether seen in its totality or in join-up-the-parts fragments, needed to be grasped as a whole in order to create the narrowly eroticised readings that were required by male culture. Not only this, but the male gaze would only appear to work within a very circumscribed perceptual band. Objectification is dependent

on distance cues approximating normal sight, which recognises the sexed body as female either as a whole or an imaginary sum of discernible parts. The degree of eroticisation depends, of course, on the nature and behaviour of that body, but once it is taken outside the limits of the erotic visual field, conventional readings begin to break down.

The body in proximity, the close-up, may well suggest the entitlement of the viewer, as Peggy Phelan has suggested, but when abstracted in extreme close-up it becomes indecipherable and is more likely to establish ownership by the woman who examines herself rather than the rights of her male viewers. In Holland, from the mid 1970s, Nan Hoover took advantage of the built-in close-up lens of the video camera to disrupt the unity of the female body. She made black and white videotapes of her own body subject to a magnification such that the usual signifiers of gender and age dissolved and transformed her body into the primordial landscape of recesses, creases and forests that we all consist of at a microscopic level. In *Landscape* (1983), the occasional eyelash slamming down on an expanse of flesh nonetheless marks Hoover as female, but a *gigantesque* feminine, abstracted and alarmingly primal, the stuff of infantile nightmares rather than the reduced performances of sexuality that establish men's mastery over their 'living dolls' in their adult years.

My own *There is a Myth* (1984) was an attempt to unfix conventional structures of erotic meaning by isolating the breast from its host body whilst still creating sensual images of the female body. Women's breasts are rarely seen as the original object of desire, sustenance and comfort to the infant. In most western countries, it is not acceptable for women to breastfeed in public places, images of the breast being restricted to sexual hot spots in the iconography of men's magazines, advertising and fashion. The breast in *Myth* was, to a degree, abstracted, offering a perfect target for the gaze and in its reference to Jasper Johns' target paintings, part of an existing modernist aesthetic. If these works closed in on the body and through various levels of abstraction occluded the established referents of sexual identity, then Mona Hatoum went a step further ten years later. Exploiting the development of video technology in the medical field, Hatoum used an endoscopic camera in *Corps Etranger* (1994) to slide away from the body's external casing and take the viewer inside the body travelling through its labyrinthine passages and organs, which were, at this range, so indefinable as to be any-body's. *Corps Etranger* was a fundamental assertion of our common physiology subverting any attempt to name and codify the artist's gender and societal position in terms of perceived biology whilst re-asserting her identity as, by then, a successful woman artist.

All these works sidestep conventional sexual marking by subjecting the body to metaphorical transformation, from woman into landscape, breast into minimalist target, outside into universal, visceral interior. This is achieved whilst retaining a sense of female presence not least because of the culturally

established authorship of the eye that propels the camera into unknown territory. It is perhaps the disembodied eye of the video artist that most radically departs from the confines of the gendered body. *Video* – 'I see' – anthropomorphises the eye of the camera into that of the artist and in the process of self-examination reconfigures the body she/it sees as the object of constitutive feminine subjectivity, the fruit of creative energies emanating from that same biological conglomeration that, for want of a better word, we call female.

THE BODY DISTANT AND STILL

The body can begin to speak another meaning when it becomes uncomfortably close and abstracted, but it can also block erotic retrieval when it is placed at a distance, not invisible, but beyond the range of the desiring eye, the prurient gaze of the camera. As I mentioned, in *Hammer and Knife* (1987) Louise Forshaw delivers her account of her rape as a small figure standing immobile in the middle distance surrounded by a field of corn. As she speaks, the camera slowly zooms in to a close-up, the image of woman as any-woman emerging into the light of an individual's controlled anger confronting the camera. Forshaw maintains her stillness both as a distant image and as an image in proximity. She refuses to perform the Feminine, she makes no attempt to seduce the camera and the spectator beyond. Instead, her story implicates every man in the audience, every spectator in their voyeuristic expectations of lurid reconstructions of the violation she suffered.

The refusal to perform to male desire was shown to be almost as disruptive as removing the body of woman from the normal focal range of vision. Martha Rosler showed that even the whole image of a naked woman when stripped of all movement and subjected to the deadening effect of continual scrutiny, can be drained of much of her sexual charge. *Vital Statistics of the Average Citizen Simply Obtained* (1977) is a videotape in which the artist is seen standing naked amongst a team of white-coated officials who measure and record her vital statistics including the length of her vagina. Although these dimensions are what qualify her as a desirable object within male culture, the clinical and deadpan manner of their collection turns the image of the artist into an ironically passive and violated generator of numbers that add up to a woman and yet signally fail to represent her.

The UK artist Jayne Parker cleverly undermined the reductive erotic grading system applied to women's bodies through a combination of duration and careful disclosure of personal information. *Almost Out* (1984) is at first sight a cruel display of maternal abuse. Parker's mother is seen naked and exposed, her middle age weighing heavy on a body long past its prime. The humiliation of Mrs Parker's physical exposure is compounded by increasingly intimate questioning that her daughter subjects her to, off-screen. These painful sequences are

interspersed with equivalent scenes of the naked artist-daughter, young and sleek and as desirable to men as her mother is degraded in the heterosexist value system. An unseen male questions the artist and the interrogations of the two women alternate for the 90-minute duration of the tape. And the duration is key to the extraordinary transformation of language that takes place. The mother, unattractive and ageing by any standard, slowly emerges as the more beautiful of the two, her strength and generosity contrasting with her daughter's manipulative peevishness that eventually dissolves any sense of beauty the younger woman's body may have at first projected. This process only works when the tape is viewed in its full 90 minutes. Any extracts would simply leave intact the initial cultural readings of the two women.

VIDEO, PUSH PULL OF THE MEDIUM

I have already looked at a number of strategies feminist artists adopted in an attempt to circumnavigate the most branded of all patriarchal products, but it might well be that these efforts to obscure, abstract or shrink the body were not as urgent in video as they were in film. To some extent, early video images of women were already deconstructed owing to their very visible means of construction. Compared to the high definition realism of film, early analogue video produced low-grade, unstable black and white images. As Eric Cameron has observed, 'a view on a television screen implies that a camera did, at some time confront just such a situation, but its reduction to a scan of shifting tones across a very visible matrix of horizontal bands leaves ample room for subjective interpretation.'[6] The small scale of the monitor did not help and video struggled to create the immersive experience of projected film. The grey, colourless image of the body was trapped in a box that it clearly could never physically occupy. In early video, the instability of the image meant that it periodically disappeared into agitated abstract patterns so that the imagination required to read the video image as real was often more a leap of faith than a suspension of disbelief. In spite of the material nakedness of early video, both film and video constituted a simulated encounter with the other. The body in moving pictures was vividly conjured up as it spoke, moved and breathed in concert with the viewer. As in the photographic image, the woman represented remained tantalisingly suggested, but manifestly absent. Union with her – sexual, intellectual or spiritual – was and still is forever out of reach. The moving image both inspires and denies desire for the female other, whether the longing be erotic or linked to primal urges to recreate a symbiotic union with the maternal body.

For some women the visual tease and materialist distantiation in video were seen as an advantage, a safe way of becoming visible, less risky than physical confrontation with an audience. As we have seen, video and performance artists

depended on their public personae to make their art and visibility remained a basic right that needed protecting in spite of astute observations of critics like Lucy Lippard who first identified the 'subtle abyss' that separated 'men's use of women for sexual titillation from women's use of women to expose that insult'.[7] As I stated earlier, UK critics and historians were similarly wary of the entrapments of visuality, notably Griselda Pollock and Lisa Tickner in the early days and, and in more recent times, Peggy Phelan in the USA. However, the veil was not an option for most western women and many still regarded the image of their bodies as a source of power. As Jayne Parker has written, 'I want power. To be seen, to be desired and to remain untouchable is to have power.'[8] This attitude was unusual in England in the early years of feminism and has been more common among women artists of the 1990s who rejected feminism's censorship of the female body. Most feminist artists of the 1970s and 1980s would have regarded Parker's approach as falling head first into the subtle abyss, but women performance artists had been operating in the danger zone since the 1960s and video-makers took up the challenge of female representation for the small screen.

THE BODY MULTIPLIED

In the USA in particular, video-makers remained undeterred by the over-determinacy of the female body and returned to the cultural images that the British women had taken such pains to deconstruct or avoid. But they did not uncritically reproduce them. Where artists like Rosler, Forshaw, Hatoum and Hoover were freezing, fragmenting or abstracting the female body in extreme close-up or rendering it non-specific with distance, a parallel group sought to confuse the representational issue through doubling, multiplication and disguise, elaborating the various masks of femininity that have been available to women within western culture. Here, the use of irony and parody led them towards narrative formats borrowed from television. Where television sought to reinforce the currency of the stereotypes it promoted, feminist artists were dedicated to exposing them as social constructs. At the root of this process was the belief that there was, in fact, no essential feminine to be uncovered once the shackles of cultural femininity were cast off, only further layers of socially constructed femininities. Culture could not be escaped.

Using a lighter touch than Cindy Sherman's multiple photographic disguises as a film still diva, Ann Magnuson played 20 separate characters in *Made for TV* (1984 with Tom Rubnitz). Mimicking the pervasive channel-hopping restlessness of daytime TV, Magnuson scrambled together fragments of programmes in which she was always the star. A damaged housewife in a dressing gown laid out the sorry details of her dead-end marriage interrupted by snippets of a film noir femme fatale weaving her nefarious magic on some hapless victim.

These were in turn interrupted by a peroxide bible-basher offering salvation in exchange for generous donations. Magnuson in yet another guise – this time a bright leotard-clad gymnast – advocated the joys of physical self-improvement. Anticipating postmodern theories of the decentred subject, of cultural replication and mimesis, these performances of femininity deconstructed what we already knew, but offered little in the way of reconstruction. The elaboration of the surface, so fashionable amongst artists later in the 1990s, saw women disappearing beneath a series of disguises amounting to what Peggy Phelan has called 'a retreat from the gaze of the other'.[9] Paradoxically, such surface display courted attention, betraying a narcissistic need to show how well the stereotypical parts could be played. As in any form of mimicry, there was what Phelan called 'an unavoidable complicity' in the reiteration of societal norms. Whenever I have seen work of this kind, I have been left with the feeling that, in these female impressions, an ambivalence or muted hostility exists towards the roles that the artists' mothers occupied and tried to make their own. An anger, too, that these same mothers once wielded such power over their daughters. However, as tactics of exposure, multiplying and quick changing the masks of femininity helped to dispel any association of particular behaviours and social roles with a 'natural', predestined female subject. It also showed that contrary to popular belief, feminists had a sense of humour.

THE BODY HEARD BUT NOT SEEN

In many of the works so far discussed, the voices of the women carry both the meaning of the work and the key to unseating conventional readings of the bodies from which they are derived. If the image of the body is excised from the work, but the voice remains, it constitutes a powerful referent to the absent body, but avoids the pitfalls of visual representations for women in a masculinist culture. As Jean Fisher has suggested, the voice not only reasserts the physical body but also returns us to pre-lingual utterance as a form of pure expression, rich in the nuances of timbre and intonation, but free from the organising constraints of verbal language and the allotted cultural place to which it consigns individuals.[10] The return to a primal use of the voice has resulted in many vocal experiments featured in purely audio works. In terms of video, it has included the mimicry of animal utterance itself reminiscent of ancient and primitive religions in which the feminine was valued if not revered. In *Duet* (1972), the American artist Joan Jonas brings her face into a tight close-up while she howls like a dog at her own image on a monitor. Descending into lunacy while howling at the moon, at the governess of menstrual tides, celebrates the darker arts such as witchcraft and other outlawed practices into which women's traditional skills were relegated under Patriarchy. In recent years, we have seen Lucy Gunning renew our membership of the animal

any others have exploited the power of what they call the voice track. Their predisposition to narrativise may arise from their experiences of the Diaspora – almost everyone in Canada is an immigrant. Whatever the reason, the voice-over is ubiquitous in Canadian video, most potently in the case of Vera Frenkel. *The Last Screening Room: A Valentine* (1984) turns on the power and unique quality of the artist's voice and the wry description of a world in which storytelling, women's traditional mode of speech, has been banned. The work takes 'as point of departure for a cycle of narratives touching on issues of censorship, privacy, national celebrations and government control, *The Tale Told by the Prisoner* that introduces a woman arrested for storytelling who breaks the law again from her prison cell, which is how we learn of her fate'.[11] Frenkel's mellifluous tones describe the plight of such itinerant storytellers who, like the 'canteurs' of the Dordogne, travelled from village to village recounting the unofficial histories of their times. In Frenkel's video, the authorities take pains to suppress the transgressive testaments of the storytellers who, 'travelling so much' become 'elusive and therefore dangerous'.[12] Like the diegetic storytellers, the artist has proved elusive to the visual desires of the audience. She achieves a transmigration of the feminine from the ocular battlefield marked out by

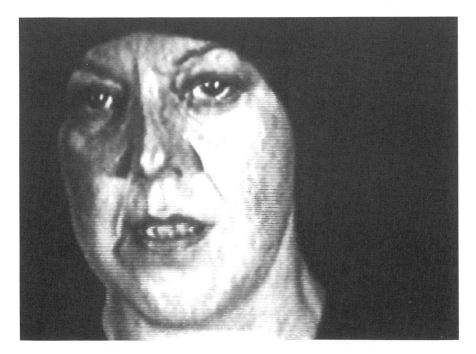

5. Vera Frenkel as one of several narrators in her video *The Last Screening Room: A Valentine* (1984, r.t. 44 minutes). Courtesy of the artist and Vtape, Toronto.

the camera, to an out-of-body vocal presence behind and beyond the video apparatus. From there, she is re-embodied through the traditional organising principle of the voice-over.

THE ABSENT BODY

In looking for new forms of narrativity in the 1980s, many women video-makers in the UK took evasive action. Long before cyber-feminists proposed the cyborgian body as the ultimate escape from culturally determined social identities, video artists shifted the female body out of sight and replaced it with the aesthetic sensibility of the artist. Elsa Stansfield and Madeleine Hooykaas, working between Holland and the UK, began a series of land and seascape videos that reduced the image of woman to a shadow, which in *Flying Time* (1982) is washed by the gentle lap of waves on the incoming tide. Like Mary Lucier in the USA, Stansfield and Hooykaas equated the landscape with internal psychic states and linked it to the pursuit of a more primal relationship with nature. *Flying Time* describes a journey from Amsterdam to Australia and back and appropriates the codes of the travel documentary. However, the images of waves and fishes swimming randomly through the water deny our appetite for picturesque scenes and we realise that the journey is undertaken more for the process of transformation and emotional displacement it represents than for the goal of reaching a destination.

Tamara Krikorian's videotapes from the late 1970s and early 1980s similarly problematise televisual formats and conventional representations of femininity. Krikorian introduces a spare form of visual poetry, harnessing duration and cultural references to both disrupt and re-position the image of woman in representation. In common with Nan Hoover, Stansfield and Hooykaas, Krikorian denies the audience her body as a total image and excludes details that would re-mark her within conventional femininity. In *Unassembled Information* (1977) she uses a mirror to reveal successive fragments of her face, the bulk of the frame being filled with the anonymous mass constituting the back of her head. The audio track features extracts from radio broadcasts that appear to be linked to the movements of the mirror. Culture in some garbled and fractured form impinges on this elusive 'antithesis to the video portrait'[13] and its quality as a constructed reality feeds back into the image of woman, itself the most synthetic of constructions. And yet the tapestry of radio fragments on the soundtrack and the slow, meditative pace of the tape suggest an aesthetic retrieval of self-image just as it exposes the alienation of women from their own natures within representation.

The shift in emphasis from the artist's body still hard-wired with masculine codes and conventions to her perceptions and views of the world reintroduced the possibility of narrative agency without recourse to conventional representations.

These remained, as it were, just out of shot, hanging on our expectations and prurient curiosity about how the women might look: preferably naked. But the works only reveal what the woman sees, what her camera records. The image created is not only that of a landscape or interior captured by the lens, but it also represents the woman's looking, her steady gaze. This approach challenged Laura Mulvey's characterisation of the film camera as intrinsically male and incapable of returning a feminine subjectivity to the viewer. Video, with its structural affinity with human temporal existence, its durational synchronicity with the human predilection for sustained observation, enabled women video-makers to shift their conventional position as object of the gaze, to bearers of the look, of the unblinking stare and ordering eye of the beholder.

Whether uncovering essential, uniquely female social and biological experiences or denying essentialism and dispelling myths of female 'nature' through parody, feminist artists working with video displaced the distorting lens of patriarchal culture exemplified by television and Hollywood film. At the level of content, they offered the fruits of a subjectivity and creative imagination that was either distorted by or absent from televisual representation. The rhetoric of feminism was to lead other groups to question the received identities that seemed to spring naturally from their gender, race or ethnic origins.

4

Masculinities

Class, Gay and Racial Equality

How are we perceived, if we are to be perceived at all? For the most part we are invisible.

Derek Jarman

THE COLOUR OF SKIN

Where feminists challenged the determinations of gender embedded in the content of mainstream media, work addressing issues of class, race, homosexuality and other 'deviant' masculinities soon joined the fray. Like feminist video, 'minority' works were often allied to campaigns seeking social and political equality for disenfranchised groups. I have already described a tape by Pratibha Parmar in which she exposed the brutal murder of a young Asian woman by white youths; a work that not only demanded justice, but also offered alternative content to the mainstream that had barely acknowledged the crime. *Sari Red* (1988) also challenged western cultural hegemony by proposing an alternative aesthetic through the use of traditional Asian fabrics and colours combined with the recently available video technique of mixing and dissolving. Parmar built up transparent layers of colour to reflect the diaphanous layering of Asian clothing and create a metaphor for the fragility of the life that was so carelessly extinguished.

In the 1990s, another UK artist used more advanced video techniques to create a rich mix of visual material, this time as a paradigm for the layers of history he peeled away in order to reveal the full horror of the British slave trade. In Keith Piper's *Trade Winds* (1992), the artist weaves together archival images of slave ships, texts, maps, statistics, colourful graphic representations and dramatised reconstructions to expose one of the most shameful episodes of our colonial past. In other works, Piper has appropriated television sports

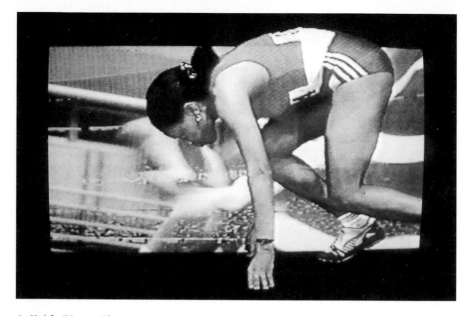

6. Keith Piper, *The Nation's Finest* (1990), videotape. Courtesy of the artist.

coverage to re-examine the western fetishisation of black athletes' bodies. In *The Nation's Finest* (1990), he skilfully employs the television vernacular – slow motion, action replay and lingering close-ups. These devices act as a foil to a searing critique on the soundtrack condemning a white culture that deifies black prowess on the track, whilst equating the athletes' physical superiority with a closer and more primitive relationship to our animal natures. This kind of ethnic exoticism reinforces the image of the white man as the higher being in contrast to the black athlete's status of 'noble savage'. White-controlled athletics camouflage with fulsome praise the discrimination that ethnic communities suffer in western countries in spite of their athletes frequently being called upon to represent predominantly white nations. By implication, *Nation's Finest* also decries the parallel silence on the discriminatory treatment of black athletes like the Olympian Jesse Owens in the 1930s.

Working at the same time as Piper and also in the UK, Amanda Holiday made *Manao Tupapau* (1990), a one-minute tape in which she turns the camera on a Polynesian woman lying naked behind a diaphanous veil. The pose simulates a portrait Gauguin painted of one of his Tahitian mistresses. The lingering camera work celebrates the dark beauty of the woman while a voice-over deconstructs the racially privileged western gaze that, in our complicit voyeurism, we share with the painter. A brief treatise on racial and sexual power relations scores through the sensuality of the image while historical references to colonial

consumerism and the syphilis Gauguin spread around his island paradise destabilise, if not totally eradicate, the appropriating gaze of the viewer.

In the last few years, the video works of artists like Isaac Julien and Steve McQueen in the UK have also tackled issues of post-colonial ethnic identity. Here the consequences of the Diasporas are combined with a celebration of male-identified desire. Their work negotiates the charged intersection of two ideologically marked representations of 'otherness'. Through the reciprocal agencies of homosexual desire and a contemporary validation of diasporic cultures, they re-inscribe the black body with constitutive meaning. Their work suggests that culture is not only played out on the body of the 'other' but that it can be transformed by the 'speaking body' of the artist. It now becomes a site of resistance to the onslaught of cultural inscription with its narrow definitions of identity hinged on external appearance and skin colour. Like Keith Piper, Steve McQueen is drawn to the athletic body, to that of two black wrestlers in *Bear* (1993). Their almost balletic bouts are slowed down to reveal the grace and strength they have achieved through rigorous and disciplined training – their bodies representing their own creative achievement. The fighting also carries overtones of sexual play and display, revealing the suppressed homoerotic subtext of many male sporting activities. The scale that McQueen uses in the installed version of the work lifts these Africanate bodies to monumental proportions, closer to heroic representations of Olympian Gods in ancient Greece or Crete than fetishistic reproductions of black exoticism in western visual culture.

THE VIDEO 'THAT DARE NOT SPEAK ITS NAME'

Isaac Julien has located many of his film and video works in the recovered histories of colonialism and immigration and has drawn on western imaging traditions to produce hybrid works centred on a redefinition of black identity. He theorises the black body as a social and historical construct, while simultaneously proposing it as an agent of social and cultural transformation. The contributions of African-Europeans to western culture are frequently highlighted in his work. Julien also locates the male body – both black and white – in the mimetic play of camp and female impersonation – a form of expression that is cross-cultural and trans-historic. Following a late twentieth-century tradition of gay filmmaking in the UK centring on the work of the late Derek Jarman, Julien's videos unmask masculinity and, indeed, heterosexuality for the narrow range of performed identities to which they are restricted. In a recent work, *The Long Road to Matalan* (1999), Julien draws on the baroque iconography of gay subcultures to tell a love story of sorts. The retrieval of the Western movie and other cinematic genres for the elaboration of 'deviant' desire in experimental film has become well-established and suggests not only

the range of masquerades that men choose or resist, but also the survival of homoerotic expression in mainstream media. Sometimes it is thinly disguised, at other times cloaked in the codes of a community that, until relatively recently, dared not speak its name for fear of imprisonment.

The rule of patriarchal law hounded the monster that it made of homosexual desire until the 1960s when reformists in the USA and UK began to lobby their respective governments to legalise homosexual acts between consenting adults. But this did not amount to approbation and constitutional homophobia survived well into the 1980s when the British Government introduced Clause 28, a law that made it illegal to promote homosexuality in any educational environment. This preposterous legislation became the target of Stuart Marshall's wry *Pedagogue* (1988), a work that hinged on a to-camera performance by Neil Bartlett. The tape opens with the performer posing in the 1980s uniform of the gay man – leather jacket, tight jeans and moustache. He innocently describes the video course he has recently delivered to Marshall's students. The students are then interviewed one by one, each declaring that until they met Bartlett, no deviant desire had ever risen in their tender breasts. Under his influence, however, they have now seen the light and embraced homosexuality and lesbianism. The absurdity of this scenario enveloped the more sinister implications of a law that succeeded in institutionalising homophobic prejudice.

THE MALE BODY OBJECTIFIED

Like many feminist and ethnic videos, *Pedagogue* was made in the context of a political movement campaigning for change. Other works explored social situations in which both the viewers of the tape and the objectifying practices of popular culture feminise the body of the male subject. Cerith Wyn Evans' *Kim Wilde Auditions* (1996) is a disturbing record of screen tests carried out to select young male actors suitable to perform in the singer Kim Wilde's newest promotional video. Two conventionally handsome men are asked to respond to the instructions of an off-screen director. They take up poses, follow the absent singer with their eyes, peel off their shirts and walk the set in an uneasy cross between a masculine stride and a sexually provocative catwalk shimmy. The obvious nervousness of the actors, the trembling of their lips and their contorted attempts to become desirable as well as maintain some degree of dignity is painful to watch and indicative of how contemporary culture is as capable of commodifying male beauty and sexuality as that of their female counterparts. Wyn Evans' own sexuality is at play and the tape demonstrates the double appropriation that the actors' bodies undergo, once by Kim Wilde's assumed heterosexual desire and by the obvious homoerotic charge the artist injects into his selection of subjects. (Of course, the absent singer is herself the object of subsequent sexual objectification.) Overlaying both projections

7. Cerith Wyn Evans, *Kim Wilde Auditions* (1996), videotape. Courtesy of the artist.

of desire onto the male body is the commercial transaction subtending the promo director's unctuous instructions on behalf of the record company. I am always surprised by the laughter that this tape engenders in audiences and can only assume that this is due to both empathetic discomfort and the guilty pleasure we take in our natural desire to look at beautiful individuals. The power relations underlying the exercise of that desire is here exposed but we do not look away however much the young men may be demonstrably suffering from our gaze and however much the 'fascism' of youth and beauty in popular culture consistently undermines our own self-esteem.

FEMALE IMPERSONATION

Many male artists have gone beyond the exposure of the male body in a position that is, within representation, traditionally female and have adopted female dress and behaviours. Female impersonation gives rise to a more complex set of social and cultural relationships. Leaving aside the psychosexual formation

of passive and active roles within homosexual encounters, the desire to explore the feminine in men would appear to constitute a refusal to conform to the socially sanctioned norms of male behaviour. The double exposures of cross-dressing encompassing both conventional masculinity and exaggerated female masquerade are seen to be arbitrary and interchangeable. Nevertheless, the repertoires of male and female identities do not spring from an equal social footing and vestiges of hostility towards women underlie many female impersonations. The images of women that men usually choose to parody are overblown, petty, vain and themselves conventional in their seductive display originally developed to reflect the crude palate of heterosexual desire.[1] Peggy Phelan ascribes this underlying hostility to the unbreachable distance between the impersonator and his costume as well as the frustration generated by the literal inability of men ever to internalise women where the woman can both take in and expel the male within her procreative role. Perhaps it is simply that the media have fetishised the trappings of women to the extent that, however repressive the cultural construct of femininity, it does allow girls to express emotions and wear pretty clothes. Big boys still don't have permission to cry or dress up. Marilyn Frye takes a harder line and sees female impersonation as 'a cynical mockery of women'[2] and many have expressed the view that by forming yet another men-only club, homosexuality reinvents what Phelan calls the 'male homosocial culture'.[3]

Whatever unresolved feelings men harbour towards the symbolic mother or women in general, the work of video artists like Colin Campbell in Canada nonetheless attempts to validate emotions and desires that heterosexual formation denies men and belittles in women. In this, Campbell is prepared to forgo the institutionalised power of the heterosexual male and pursue what Bruce W. Ferguson has identified as a certain incoherence in work that has 'no will to power of its own'.[4] A seeming lack of linear mastery and the feminine talent for intuitive means of progressing whilst digressing is played out in the many female characters Campbell inhabited from the early 1970s to his death in 2002. In works that cross melodrama with the politics of the personal confession, Campbell's video personae: the Woman from Malibu, Robin the punk star and Anna the Belgian art critic all represent aspects of his own nature and imagination that cannot be accommodated within the normative behaviours of a heterosexual male. The Protean Campbell never lingers long in any one of his cast of female characters. As a result, Campbell the male subject under disguise remains the one constant and is therefore never occluded by his female Doppelgängerin. He avoids being snared into 'the illusion of (a) complete identity',[5] constructed as a female 'other'. Like the floating femininities employed by feminist artists, Campbell finds a provisional sense of self in what Ferguson describes as 'a marginal realism' made up of partially true and physiologically false fragments. In spite of his apparent willingness to give up

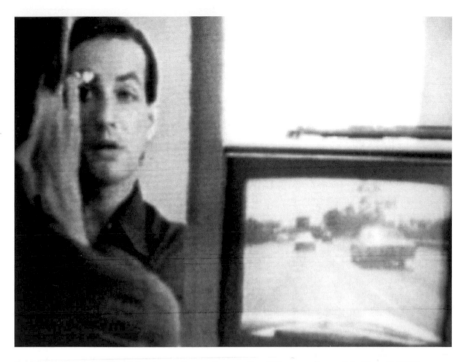

8. Colin Campbell, videotape from the series *Woman from Malibu* (1976). Courtesy of Vtape, Toronto.

the authority of a masculine identity, Campbell exploits the traditional agency of the male artist albeit in disguise in order to avoid being fixed as either one or the 'other' to patriarchal norms. Through his multifarious female personae, he pursues a radical self-estrangement turning on the impossibility of either escaping into the female artifice or resting in the embodied masculinity that would, with good behaviour, confirm his membership of the patriarchal order. His work stands as a protest against the necessity for Campbell to temporarily forego his privileges as a male in order to explore those culturally feminised aspects of his psyche and desire that, in the eyes of polite society, turn him into a monster.

AIDS, THE 'GAY PLAGUE'

In recent years, the monstrous other has found its ultimate embodiment in the AIDS sufferer. The AIDS crisis, quickly dubbed the 'gay plague' by social and political commentators in the 1980s, inspired a direct form of artistic expression that revisits many of the strategies of protest used by feminists and activists in the 1960s and early 1970s. Combining personal and political analysis, works

prompted by AIDS explore the experiences of individuals while revealing the ways in which entrenched cultural, theological and medical attitudes to homosexuality affect medical treatment and influence the way gay men experience their illnesses. This battleground of representation has produced much-needed educational and campaign tapes, and artists have also attempted to express their fractured experience of the illness in a hostile society. In *Positiv* (1997), the Canadian artist Mike Hoolboom divides the screen into a grid-like montage of medical imagery – representations of what is going on inside his body – and found footage of movies and TV programmes that were instrumental in fashioning his identity as a gay man. The artist speaks of an 'identity clinging to numbers that continue to betray you' as well as the contrast between the unity of his body before the onset of the disease and the subsequent split of body and self that gives him a sense that his 'real body is somewhere else having a good time'. In the UK, Derek Jarman echoed the dislocation of mind and body in his video *Blue* (1993). His mind, he said, was as 'bright as a button, but my body is falling apart – a naked light bulb in a dark and ruined room'. Also in the UK, Stuart Marshall observed that, even before AIDS, this experience of a ruptured identity seemed to come with the sexual territory. A man is an individual with full civic rights until he is recognised as a homosexual, a dangerous 'other' to manly norms. Once he is ill with the 'gay plague', he is quickly reduced to 'a case history of a pathological illness'.[6] Marshall dedicated much of his later work to promoting the civic and medical rights of homosexuals with AIDS and was one of the first artists to make television programmes about the disease in the UK. Through works like *A Journal of the Plague Years* (1984) and *Over Our Dead Bodies* (1991), Marshall celebrated the activism of AIDS support groups and decried the homophobia conflating 'deviance' with an illness that was, in some quarters, welcomed as divine retribution. Towards the end of his life, he abandoned television and returned to the artistic context of video with a final work, *Robert Marshall* (1991). The tape records a nostalgic journey Marshall made to the place in Ireland where his father had died when he was himself only a child. Marshall makes peace with the shadowy figure of his father reanimated by the memories of family members who declare the artist to be the spitting image of the dead man. The picture slowly sharpens of a paternal presence that played its part in shaping Marshall's identity even from beyond the grave. The artist struggles to come to terms with the early loss of his father as well as his own tenuous hold on life. The progressively desperate treatments to which he submits fail to save him from the disease that already had claimed so many of his friends.

In both North America and Europe, there was a defiant reaction to the puritanical backlash that the gay community suffered in the wake of the AIDS crisis in the 1980s. Much public broadcasting emphasised preventative measures, with an emphasis on abstention from gay sex which was, by

9. Stuart Marshall, *Over Our Dead Bodies* (1991), television programme commissioned by Channel 4. Produced by Rebecca Dodds and Maya Vision Productions.

implication, held responsible for endangering the health of ordinary citizens as well as corrupting public morals. In 1988, the US public access channel Deep Dish broadcast a tape by John Greyson exposing the attempted censorship of an explicit health education comic aimed at the gay community. In the same year, a collective of gay artists and activists in Toronto countered the demonising of gay sexuality with the video *Amsterdam*, the central message of which was to have sex, 'use a condom... use your imagination'. Working in the UK, Michael Curran exercised his imagination in a series of equally subversive tapes that explored gay eroticism and celebrated the male body. Marked by a recognisable English eccentricity and a love of popular cultural forms of display, the tapes are extravagant and playful performances to camera. Curran frequently offers up his gyrating, naked body to the camera against a backdrop of mute interiors or, as in *L'Heure Autosexuelle* (1994), against an uninterested female figure curled up in an armchair. These comedic attempts to subvert the anti-sex campaigns made way for a more uncompromising approach in *Amami se vuoi* (1994). Enveloped in the strains of the sentimental Italian ballad of the title, Curran lies naked on a table while a long-haired youth bends over him and repeatedly spits into the artist's gaping, welcoming mouth. This exchange of bodily fluids becomes sexually charged as Curran opens his mouth ever wider and strains towards his companion whilst remaining prone. What would more

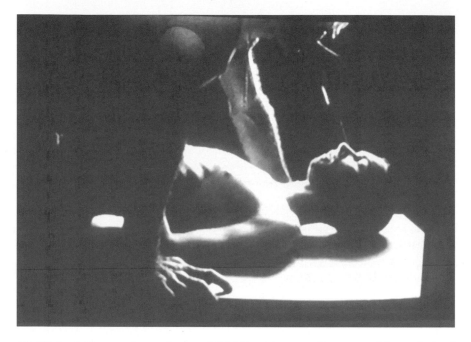

10. Michael Curran, *Amami se vuoi* (1994), videotape. Courtesy of the artist and David Curtis at the British Artists' Film and Video Study Collection, University of the Arts, London.

usually be read as a gesture of abuse becomes aggressively eroticised whilst the danger of infection from the exchange of bodily fluids is both satirised and blatantly disregarded. In a more innocent age, a work by the Canadians Paul Wong and Kenneth Fletcher had also featured an exchange of bodily fluids. *60 Unit:Bruise* (1976) involved taking blood from the arm of one and injecting it into the other's back causing little more than a bruise. Like *Amami se vuoi*, the work treads a knife-edge between abject bad taste, and a powerful affirmation of homosexual desire, in representation as in life. In a contemporary context, these works proclaim the rights of men with or without AIDS to speak out in what John Greyson called one of the 'most contested sites in society, in the area of sexual politics'.[7]

THE COST OF 'FEMINEITY'

A redefinition of masculinity has not been restricted to artists working with issues around AIDS or celebrating gay sexuality. Influenced by the explorations of female identity within feminism, heterosexual men have also questioned the social and psychic divisions that have conferred on them political power, but

robbed them of aspects of their humanity. It is by no means unusual for straight men to explore speculatively their 'feminine' side and promote their 'negative capability' in the interests of art and literature.[8] However, the critical culture of video art has provided a discursive space in which to question the construction of masculinity and its relation to structures of privilege, social power and influence. As Bruce W. Ferguson suggested in relation to the work of Colin Campbell, an analysis of conventional masculinity necessitates a surrendering of power and phallic agency in order to find out what, if anything, lies beneath. Few men are willing to pay the price. Even an artist like Matthew Barney never renounced his core masculinity when he scaled the walls of the Guggenheim dressed in an exotic kilt as part of his *Cremaster* series.

Most heterosexual men find the deconstruction of masculinity an impossible task. The sexual urge to enter the body of a woman with its implied return to the maternal body is already fraught with dangers, principal among which is sexual inadequacy. Vito Acconci, whose tapes often betray considerable aggression towards women, explains his despair of ever knowing the feminine: 'I could go through the process of wanting my body to change to female... the action was futile, the change could never happen. Or I could live up to maleness, play out maleness.'[9] For Acconci, it was easier to foster an exaggerated masculinity than explore the feminine aspects of his psyche. Psychoanalytic theory has argued that, at a deeper level, men experience a subconscious fear of castration that Freud linked to the imagined punishment by the father of the Oedipal infant's desire for the mother. Although men pursue women to prove their manhood, losing oneself in the feminine, in whatever form, entails a potential loss of gender identity for those whose masculinity is not secure. In his psychotherapy practice, the American therapist Tom Ryan has observed that men's common fear of commitment is 'a more basic fear about the disintegration or loss of their sense of maleness'.[10] Ryan contends that in his adult relations with women, a heterosexual male is always deeply conflicted because 'any expression of need or desire carries with it the threat of succumbing to a wish to be united with, or the same as, the woman.'[11] Within a patriarchal order, being the same as a woman means existing without power. However, there have been male artists who were willing to take the risk and with a more humanist approach, look beneath the macho masquerade interpreting what they found as evidence of a truer, more equitable masculine identity waiting to be released.

BE A MAN

In *State of Division* (1979), an early black and white video, the UK artist Mick Hartney explored the psychological consequences of the pressures on men to replicate the masculine ideal. The tape is dominated by an image of the artist in a head and shoulders shot, drifting in and out of frame whilst speaking directly

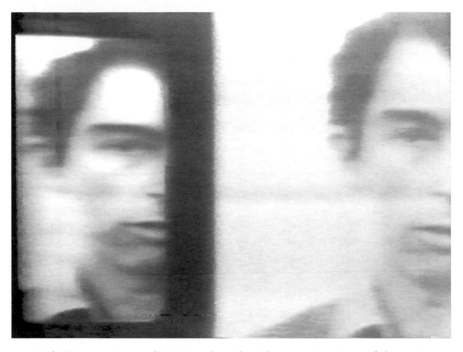

11. Mick Hartney, *State of Division* (1979), videotape. Courtesy of the artist.

to his audience. The work was originally shown on a monitor, so the sense of the artist being trapped by cultural masculinity was all the more poignant for the three-dimensional prison he seemed to be trying to escape. Hartney's commentary is self-reflexive. He describes the distress he experiences when faced with our unspoken demands that he should demonstrate all the attributes of male mastery: 'The audience is waiting for me to do something, to say something so that they can analyse it, criticise it, take it apart.' Here, Hartney refuses to conform to the iconic image of the male artist endowed with what Linda Nochlin called his 'golden nugget of genius'.[12] Instead he lays bare the fear and uncertainty that destabilises men's public role and acknowledges that most men fail to master masculinity. Most men barely learn to put on the show Hartney cannot bring himself to perform.

The social inscription of male or female identity onto the individual was neatly demonstrated by the UK artist Steve Hawley in 1981. *We have fun Drawing Conclusions* appropriates the words and pictures of the Ladybird children's series *Peter and Jane,* books that were widely read in the 1950s and 1960s. Using only the lightest hint of irony, Hawley reads the text over the original illustrations of the eponymous brother and sister whose duties in the home reflect the roles they will play later in life. Peter helps daddy to wash the

car while Jane is making tea with mummy in the kitchen. When the tape was first shown, audiences were well able to laugh at the absurdity of Ladybird's transparent attempt to manufacture complementary male and female subjects. However, the reality for countless individuals who were exposed to this form of brainwashing at an early age was that they would never entirely shake off the cultural ghosts of Peter and Jane.

The American Bill Viola has never been shy of investigating masculine identity through his relationships to his mother, his wife and his children. It is more usually women who define themselves in terms of their relationships with others, while men establish their credibility through what they achieve in the public arena. Viola took the step of locating his identity at least in part within his domestic relationships through works that observed his family in life and in death. These contemplative video portraits are combined with an almost transcendental sensibility, a product of the West Coast immersion in eastern mysticism that was characteristic of the 1960s and 1970s. Viola sees his own familial relationships as part of a wider universal consciousness. His life is tied

12. Steve Hawley, *We have fun Drawing Conclusions* (1981), videotape. Courtesy of the artist.

to sacred cycles of life and death that go beyond the crude social condition into which individuals are born. Viola's most 'eternal' family grouping takes place in the *Nantes Triptych* (1992). Installed as a dramatic video triptych, the work features slow motion footage of a woman giving birth and his mother dying flanking a centrepiece in which the artist falls naked through water in a similar timeless slow motion. His identification of woman as central to fertility and the processes of life and death are fundamental to all cultures, whether as a positive or negative configuration. The work aspires to a trans-historical condition of unity, a oneness with nature as it is manifest in Viola's immediate family. At first glance, Viola's helpless suspension in an excess of amniotic fluid places the artist in a passive relationship to his womenfolk and the mysteries of life and death they embody. However, this ignores the relative positions of public power occupied by those monumental women, particularly in relation to their famous husband/son. The personal and social reality in which the performers exist militates against the full achievement of the transcendental reading, the two held in tension in art as they are in life. The work also makes reference to the dominant western religion of Christianity in which the abject naked figure on the cross (which Viola so closely resembles) symbolises a male God's dominion over all women and indeed all other religions. The patriarchal overtones of this virtuoso video work do not nullify Viola's radical identification with aspects of life that would be anathema to the conventional male. His struggle is with the culture itself that, like it or not, continues to be largely male dominated. A female image, even when dying or giving birth, is always marked by her secondary social position. The image of the male artist, meanwhile, retains the status of western masculinity albeit in a state of agonised resistance to its emotional and spiritual limitations. As Rozsika Parker and Griselda Pollock have argued: 'A man can be placed in a feminine position, but will not become feminine. Because of the social power of men in our society, no man can ever be reduced to a crumpled heap of male flesh in the dark corner of some woman's studio.'[13] Viola's appropriation of traditional Christian iconography will always set up a tension between what he makes in the name of the father and the radical new masculinity he has championed in the twenty-first century.

Back in the twentieth century, the UK video artist Jeremy Welsh turned to images of his male lineage to reconfigure masculinity both inside and outside the private arena of hearth and home. *Immemorial* (1989) is a video installation that eschews the perilous terrain of male gods and female relatives *in extremis*. Instead it features images of a dead father and a newly born son whilst the artist, himself in mid-life, looks back as well as forward along the patrilineal continuum to which he belongs. Welsh attempts to synthesise a provisional masculinity from men's public role, which is represented by his father's uniform and the private attachment to his son that demands of him nurturing skills that his own father would never have allowed himself to practice. As men

were discovering that 'Big Boys' do cry after all, Welsh was injecting his work with equal measures of loss and hope, interestingly, without turning to images of women to carry the meanings. Chris Meigh-Andrews, working in the UK, has also attempted to redefine masculinity by examining socially unacceptable emotions. Like Welsh and Viola, Meigh-Andrews forges his identity partly through his personal relationships. In *Domestic Landscapes* (1992–1994), he introduces the geographical locations in which these relationships took place as an anchor to the feelings they evoke. Rather than fixed through blood ties or marital bonds, these relationships change and evolve, as does the nomadic artist moving from one landscape to another. Like Viola, Meigh-Andrews also sees his life as part of a continuum, an infinite human drama playing a modest part in the inexorable workings of Mother Nature. However, as the title of his work suggests, his fluid, shifting sense of identity takes on the more modest proportions of a domestic life played out in a tamed, contemporary landscape. His is a vision of masculinity bounded by social and historical realities as much as by blood ties and the timeless laws of nature.

Socially gendered identity is most clearly established in what people wear. The suit, the most emblematic of masculine trademarks, has been appropriated by a number of artists, but perhaps most effectively by UK video-maker Mike Stubbs. He forged the ultimate deconstruction of the double-breasted corporate automaton in *Sweatlodge* (1991), a choreography of masculine mannerisms featuring the performance group, Man Act. With and without jacket, the performers walk and talk, shake hands and slap each other on the back in gestures designed to signal strength and efficiency while establishing the male pecking order. Through the classic body language of the corporate male, Man Act recreate the corridors of power, but just as the well-oiled army of suits seem most coolly in charge, little demonstrations of affection are introduced as well as a feminine grace that begin to unsettle the supremacy of the Master-Race. The cynical alliances forged between individuals vying for position now look more like new forms of male bonding in the boardroom. Co-operation, co-ordination and inter-male affection are the unlikely outcome of this apposite parody of 'the suit'.

THE CLASS DIVIDE

The suit is not only an indicator of gender, it is also a marker of class, a hierarchical social institution of extraordinary complexity in the UK. Curiously, outside campaign or 'agit prop' tapes, few video artists have addressed the problems of class prejudice directly. It could be argued that all UK work in the last 40 years is inescapably class-bound, because class is inscribed in British accents and patterns of speech. Scratch video in the 1980s was said to be a working-class movement but was soon gentrified as it became part of the

repertoire of UK video and its proponents moved into establishment jobs. Artists such as John Carson, Simon Robertshaw and Ian Bourn have addressed class in their work, albeit obliquely. In Bourn's case, class featured more prominently because of his declared ambition to shake off his working-class origins.[14] In *The Cover Up* (1986), Pictorial Heroes gave voice to the disenfranchised worker through a character who wandered among the ruins of an abandoned factory railing against the Thatcherite policies that had robbed him of his livelihood. Andrew Stones combined video with slide projection in *Class* (1990), a work that argued the tenacity of the archaic class system. Projected images of the Queen were bisected by ladders as a metaphor for a society still determined by social inclusion and exclusion with the obligatory social climbers trying to beat the system. Middle- and upper-class video, if there is such a thing, remains mute on the subject of class, as privilege usually does (and here, I include myself). In a subtle twist, Mike Stubbs made *Contortions* (1983), a sympathetic portrait of an unemployed youth. However, Mike was himself a middle-class boy and I am tempted to interpret the video as a reflection of his ambition to escape his 'soft' bourgeois background as well as a sincere gesture of solidarity with the working classes. When we were all radicals in the late 1970s and early 1980s, it was not fashionable to be middle or upper class. Working-class credibility was associated with 'right on' left wing affiliations. Masculinity was also implicated in the aggressive working-class stance of radicals, particularly if they were sculptors. As a student, I felt compelled to drop the 'Cary' part of my double-barrelled surname and did my best to Cockneyfy my public-school accent. Nowadays, class distinctions have blurred under estuary English and the supremacy of commercial success over 'background'. However, residues of class prejudice can still be found in all walks of life, and are now complicated by issues of race and socio-economic status overlaid with notions of 'hard' masculinity left over from traditional working-class environments.

The works of Viola, Welsh, Hartney, Bourn and Stubbs are genuine attempts to discover and recover qualities of existence that are denied within masculinist and classist acculturation. However, most of these artists betray the difficulty of becoming vulnerable and admitting to doubt and personal weakness in an art arena where mastery and virtuosity are a measure of success and a sign of masculinity. It is tempting to interpret many of Vito Acconci's early works as an elaborate strategy to stave off the potential objectification of his male body within the video image. Many of his tapes feature the artist haranguing the audience or, as in *Pryings* (1971), abusing a female companion by trying to prise open her eyes having instructed her to keep them tightly shut – as if her look could kill. Many of the works I have cited in this chapter are isolated examples of heterosexual men investigating masculinity and class in a body of work that is dominated by other concerns. I find it hard to believe that they exhausted their search for a new masculinity after one or two videos,

but such is the hold of the dominant culture and so real is the threat to status and heterosexual orientation that most of them quickly abandoned this form of investigation. However, together with the work of gay, black and feminist artists, these videos mark an upsurge of content-based work in the 1970s and 1980s that questioned the identities we were allocated by birth, geography or gender. In their determination to interrogate conventional masculinity, male artists joined in a widespread attempt to rupture the supremacy of mainstream ideologies. Beyond that, many of them subscribed to the revolutionary zeitgeist that decreed we should shake the foundations of a divided and unequal society. Briefly, they were a sign of the times.

5

Language

Its Deconstruction and the UK Scene

These works are all difficult (in the sense that a child is said to be difficult) in that they seek to resist or stand apart from dominant ideological practices.

Stuart Marshall

PROBLEMS OF LANGUAGE, SUBJECTIVITY AND THE UNIFIED SUBJECT

In the early days of video, artists attempted to define a creative space independent of broadcast television. As was particularly the case in the UK, many also determined to develop an oppositional practice with an underlying critique not only of television but also of existing social and political structures. We have seen how the modernist approach tackled the problem by deconstructing the illusion of the televisual image revealing the mechanical and electronic mechanisms responsible for creating the smooth face of television. Others worked at the level of content and made visible what was absent from our TV screens. The silent majorities that we more usually think of as minority interests in western civilisation – women, ethnic groups, gays, lesbians and, to some extent, the working classes made themselves heard through the work of avant-garde artists.

For those attempting to offer alternative content, difficulties arose when they claimed to access definitive truths about individual subjectivities. Postmodern thinkers including Jacques Derrida have argued that identity is constructed by unstable systems of interrelated cultural meanings or 'texts' leading to an individual who is internally fractured and externally determined. Personal truths can only be partial, distorted as they are by the fictionalisation of experience that constitutes remembering, the inassimilable nature of extreme experience and what the film-maker Abigail Child calls 'the conceptual and social prisms through which we attempt to apprehend'.[1] All video based on self-representation faces the

difficulty of ever truly knowing that self when it is as much a product of social and political conditioning as of nature, nurture and that indeterminate force, free will. On this basis, we are left with the problematic quest for self-knowledge and 'the impossibility of securing the authentic view of anyone or anything'.[2]

The postmodern view of identity has challenged the concept of the individual as a unified, autonomous subject. According to the recent Meme theory I mentioned earlier, individuals are simply temporary staging posts for ideas and ideologies circulating in the universe under their own steam.[3] The old injunction to 'know thyself' has become an impossible project. Back in the 1970s and 1980s, those of us who still felt it was legitimate, indeed vital, to speak from an individual position had a problem: how to pursue the slippery concept of the real within a matrix of languages that necessarily limits and delimits what we are able to say?

FEMINISM AND LANGUAGE

The realisation that signs or images are neither stable nor ever 'fully meaningful' and come to us pre-stamped by culture, meant that feminists in particular never took language for granted.[4] Women could not assume that the available linguistic vehicles would transmit the meanings they were trying to impart. Verbal language was understood to be intrinsically male – what the feminist writer Dale Spender called 'man-made language' with its dualistic, positive (masterful) and negative (effeminate), gendered positions already firmly fixed within its structures.[5] Both polarities were seen to be syntactically and ideologically dependent on the other. Once we enter into a dualistic symbolic order, and master the current forms of communication, we do not speak with language, but rather, as the saying went, 'language speaks us'. Historically, representations of femininity, ethnicity and gay sexuality in visual culture were all seen to occupy the 'other', negative polarity against which the central position of the white, heterosexual male was confirmed. In the late 1970s, French feminists like Luce Irigaray and Hélène Cixous had urged women to develop what Irigaray termed an *ecriture feminine*, a feminine writing centred on the deviant languages of neurosis as well as the utterings of infancy, witchcraft and the body in extremis. Cixous also urged women to 'write through their bodies'[6] and saw a similar freedom in the expressive potential of embodied experience that, like the ravings of the mad, could escape the constitutive structures of the male symbolic order. Although these ideas later gained greater currency, many 1980s feminists in the UK followed the more widely read Spender and believed that current languages, both verbal and visual, were inescapably masculine and patriarchal, and decided to work with what they had. I have already described examples of videos that used the same tainted systems of representation to deconstruct social stereotypes and build alternative models of 'minority' subjectivities. In

the UK it was not only literary theory and feminism that placed the problems of language and subjectivity at the centre of the cultural debate. By the mid 1960s, the rhetoric of structuralist film had already set the agenda with a critique of Hollywood narrative that found echoes in the later work of new narrativist video-makers in the UK.

STRUCTURALIST FILM

English avant-garde film-makers analysed the language of Hollywood cinema and, just as Spender, Irigaray and Cixous had discovered in spoken language, they found it riddled with negative role models for anyone who wasn't white, heterosexual, middle class and male. Drawing on the arguments of psychoanalysis and Saussure's structural linguistics, artists like Peter Gidal, Laura Mulvey and Malcolm le Grice examined narrative structures in film and by extension in television, and identified them as the vehicle through which these repressive cultural ideologies were being disseminated. They observed that the mechanism that enables 'family entertainment' to become such dangerous propaganda was rooted in the psychosocial pleasures of spectatorship and voyeurism.[7] Cocooned in the darkness of a cinema, spectators wear a 'cloak of invisibility' that gives the illusion that 'they can't see us, but we can see them'. Thus camouflaged, viewers look through a window onto an imaginary world that pretends to be unaware of their voyeuristic gaze. The theory went that whilst harbouring an infantile illusion of omnipotence spectators are, in fact, passively identifying with one or other character on the screen. They are drawn into the story unaware that they are simultaneously internalising ideological messages hidden in the narrative and the fabric of the spectacle. For instance, within the diegetic space, within the story itself, women in classic Hollywood film are there to be looked at and, as Laura Mulvey observed, they provide a motive for the men to act and move the story on. This reflects and reinforces their relative passive and active positions within a phallocentric society outside the cinema. According to the structuralists, the gaze inscribed in the camera's eye is fundamentally male and western – what Gidal called 'the I in endless power'.[8]

In the early 1970s, structural materialist film-makers in the UK like Peter Gidal, considered any form of narrative to be determined by power relations that are embedded in a fixed structure of signification based on difference – black vs. white, male vs. female, etc. As their name suggests, structural materialist film-makers avoided the ideological pitfalls of narrative by emphasising the structure and stuff of film, sharing with the modernists an interest in materials and processes – celluloid, light, duration, camera moves, cuts and dissolves. In this way, structuralists turned film into a kind of a stripped-down optical phenomenon. In North America, Michael Snow had made the classic structural film based on a 45-minute zoom into a photograph of a wave pinned to his studio wall. The film historian A.L. Rees identified *Wavelength* (1967) as a film

in which 'form becomes content.'[9] In the UK, Gidal, a hard-line materialist film-maker, considered even the photograph of the wave to constitute too much realist content and in his own work avoided all storylines and most representations. What little you saw was out of focus and hard to make out. In 1973, he created *Room Film* in which the camera drifts apparently aimlessly around his room constantly shifting focus so that no specific object (and its cultural meaning) can be identified. As the critic Stephen Heath has commented, the materialist project, exemplified by Gidal, concentrated on 'the specific properties of film in relation to a viewing and listening situation'.[10] Spectators were now compelled to concentrate on the effects of optical printing, repetition and ambiguous imagery and in the absence of any storyline would frequently become as aware of their own breathing and the proximity of their neighbours as what was (not) happening on the screen.

Structuralists believed that attention to material and process in the recording, printing, projection and consumption of the image was the way to avoid the sins of narrativity and voyeurism. These non-narrative films were often hypnotic, visually compelling and evident of a painterly sensibility operating behind the lens. The rigorous cultural critique being proposed through the work was tempered by what Rod Stoneman called 'the aesthetic compensation of structuralist film'[11] and was most evident in the captivating landscape films of William Raban and Chris Welsby. Whatever the furtive visual pleasures offered by experimental film in the UK, the central aim was to refuse the audiences' narrative expectations and thereby open their eyes to the politics they were being fed along with their *Star Wars*. The theory was that once the scales had fallen from their eyes, spectators would question all voices of authority and become active in dismantling an oppressive social order. However utopian this may seem, the idea that we are formed by the cultural images to which we are exposed is still current and forms the basis of censorship in both film and television. The denial of narrative pleasures brought structuralists dangerously close to conservative voices who blamed *Kojak* for the actions of psychopathic murderers in the 1980s and, nowadays, point to Gangsta Rap as the cause of urban violence among adolescents. Although spectatorship was later recognised to contain active elements and narrative strategies were reintroduced in film to more subversive ends than simple entertainment, structural materialists in their rigorous analysis of narrative and voyeurism showed us how the packaging of ideology works in both the art and the entertainment industries.

THE STRUCTURALIST INHERITANCE

In the UK, independent film developed as a separate and distinct practice and, in the early 1970s, primarily concentrated on a critique of mainstream film. For video artists, television was the main adversary. However, there was common

theoretical ground between them in their analyses of popular culture and, in educational institutions where both film and video were taught, a cross-fertilisation of ideas took place. Film theorists had ample opportunity to apply – or sometimes misapply – their critique to what video-makers were doing. Structural materialism posed problems for video artists in the UK in its total rejection of narrative, even 'good' narrative in which minority voices could now be heard. For feminists who had based their strategies on a reconfiguration of the personal as political and for ethnic minorities and gays who needed visibility in order to pursue liberation campaigns, the disappearance of the artist into grainy views of their bedroom walls was not a viable proposition. In the early 1970s, anyone attempting to build a career in moving image whilst conforming to the visual politics of the day would start from a position of being neither seen nor heard.

There is no doubt that we needed to learn the central lesson of structuralism, that the language of the moving image is not transparent but loaded with ideological precedents. However, the evacuation of meaning advocated by the structuralists was unsustainable. The second generation of independent film-makers soon defied the reductive prohibitions of their elders and lyricism, poetic manipulations of narrative, fantasy and what Nina Danino calls 'the intense subject'[12] soon returned to artists' film. The younger generation of film and video-makers also challenged the concepts of the passive cinema-goer and the couch potato television consumer indiscriminately soaking up ideologically marked entertainment. The audience was now recognised to be heterogeneous, made up of gendered individuals of different ages, colours and creeds whose reading of images was determined largely by their own histories and the historical moment in which they encountered the work. Laura Mulvey's characterisation of the female spectator as oscillating between passively identifying with the objectified woman on the screen and abdicating her gender to take up the consuming masculine position was challenged, not least by Mulvey herself.[13] Jackie Stacey identified a fascination between women in cinema that excluded the male gaze. Richard Dyer proposed the male as erotic object for both gay men and heterosexual women and David Rodowicz insisted on the existence of a desiring woman spectator, capable of herself becoming the 'bearer of the look'. Feminist commentators such as Jackie Byars and Jeanne Allen have proposed that women's discourses exist as subtexts in mainstream film alongside those of their male creators and that, given an active spectator, these subtexts can be recognised and consumed by the women in the audience.[14] Creating meaning from a range of gendered and ethnic spectator positions, this newly 'performative'[15] viewer has since been encouraged to play an active part in the creation of meaning in art. The languages of art are now viewed not as fixed, but fluid, layered and in a constant state of becoming in the charged spaces between maker, viewer and object/video.

For many artists, these semiotic arguments lost their usefulness in the business of making art. Such hardy souls subscribed to Eric Cameron's cautiously empiricist view that, in spite of the wobbly business of representation and the conceptual inadequacy of assuming a unified subject, something or someone did, at one time, stand before the camera with the capacity to speak in a common, communicable language. This approach also assumed that a social individual, sometimes one and the same person as the subject of the work, then made the decision to record the event and later edit and disseminate the results to other social individuals. However distorting the mirror of the senses and loaded the vehicle of representation, artists experience their bodies and the specificities of living as a quotidian series of quantifiable fluctuations. These are peppered with elements of lived experience derived from the environment like the rain, wind and sky, what Levine places beyond the distorting lens of language and endows with 'qualia', the ineffable, phenomenological experience of the world. Within the context of moving image art, this embodied subjectivity of the moment can be extended to embrace experiences of the body over time and indeed, when rooted in a specific historical time and place, to social experience, itself apprehended through the senses.

The legitimacy of representing and bearing witness to experience within the realms of art in general and the factual medium of video in particular, found further support in the real world by contiguous gains being made by activists in politics, education, employment and health. The late twentieth century saw political changes that were slowly introducing the ideal of social equality into western society. If video artists needed a notion of the real on which to anchor their perceptions, they only had to look around them. The transformative power of language was everywhere in evidence; in politics, literature, theory and the visual arts. Ironically, structuralism, one of the most radical analyses of filmic language, had threatened to rob artists of the greatest instruments of change – narrativity.

NEW NARRATIVE IN THE UK AND POST-STRUCTURALISM

Amongst UK video-makers few did, in fact, adopt the modernist-structuralist position in its total rejection of realism and narrative. Stuart Marshall has pointed out that although UK video-makers drew attention to the mechanisms that created the illusion of the video image, the tape itself could not be worked upon directly and, as a result, their critique became necessarily 'embroiled in the practices of signification'.[16] In Chapter 2, I have argued the opposite position and showed the many ways in which artists did open up the medium as a medium. Nevertheless, in the UK a modernist approach was less prevalent and, as Marshall observed, artists tended to deconstruct the codes of television realism rather than the mechanisms that produce the televisual image itself.

Video artists did not deny representation as the structural materialists had done, but neither did they go to the opposite extreme and attempt to reinstate the narrative regimes of realism. The project of new narrative in the UK was more in line with the deconstructive strategies of Jacques Derrida who argued that through a critical investigation of linguistic structures, ideological 'norms' would be disrupted making way for change. Video artists re-introduced what was signified along with its sign. Thus, a table was once more linked to the image of a table, but in such a way as to call into question the natural association of one with the other and so develop a better understanding of the 'ideological effects of dominant televisual forms'.[17] It was not only a question of understanding the status quo, but, according to new narrativists, there was a need to forge a radical reconstruction out of the ashes of deconstruction. Armed with a notion of language as fluid and malleable, they found a way out of the nihilistic refusal of content that had bogged down the more extreme exponents of structuralist film.

New narrative was careful not to replace the old order of hierarchical representation with new truths that could become just as dogmatic and entrenched as the old 'Master Narratives'. In order to avoid this pitfall, artists developed narrative forms that took something from the distantiation techniques of the playwright Bertolt Brecht. In the political ferment of the 1930s, Brecht emphasised the artifice of stage performances with what he called 'Verfremdungseffekt' or 'alienation effect'. His actors changed gender, frequently burst into song and, in the tradition of music hall and pantomime, addressed the audience directly as Shakespearian characters had done several centuries before. Brecht used these distancing techniques to counter the manipulations of 'emotional theatre' and required from his audience an intellectual engagement with the wider social and historical picture. The aim was to induce an imaginative engagement in the viewer whilst simultaneously maintaining what Barthes called a 'pure spectatorial consciousness'. New narrative developed similar techniques for telling stories whilst making the mode of storytelling visible, the artifice of narrative laid bare as it weaves its spell. The political aim was clearly expressed by Maggie Warwick when she wrote that artists must 'construct fictions about existing fictions in order to gain a better understanding of how and in whose interests those fictions operate'.[18]

VERBAL AND VISUAL ACROBATICS

These new narratives took many forms. One strategy involved a shift away from using language in its role as a neutral cipher for human experience towards a deconstructive play with the verbal and visual codes we use to draw our internal maps of the world. I described earlier how Steve Hawley unpicked the *Peter and Jane* children's books to expose the didacticism of the gendered role-playing in

which well-behaved characters engage. Hawley went on to unsettle further the arbitrary union of words and meaning in a series of videotapes that investigated what he called 'the specific gravity of meaning'.[19] In *Trout Descending a Staircase* (1987), Hawley attempted to reinstate the limnal delights of the painterly gesture by harnessing Paintbox technology to create a series of animated still lifes. At the time, the Paintbox could generate a tracer effect that resembled the decaying repeat patterns in Duchamps' painting *Nude Descending a Staircase No.2*. Hawley devised a method whereby he could key into an ornate gilt frame a series of classic still-life subjects – flowers, bananas, leeks and, most absurdly, a trout. When he held the various objects of *nature morte* up to the frame, their images became magically imprinted on the electronic canvas. They repeated in meandering and overlapping trails as he moved carnation and trout around the frame. Hawley even 'painted' multiple paintbrushes with a paintbrush thus completing the cycle of references whilst admitting to the enduring need of the artistic ego to make its mark.

These instant Futurist paintings not only exposed the workings of video effects within a modernist framework, but also mocked the march of art historical progress, which at one time endowed similar daubings with deep cultural significance. Hawley seemed to be agreeing with the classic philistine position that 'even a child could do that' especially with access to the latest 1990s Paintbox trickery that could now reproduce historical art forms at the flick of a switch. At the same time, his work reintroduced a narrative – that of the artist in the act of making images – while continually emphasising the constructed nature of what he was creating.

Hawley's finest ludic exploration of cultural and linguistic conventions tackled our fundamental mode of communication – verbal language itself. *Language Lessons* (1994 with Tony Steyger) is a long documentary video charting the development of invented languages from Esperanto to the absurdly named Volapuk, a language that is spoken by only 30 people worldwide. One of the many experts Hawley interviews reminds us that the original lingua franca was Latin and all subsequent attempts to create international languages had at their heart the belief that these would create a commonality promoting world peace and unity. In addition, these aficionados of international languages decry the linguistic imperialism of a globalised English, a language based not on the supposed purity of our mother tongue, but on a bastard mix of Anglo-Saxon, Latin and French spiced with the odd Nordic and Oriental influences. *Language Lessons* provides a delightful insight into the more eccentric pastimes of the average Englishman as well as the realisation that all languages are constructed and, as one learned interviewee averred, speaking English now 'ties you to a world-view of dominant American culture'. With the acquisition of language, a social order is entered and our place in society and the world at large is set in semiotic stone.

LANGUAGE SPEAKS WITH FORKED TONGUE

The duplicity of language was further demonstrated by David Critchley's *Dave in America* (1981) in which he describes exciting trips to the USA he took only in his imagination and later by John Carson who similarly dreamed of 'Going Back to San Francisco' in *American Medley* (1988). Steve Hawley went on to tell elegant lies to camera in *A Proposition is a Picture* (1992), a work based on photographic images that he actually borrowed from his wife. The creeping implausibility of his tale makes us suspicious, although I only discovered the extent of the lie by asking the artist himself. The tape never descends into incoherence and the fabricated journey tells a poignant story of a son's quest to find his absent father, a story that might even be based on elements of the truth. It is perhaps hard to fabulate as elegantly as does Hawley without drawing on personal experience. The doubts that the tape sets up in the viewer's mind bring into relief the need we have to surrender to the evocative powers of narrative. At the same time, the artist delivers to us a story, a quest for the father, that is as inconclusive as our attempts to pin down the precise meaning of the tape.

David Critchley, also working in the UK in the late 1970s and early 1980s, liked to undermine linguistic conventions by contradicting himself as the work progressed. His videotapes made it difficult to believe our eyes and ears or settle on any one version of the 'truth', however convincing he sounded. *Pieces I Never Did* (1979) is a combination of raw performances to camera and views of the artist at his desk talking calmly about ideas and concepts he has forged for his work, and then rejected. These two narrative strands are constantly disrupted by fragments of a sequence in which the artist, naked this time, repeatedly screams 'shut up' to the camera. In these angry outbursts, the continuity of the work is established by Critchley's voice slowly failing across the duration of the tape. Each 'piece' is described verbally by the artist in his calm, reporter mode, then disowned – 'I wanted to do a piece about sweeping, sweeping up rubbish... but I didn't do that one'. He then proceeds to act out what he apparently decided not to do and since his actions were preceded by his verbal description, there is no audience anticipation. The work is deconstructed before it takes place. We are left with the conundrum of the demonstrable lie that he didn't do the work, or the possibility of having got our wires crossed – did he mean that he wouldn't do the work live? There are no clear answers, the artist's artistry itself is shown to be a fabrication rife with clichés and conformity to the fashionable ideas and phrases of the time: 'process pieces', 'endurance pieces', 'oppositional pieces', 'transformative pieces'. It's all there in the art-speak of the 1980s.

Although Critchley had his tongue firmly in his cheek, he also subscribed to the serious agenda of the new narrative movement in the UK. Artists were determined to find politically acceptable ways of reintroducing content, humour and pleasure into independent work after the anti-narrative period of

13. David Critchley, *Pieces I Never Did* (1979), videotape. Courtesy of the artist.

structural film. To my mind, new narrative cannot be reduced to the surface play of postmodernism that, like much earlier theory derived from semiotics, denied the possibility of authentic speech within existing linguistic structures. Although a self-referential play with linguistic codes is common to both, post modernism has taken on a nihilism that was not shared by the new narrativists in the UK. Postmodernism proposes artistic expression as individual, but arbitrary and interchangeable, divorced from any social or historical context and therefore politically ineffective. New narrativists in the 1980s believed that they could speak, although they were aware that their speech was mediated by precedents in the history of art, in the vernacular of Hollywood film and in contemporary mainstream media. What new narrativists struggled to say was designed to maintain political awareness in an audience, a consciousness that might ultimately lead to activism and greater political freedom. In this they shared the utopian aims of the structuralists, but within a postmodern scenario they would be dismissed as naïve humanists.[20] In new narrative the new fictions challenged the old and, in their opacity, created the possibility for other fictions to displace them in turn. A kaleidoscopic and fluid vision of reality takes shape that nonetheless is propelled towards an approximation of an attainable and observable truth.

SPEAKING IN (MANY) TONGUES

For some time, the cultural theories of the 1970s and 1980s had been eroding the importance of the role of both the author and the artist. Although some new narrativists might have subscribed to Barthes' notion of the death of the author and the ascendancy of the viewer's subjectivity in the creation of meaning, it was in the proliferation of voices that they sought to displace Gidal's 'I in endless power'. By multiplying voices and points of view, a narrative would no longer be attributable to a single originating source. The works became polyphonous,

thereby suggesting that no one position was the correct viewing position, no one version of the truth immutable and definitive, but the true picture floating somewhere between and within all declared positions. The later conception of the individual as merely a gathering point of cultural influences had not yet taken hold. The individual was still regarded as an independent locus of consciousness capable of Cartesian introspection and judgement. Within new narrative, the conception of self was more fluid, taking on different voices and modes of speech. This created a range of identities attributable to a generic type or emanating at different times from the same individual.

A good example is my own video, *Kensington Gore* (1981), a work that proliferates vocal sources and narrative modes by telling a story in as many ways as I could think of. The bloody incident on a film set is recreated as mime, as a news report read in BBC tones – doubled by a different voice reading the same text and as a 'spontaneous' interview. It also includes a demonstration of how to create a theatrical wound on a neck – so realistically that one member of an audience dragged her child away even as he protested, 'but Mum, it's only wax and paint!' The various voices and actions describe the perceptual disruption

14. Catherine Elwes, *Kensington Gore* (1981), videotape. Courtesy of the author.

that arose when I was working on location as a BBC make-up artist. Over the image of mortician's wax being smoothed into the actor's neck, we hear how my absorption in the fake wounds I was creating with wax and Kensington Gore (theatrical blood) prevented me from switching off my professional eye when a member of the crew was hit in the face by a horse's hoof. It was only when the director fainted that I saw the incident as real and stopped making mental notes about the angle of impact and the flow of blood. The different modes of representation I used were intended to reveal the slippery relationship between fantasy and fiction, between what we know to be simulated and what we nonetheless accept as real. In the fracturing of the narrative, I offered multiple points of view adding up to a provisional representation of an event.

THE DIVIDED SELF, DIVIDED AGAIN

Other artists achieved the same 'open' narrative by restaging or proliferating the individual voices that told the story, like a game of Consequences,[21] each person adding another piece of the narrative, with no one character or individual or point of view laying claim to the 'real' story. Back in 1975, the German artist Dieter Froeser presented his *Re-stage* series in New York in which conversations in German were re-enacted in English and shown together with other media representations that compared and analysed the original conversation. This kind of pass-the-parcel narrative structure finds echoes today in Kutlug Ataman's work in which the Turkish transvestite Ceyan Firat performs to her own script based on an interview she gave the artist at an earlier date. In the 1990s Gillian Wearing has also confused identities by putting words into mouths from which they did not originate and Bruce Nauman fractured a tense dinner party across nine screens and as many participants. The new narrative strategy of wearing a text like any other accoutrement of identity has had an enduring appeal for artists arguing a new decentred subject or simply courting 'negative capability', the chameleon nature of the creative imagination.

The proliferation of voices and points of view within new narrative video in the 1980s offered a critique of television naturalism, itself built on a notion of the unified subject, notwithstanding the split personality often suggested in Jekyll and Hyde-style scenarios. Many artists destabilised the fictive unity of a character by fracturing its image through the polysemic devices I have described above and through mirroring and doubling of the subject. Max Almy in the USA divided the image of a woman into four physically identical but emotionally contradictory parts using the simple device of building a stack of four black and white monitors and re-recording four sequences of the same pair of lips giving four different perspectives on a story of love. *I Love You* (1983) describes the progressive withdrawal of a woman from a love entanglement, each time reinventing her position to suit the current state of her mind and

heart. Where the first pass tells how she can't live without her partner, the last repeats her commitment but justifies her withdrawal with the well-worn clichés of needing time and space to grow as a person. Not only is the individual woman fragmented but there is also a sense that her clichéd dialogue is cobbled together from half-remembered Hollywood scripts. And yet, we have a sense that all of her statements are true at the time of telling, each projected personality part of the whole, a whole that can never be reduced to any one dominant part. In the UK, Marceline Mori used even simpler means to fracture her self-image in the two works *2nd and 3rd Identity* (1977). With a small grid of mirrors attached to a monitor and an identical monitor positioned opposite, Mori's face breaks up into multiple reflections, layers of mirrored images as her voice describes the fragility and fugitive nature of her subjectivity.

UNHOLY COUPLING

With the new techniques of montage that video keying and mixing later allowed and which had long been possible in film, the visual atomisation of the individual became more sophisticated. Figures and faces were doubled, mirrored and dispersed, or merged with other bodies combining into hominid hybrids, sometimes grotesque, sometimes evocative of psychic states. In Judith Goddard's *Celestial Light/Monstrous Races* (1985), a woman's eye is keyed into the belly of a man like a misplaced Cyclops or an evil eye with malignant intentions. For me, the image suggests something of the anxiety women can feel in the face of overwhelming male physicality. Later, in Scotland, Lei Cox used the new digital technologies to flicker between the naked body of a man and a woman creating a hermaphrodite without quite losing track of the two gendered positions from which it was born. *The Sufferance* (1993) creates a hybrid offering of what Joan Key described as 'a space of rest from the endless vying for position of male/female cultural organisation'.[22] Cox himself sees the work as a technological metaphor for the fusing of physical and psychic boundaries that takes place in heterosexual intercourse and the 'mirroring and narcissism of romantic love'.[23] Exploiting another technological development, the American artist Dan Reeves used morphing techniques to merge one person into another as if speeding up the evolutionary process. *Obsessive Becoming* (1995) is the story of Reeves' family told by individuals who then appear either to regress into their ancestors or mutate into their own children, their individual identities blurring across the genders and the generations.

From the new narrativists onwards, this need to internalise contradiction and reconcile psychic oppositions has been much in evidence in video art. In the early days, these attempts simultaneously to reiterate and suture the divided self found echoes in contemporary psychotherapeutic practices. Freud had observed how the human mind is divided between the conscious and the unconscious;

the child is alienated from the adult; the past subsumed into the symptoms of the present. From gestalt to primal therapy and psychodrama, regressive journeys into childhood were used in the 1980s to reconnect patients with the exiled parts of their psyche. Perhaps because video artists have traditionally used the medium as a mirror, they found more significance in Lacan's theory of a psychic split, the 'spaltung' represented by the mirror phase. As I mentioned in Chapter 3, Lacan characterised the defining moment for the infant when it first recognises its own image in the mirror. The embodied knowledge of self is projected into an external entity existing in language and representation, forever causally connected, but psychically separate from subjective experience. Entry into the symbolic order of human discourse and society necessitates this alienation of self from image of self. Paradoxically, this developmental moment also offers the individual an idealised image of unity, of a bounded, social self, achieving mastery and self-determination where the infant is fragmented and dispersed in a sea of bodily sensations. The struggle of culture to reunite the disparate selves that constitute an individual was the preoccupation of much new narrative and postmodern art in the 1980s and beyond. The cultural theorist Sean Cubitt takes a sociological view when he hails video as the medium best suited to 'reorganise this chaotic chorus of subject positions into something that will fit into the large-scale organisation of society'.[24] Video, he believes, can take on this task because it 'begins its work precisely in the heart of the regime of looking'.[25] It begins in the mirror phase.

If human creativity and desires can be understood in terms of the need to reconcile these psychic splits, then the new narrativists in the UK were intent on exploring both internal fragmentation and the ruptures inherent in language. They began by splitting the signifier from the signified, the speaker from the sign in televisual language thereby evoking our essential separateness from the images that represent us. At the same time, they re-introduced the possibility of narrative communication and visual pleasure, healing the alienation of subjectivity under the academic strictures of structural materialism. The subject could now be conceived as a continuum, a fluid entity manoeuvring the cultural precedents it sets out to dismantle, but containing within it a core resistance that cannot be explained as a product of social conditioning or be reduced to a symptom of internal divisions. The new narrativists were not looking for a closed, settled unity, but an internal co-existence of a fractured subjectivity. As Sean Cubitt remarks in his discussion of Max Almy's tapes: 'It's at this point that it becomes possible to think about the politics of a new sociality based in unstable identities.'[26]

When examined up close, the distinctions between the different tendencies can become very fine. In spite of their tamperings with the technology, structuralist film-makers never entirely eradicated representation and a narrative of sorts always emerged in their work as a kind of return of the repressed, individual

humanity that narrative embodies. New narrativists for their part were intent on re-introducing narrative content in video, but simultaneously took a modernist and to some extent a materialist position in relation to televisual representation. They made visible the material codes, conventions and structures of television naturalism, the panoply of entertainment formats that, as Marshall pointed out, pre-existed artists' involvement in the medium. Throughout their linguistic explorations, new narrativists believed in the transformative potential of art, the possibility of raising consciousness, and indeed the capacity of artists to speak from an authentic position through the complex and ever-shifting mesh of linguistic conventions.

FURTHER TAMPERING WITH NARRATIVE CODES

As we have seen, the early grammatical rules of television and cinema required that their codes and procedures remained, if not invisible, then largely unconscious to the viewer. Artists showed that excising the storyline or disrupting the synchronisation of sound and image could easily undermine television realism. Linear narrative also proved vulnerable to the discontinuities, misrepresentations and multiple performance modes that new narrativists introduced into their work. Such devices not only disrupted the internal logic of narrative structures, but they had the added bonus of undermining the veracity of the ideological doctrines promulgated by broadcast television.

Television realism also depends on the invisibility of edits, so programme-makers use dissolves and other transitions to ease us from one scene to another. Where structuralist film-makers often slowed sequences down to virtual stasis in order to evacuate meaning and avoid narrative fixture, new narrativist video-makers fractured, multiplied and speeded up the editing process to bring into relief the montage of discontinuous images that are the substrate of conventional film and television. The fast-paced editing achieved by these artists was made possible with the advent of analogue editing in the late 1970s and the development of the Series 5 Sony edit suite that could edit down to five frames. In the 1980s, more complex two- and three-machine editing became generally available in the UK and artists like Dara Birnbaum in the USA and Klaus Blume in Germany were already experimenting with editing as a structuring device. With the benefit of five-frame accuracy it was possible endlessly to repeat sequences, copying from the same original source and editing rapidly, almost reaching the speed levels of film animation. We were to see the joins in post-production as well as in the production phase. Works like Steve Littman's *Crisps* (1980) did just that. The artist is seen seated in front of the camera staring into the lens with a listless air. He then crams as many crisps into his mouth as he can whilst the editing jump-cuts back and forth in rapid-fire repeats orchestrated into a frenetic exhibition of compulsive eating.

Jeremy Welsh in the UK and Sandborn and Fitzgerald in the USA also began to explore the visual disruption that rapid-fire editing could produce, taking the image to the edge of coherence and legibility. On one level this could be read as analogous to the high turnover of images that the increasingly jaded palate of television viewers demanded throughout the 1980s and 1990s. Coming across like *General Hospital* on acid, these parodies of information overload exposed our need to consume mindless television entertainment. On another level, rapid editing could represent the descent into incoherence, the senselessness that Baudrillard sees as the only defence against the invasion of the social machine of culture.[27] Either way, the emphasis on the edit had a compensatory visual appeal. The frenetic cutting created semi-abstract and painterly patterns that once again tuned into the hallucinogenic experimentation that was still part of youth culture in the early 1980s. The principal aim of new narrative video remained the deconstruction of televisual signifying practices and the reconstitution of the artist's subjectivity, albeit as a shifting pattern of self-reflexive fragments.

The previously well-hidden substrate of editing that supported linear narrative in mainstream narratives was now exposed and became a major element in the creative enterprise of new narrative. The temporal tamperings made possible by editing ruptured narrative continuity and the internal coherence on which television depends. It also offered new ways of thinking about time, perception and, in the case of works like *Crisps*, of psychological states analogous to the visual and conceptual disturbance that can be induced by repeat editing. The sustained reiteration of a sequence in film loops or repeat-edited videos has the capacity to disrupt and drain meaning from the image, and simultaneously create a new entity, what Vito Acconci called 'the replicating aspect'. When something is repeated, says Acconci, 'it becomes matter, it becomes fact'.[28] In dismantling the codes of conventional televisual language, new narrative began to reconstruct a language of the imagination, a skewed vision of the world that slid between the cracks and fissures of what is known.

OUT OF SHOT, REVEALED

The whole range of televisual and cinematic conventions came under scrutiny within new narrative, including the organisation of the studio. Television drama requires that the crew behind the camera remains unseen and unheard. The director and technicians are also kept out of shot. Camera operators must not allow the camera to stray to the raw edges of the set and give the game away. The lights, microphones and cables – all the paraphernalia of the television studio – are similarly put beyond the visual range of the camera. Long before the advent of breakfast TV, artists began to defy cinematic rules such as 'crossing the line'. This was a delineated border beyond which a camera should not stray because, during editing, it would unseat the logical orientation of the gaze within the

geographical space of the set. Artists allowed the camera to cross the line and confuse the illusional space or drift away from the actors onto the set, revealing the pre-fabricated interiors that replicate a domestic environment. In the late 1970s and early 1980s, Stuart Marshall made a series of video experiments that included the deliberate exposure of the set as a simulated construction. He did this, not by showing the edges of the set, as did many other artists, but by tilting the set in such a way that the actors were obliged to stagger to one end only to be pitched the other way as the set swung back. Watching the actors struggle to say their lines whilst maintaining their balance was both comical and instructive. Not only was the set revealed as a critically bounded space but the script was also declared the invention of the artist, one among the myriad televisual fabulations that we so willingly accept as fact.

Marshall developed a form of anti-acting that was very different from the intimate, naturalistic style of other artists. Participants in Marshall's tapes delivered their lines in an emphatic monotone, often speaking directly to camera. These declamations were not unlike the theatrical tradition of epilogues addressed to the audience at the end of a play. As I mentioned, they also borrowed from the exaggerated tones and asides of pantomime, a mainstream form that acknowledges both the artificiality of the performance and the credulity pact between audience and performers across the proscenium arch of the theatre. Marshall liked to frame his performers awkwardly and, in common with Critchley, he often drove them to the limits of their vocal capacity. He once asked me to act in one of his videos and my role was to read the witches' speech from Macbeth lying on my back with the script just out of shot above my somewhat forbidding profile. I had to shriek the text as loudly as possible until I made a mistake or my voice cracked, then I was to start again. The mistakes always came first, but eventually my voice gave out and with it any pretence at naturalism.

Although Marshall went on to make significant television programmes around gay issues, he maintained his experiments with televisual forms. He concentrated on textual delivery influenced by linguistic theories of 'intertextuality' in which the substance of a cultural text is seen to exist only in relation to other texts and is a product of textual commingling rather than the individual creativity of its author. While demonstrably committed to communicating through the moving image Marshall always maintained that 'the meaning of a work is precisely a social construction.'[29]

CASTRATING THE GAZE

Stuart Marshall undermined the realism of acting by making it difficult for his performers to deliver their lines. Other new narrativists announced their work as cultural constructs by revealing the cables, microphones and all the technical

miscellany of video recording. Yet another group of artists began to declare themselves as author/directors, deliberately failing to edit out their directions to the performers. As we saw in *The Cough* (1985) by the Americans Terry Dibble and Peter Keenan, an off-screen director instructs the performer to cough, and cough again, saying 'next time with more feeling'. The agony of witnessing the racking sounds of the artist's cough is all the more disturbing for the fact that the performer is staring straight into the camera. This was a standard new narrative device that breaks one of the cardinal rules of television and film drama, never to look at the camera. By doing so, the performer was deemed to have 'castrated the gaze' as film theory would characterise it. Beyond the Freudian implication of deflated mastery, this means that the performer makes the viewer aware of his/her own voyeurism by returning the gaze. The spectator is caught looking and the gaze becomes an active element in the work. The cloak of invisibility is pulled away and s/he is compelled to take responsibility for scopophilic desires. This strategy was widely used by the first generation of post-structural film-makers as well as by video artists like Marshall, Critchley and Dibble, not forgetting the many women artists for whom the 'male' gaze had long presented difficulties.

My own attempts to problematise the male gaze consisted of staring hard at the viewer through a pair of thick glasses whilst eight months pregnant. *With Child* (1983) appropriates the cinematic convention of blocking the eroticism of a woman's face with the sign of her intellect, the thick glasses of the conventional 'blue stocking'. In the movies, when the spectacles finally come off and the hair tumbles down, the woman is returned to her designated position as object of male desire. In *With Child*, after brief interludes of myopic and self-induced emotional upheaval, the glasses always go back on. I intended to create a subjective position behind the lenses (replicating the objectifying lens of the camera) as a foil to the plenitude of biological meaning in the image of my swollen belly. Although the creation of an image of fecundity was rarely seen at the time and went some way to disrupting the conventional eroticism of a woman's body, the recurring image of the glasses perpetuated the deferred moment of erotic revelation that is always implied by the bespectacled frump. The new narrative always references the old.[30]

STEPPING OUT OF CHARACTER

The direct gaze of *With Child* departed from dramatic conventions that required actors not only to keep their eyes averted from the camera's line of vision, but also to remain in character and in costume. Mark Wilcox was another artist who unravelled dramatic televisual forms, not by abandoning scripts or forced 'acting' but through reconstruction and subsequent deconstruction of familiar televisual and cinematic scenarios. In *Calling the Shots* (1984), Wilcox

creates narrative expectations with actors setting the scene for a well-known Hollywood drama – a re-staging technique that became popular with artists in the late 1990s. Just as the viewer settles into the cosy irresponsibility of spectatorship, Wilcox's actress takes off her wig, pulls away her false eyelashes and speaks directly to the camera. The set, technicians and apparatus of video recording are similarly revealed and, as Wilcox put it, 'Reconstruction becomes Deconstruction.'[31] The following year, the cult American TV show *Moonlighting* was launched and displayed elements of self-reflexivity – the set was stashed away at the end of each episode and the series' TV ratings were discussed to camera. However, the basic realism of the show was not fundamentally challenged whereas Wilcox's performers created an unbridgeable distance between themselves and the parts they were playing by stepping out of the scenario and insisting on their identities as actors. Not only was the fictive nature of 'acting' declared, but the underlying ideologies embedded in the roles the players embodied were also exposed. Wilcox insisted that in *Calling the Shots* he created 'a piece of subliminal agit-prop for the liberation of women and men from stifling social roles'.[32]

THEN AS NOW

In spite of their efforts to reinvent language as a demotic vehicle for artistic expression, new narrativists and early postmodernists might appear to have been trapped in a confrontational relationship with dominant forms of representation. However, in their efforts to wrong-foot the 'loaded' forms of speech developed by the institutions of television and mainstream film, new narrative video artists displayed considerable inventiveness as well as counter-cultural commitment. New aesthetic forms emerged from the project of linguistic deconstruction that could not be reduced either to the objects of their critique or, indeed, to the critique itself. The artists were quick to recognise that in deconstructing language they had reinvented it and opened it to the intrusion of experiences and perspectives that had, as yet, not found a form within dominant representation.

It is now hard to imagine the impact of new narrative strategies on audiences in the 1970s and 1980s. Up until the 1990s, broadcasting was a very formal affair. Great pains were taken to disguise the mechanisms that create drama, current affairs, the news and even game shows. The continuity of an evening's viewing was hard to maintain because of the disruption of advertising, live news programmes and announcements between shows. It was necessary to hold the fractured schedule of viewing together by not deviating one iota from the golden rules of television realism. Video artists broke every rule in the book, and, as has happened with most other innovative art movements, the mainstream was quick to appropriate devices that were originally devised to

attack them. Discontinuity soon became fashionable in pop promos, the camera took flight from the tripod, editing became faster, lighting both more naturalistic and more deliberately artificial. The long-hidden technicians, directors and technical paraphernalia of television studios came into view and programmes like *The Big Breakfast* and *TFI Friday* on the UK's Channel 4 made a virtue of continually referring to the means of television production. This loosening of stylistic modes coincided with a reduction of the content of what was being communicated to safe depths of banality. It is sobering to observe that many of the techniques of contemporary broadcasting originate in often-forgotten artists' cultural interventions, the new narrativists notable amongst them. Their influence stands as a testament to the critical and inventive nature of the artists' initiatives whilst demonstrating the power of mass media to recoup, consume and defuse the most radical of artistic innovations. This story of repossession by the mainstream is one that I shall expand in the next two chapters of this book.

6

Television Spoofs and Scratch
Parody and Other Forms of Sincere Flattery

Unlike earlier work, they do not construct dominant television as an irredeemably 'bad object', but rather attempt to rework modes of representation such as soap opera to their own advantage.
Stuart Marshall

New narrative heralded a less combative phase in British video art, producing a parodic strain that had long existed in the USA where structural materialist philosophies had much less of an impact. Although it was still important to deconstruct the intrinsic codes and implied value systems in mainstream formats, a more playful and interactive relationship with television was consolidated in the mid 1980s, anticipating the convergence of high and popular culture we are witnessing today.

Mainstream television in the 1970s already contained elements of self-parody most obviously in comedy programming. In the previous decade, the American show, *Rowan and Martin's Laugh-In* satirised regular programmes with spoof interviews, ongoing soap melodramas and featured Goldie Hawn perfecting a dramatic self-reflexivity by repeatedly fluffing her lines. Over in the UK, *Monty Python's Flying Circus* plundered established television formats, one of their most memorable parodies being the fragmented 'Alan Whicker' commentaries. Each member of the Python team appeared wearing the black-rimmed glasses and moustache that were so characteristic of the well-known TV presenter, but only delivered two or three of his lines before another 'Whicker' appeared to take up the narrative. Also in the UK, *The Morecambe and Wise Show* specialised in humiliating willing celebrities like Glenda Jackson and Vanessa Redgrave. In fact, an invitation to star in one of Ernie Wise's 'plays' in the 1980s was a sign

that you had arrived as a performer.[1] Television comedians operated like the court jesters of old, blurting out what ordinary citizens could not say without losing their heads. As Freud observed, such jokesters are able to criticise the establishment only obliquely along the 'circuitous paths' of humour when direct attacks are impossible.[2] Small-screen parody exemplified by Morecambe and Wise and the Python and Laugh-In teams was certainly irreverent and allowed viewers to experience vicariously what John Ellis has called 'orders of discourse presented in disorder'.[3] However, their parodic subversions were well contained by the structure of the scheduling that surrounded them and by the predictability of the running gags and humorous situations they created weekly. The comedies themselves were based on an affectionate familiarity with television grammar and served to reinforce the programming conventions they sent up. They also confirmed the celebrity status of those they lampooned or drew into their satirical caprices. Although rooted in conventional narrative structures, television comedy in the 1970s developed techniques – including the fragmentation of identity employed in the Whicker sketch – that are very close to the deconstructive strategies of new narrativists in video and later postmodernists in the wider reaches of fine art practice.

By the 1980s, the Brechtian acknowledgement of the gap between performer and performance was well established in new narrative video as we saw in Mark Wilcox's *Calling the Shots* (1984) in which the actress stepped out of character, removed her wig and false eyelashes and spoke directly to camera. We can now recognise a parallel between these deconstructive strategies and the play within the play that Morecambe and Wise so cleverly manipulated for television audiences. There are convergences between video art and the style, content and counter-cultural impetus of television satire, but the aim of self-parody in television was not so much to raise the political consciousness of audiences, but to entertain and, as Andy Lipman put it, to gently 'prick the bubble of TV's self-importance'.[4]

NOT THE NEWS

In the early 1980s, Wilcox was not alone in appropriating film and television formats to uncouple the false unity of simulation and truth. A British compatriot, Ian Breakwell, tackled the idiom of television news in a spoof bulletin and, by implication, raised questions about the veracity of news reporting. Where Orson Welles' famous 1938 'Mars Invasion' radio broadcast went for maximum dramatic impact, Breakwell's *The News* (1980) deliberately harnessed the banal.[5] The work features a bland-looking newsreader framed in the usual head and shoulders shot, trapped behind a desk with relevant images keyed onto a screen above his head. The only difference here is that the news he reads consists of minute, fictional events occurring in the local community and becoming

progressively more absurd as a group of pensioners persistently disrupt public events. The tape is slow and tedious and delivers its gentle punch over an extended period. It is salutary to observe how Breakwell's elevation of the banal to the status of art has been adopted as a governing principle of much reality TV. We sit through hours of domestic revelations, shopping trips and house renovations and few people now consider it a radical form of spectatorship.

In the context of 1980s broadcasting, Breakwell was able to draw on the everyday to satirise the breathless style in which world events are made to seem like an international soap opera – none more so than in the 2003 'Reality War' that was beamed to our homes from the front line in Iraq. The interminable news reports were artfully packaged by intervals of 'regular' programming that featured documentaries or Hollywood reconstructions of earlier conflicts and made delicate distinctions between justifiable western aggression and the reprehensible, evil intentions of foreigners. In *The News*, Breakwell gave us nothing to package other than the colourless existence of ordinary folk, which in pre-reality TV days would never have made it to the small screen.[6]

ON REPRESENTATION

Breakwell belonged to a new generation of parodic artists who freely appropriated the idioms of broadcasting, importing them wholesale into their work and playing with their conventions. New narrativists aspired to the same degree of verisimilitude of which television was capable – even David Hall's *This is a Television Receiver* (1971–1976) depended on the initial establishment of a recognisable image of a newsreader against which the gradual break-up of the sound and picture made its impact. Where the early modernist video artists dismantled the image to the point of abstraction, new narrative and later postmodern artists who quoted popular culture, employed high-definition realism to achieve their televisual simulations. They created satirical, absurdist or self-reflexive black comedies – within the declared fictional space of new narrative.

Although it embraced a broadcasting language that modernists had rejected, the new narrative, parodic phase of video art harnessed televisual realism to make the same point as the modernists made before them – that television reality, whether high definition studio-lit interviews, dramatised reconstructions or low-grade, subjective reports from extreme environments are all manipulated to normalise and promote the interests of the powers that be. In spite of valiant efforts on the part of national networks to remain independent, broadly speaking, the job of television is to win the hearts and minds of the viewing public and bring them to the 'correct' point of view. The job of artists in the 1970s and 1980s was to interrupt that process by whatever tactical means they had at their disposal.

TELEVISION DELIVERS PEOPLE

Artists like Marty St. James and Anne Wilson in the UK and the Americans Tom Rubnitz and Ann Magnuson, created hymns to cultural consumption, to the viewing process itself. St. James and Wilson delighted in producing pseudo-American soaps, complete with stilettos and swimming pools. As we saw in Chapter 3, Magnuson parodied the experience of the restless viewer, channel-hopping through daytime TV in search of meaning. In *Made for TV* (1984), Magnuson's cast of media characters are interchangeable, from the heroine of a film noir to the *Playschool* presenter – all performed by the artist herself. The meaning of the work lies not so much in the overt content of the piece, but in the image of Magnuson as viewer of her own goal-less meandering through the numerous TV channels already available in the USA. She turns away from life and embarks on a fruitless search for her own identity in the narcissistic hall of mirrors that is television. Here she will find only stereotypes because 'acceptable entertainment has to flatter and exploit the cultural and political assumptions of the land of its origins.'[7] By extension, it must promote the interests of the oligarchy governing that land and not those of alienated individuals represented by Magnuson. The fact that Magnuson only finds her own image in various guises attests to the widespread view among artists that the media were increasingly determining experience – I am what I watch. In the 1960s, the cultural theorist Marshall McLuhan pointed to the social consequences of new communication systems. He observed that the content of a television broadcast was less important than the new viewing habits it engendered, 'the change of scale or pace or pattern that it introduces into human affairs' – this was the real 'message' of any medium or technology.[8] Television dictates behaviour.

If television entertainment contributes to maintaining our conformity to the status quo and fixing our place in the matrix of power relations defining the social order, the function of commercial television is to control our behaviour as consumers. Back in 1973, the American artist Richard Serra made one of the first direct critiques of TV in a declamatory video entitled *Television Delivers People*. The tape consists of a series of captions in which the artist promulgates the view that the primary role of television entertainment, of 'soft propaganda', is to deliver viewers to the 'corporate oligarchy'. A commercial transaction takes place in which the viewer is sold to the advertiser by the networks. And, as Serra observes, 'the viewer pays for the privilege of having himself sold.' Not only is the viewer as consumer controlled by advertising, but, according to Serra's captions, television information is 'the basis on WHICH YOU MAKE JUDGEMENTS. By which you think.' In *Television Delivers People*, Serra paints a picture of the western world in which its peoples are at the mercy of the NEW MEDIA STATE. Once again, we see politics dominated by multinational corporations conspiring with the entertainment industry to exert unprecedented social control for the benefit and profit of those in the driving seat.

COMMERCIAL BREAKS

As we have seen, the overall narrative continuity of commercial television is vulnerable to disruption – first by domestic events in the nation's living rooms, but more importantly by the advertisements themselves and those transitional moments on television in which programme 'links' create a hiatus before the next scheduled item enthrals us once again. In spite of the recent adoption of busy graphics and surreal juxtapositions of images, advertising is still heavily dependent on television realism and conventional narrative forms to get its message across. The underlying discourse extolling the benefits of a particular product must remain clear in order to control viewers' buying habits successfully. Like his counterparts in television advertising, the American video artist William Wegman used realism and enactment to communicate his message. In contrast to advertisers, who seek to communicate the desirability of consumer goods, Wegman's now classic *Deodorant Commercial* (1972) extracts and amplifies the narrative caesurae of advertisement breaks. Wegman's ad begins with a familiar product theme, personal hygiene. The half-naked artist, standing in profile, sprays his armpit with an aerosol deodorant. As the scented mist builds up on his skin, he delivers a rambling monologue on the

15. William Wegman, *(Selected Works – Reel 3) Deodorant Commercial* (1972), videotape. Courtesy of the artist and Electronic Arts Intermix (EAI), New York.

efficacy of the product: 'With this deodorant, I don't have to worry about social nervousness… it keeps me dry all day.' By the end of his very long speech, 60 seconds is a long time in ad-land, the now liquid deodorant is dripping down his body, signally failing to keep him dry. In this work, Wegman neatly fuses the absurdity of his faux naivety in abusing his chosen consumer product with a critique of the commercial exploitation of social conventions that demand a body sanitised of all its natural odours.

Wegman's anarchic brand of pseudo-advertising anticipated television's subsequent development of a postmodern intertextuality that employs references to familiar popular cultural modes. In England we witnessed recently a series of 'Mini-Drama' commercials that accompanied the re-launch of the Mini car. The heroic Mini stars in 30-second epics including a Mini-blockbuster in which the car saves the planet from an alien invasion. Like a joke or a pun, the commercial makes an equivalence between two unrelated cultural phenomena that it knows the viewer will 'get' – in this case the current nostalgia for the 1960s embodied in the revamped Mini and the well-worn Hollywood scenario of alien invasion. The advert draws the viewer into an acknowledgement of a shared cultural heritage and through this cosy commonality the insidious suggestion is made that successful membership of the contemporary cultural scene necessitates the purchase of a new Mini. Where Wegman was careful to avoid narrative closure (the work comes to an abrupt end), advertisements like the Mini-Drama series depend on a repeated denouement to re-orient the audiences' desires towards the relevant product – 'Mini saves the world. The end.' (Buy this car.) By refusing to provide a coherent narrative of consumption, Wegman's tape exposes the dependency of advertisers on narrative conventions to sell their wares, but he also demonstrates the inherent narrativism of television itself.[9] Commercial breaks must conform to the rules of broadcast storytelling in order to suture the syntactical fissures that advertisements open up in the continuity of an evening's viewing. The transition from story to story must be seamless.

It would appear that the more potentially disruptive the television moment, the more strictly the rules of television grammar are adhered to. I have already mentioned the self-reflexive elements in *Moonlighting* that in the 1980s flattered the viewer with knowing references to the set and studio whilst doing nothing to undermine the conventionality of the narrative genres the series employed. In the 1990s, the American series, *NYPD Blue* started aping deconstructive experimental techniques by liberating the camera from the tripod and the lens from the necessity to maintain focus. However, the storylines reverted to tried and tested formulae reinforcing the sanctity of marriage, the superiority of the American way of life, the primacy of Christian values etc. In television hands, the deconstructive techniques of artists soon become mannerisms and, as Caldwell pointed out, are used as visual and conceptual stimuli in a 'ritual of display' to keep the viewer interested in what is invariably a conventional narrative.[10]

The Canadian artist Stan Douglas demonstrated just how disruptive of audience expectations and television priorities images can be once stripped of their narrative infrastructure and ideological roots. In 1991 he made his own mini-dramas in short 30–60-second works. *Monodramas* (1991) are a series of video vignettes in which image and soundtrack are used to set up narrative expectations that are then abruptly frustrated. Like a cross between a drama and an advertisement for the American way of life, *I'm not Gary* sets the scene in a mid-western town, the camera gliding in to isolate the protagonist, a man walking purposefully along the dusty street. A passer-by greets him with 'Hi Gary' to which he replies flatly, 'I'm not Gary' and goes on his way. Douglas himself tells the story that when this narrative non sequitur was broadcast on American television it provoked viewers to call in and ask whether something had gone wrong with the broadcast or whether the video was part of a quiz or candid camera surprise, and was there a prize for spotting it. When informed that the source of such a disturbing broadcast was an artist, viewers sighed with relief and the power of the work was quickly defused.

CORPORATE VIDEO

The corporate video, whether destined for television or the business world, was no less embroiled in dominant forms of televisual representation and attracted the deconstructive attentions of 1980s video artists. In the UK, John Butler, working between art and commercial video, used the skills he obtained in his day job to create spoof corporate videos for the independent video art circuit. *World Peace Thru Free Trade* (1989) is a sophisticated combination of video and graphics based on the cutting edge imaging techniques of the period. The activities of 'Globex', a fictional multinational company, are described through full screen captions intercut with male hands shaking on a deal. These sequences are accompanied by short animations of smooth-edged logos and computer generated objects associated with the extensive commercial activities of the company. We are told that Globex believes in the future, a future based on consumerism and expansion into 'New Worlds, New Markets'. It is no surprise to learn that defence is one of Globex's key activities, specialising in the production of arms up to and including smart bombs. The ersatz company sees no contradiction in developing arms alongside farming techniques for 'rapid fire egg production'. Butler cleverly parodies the style and presentation of 1980s corporate video while exposing the hypocrisy of what he calls the 'libertarian mythology' that justifies expansionist capitalism to this day.

Capitalism, with its infrastructure of factories, offices and shopping malls, has provided the backdrop to many videos over the years. These range from overt critiques of the system to satirical exposés as in John Butler's work. Occasionally, they reinvent the corporate video as a poem to the glassy alienation of the urban

16. Stan Douglas, *I'm not Gary* (1991), videotape from the series *Monodramas*. Courtesy of the artist.

environment, as in Jeremy Welsh's *White Out* (2002). New York's financial district is depicted as a hall of mirrors in which anonymous individuals drift and dissolve into the building's reflecting surfaces. Beyond the sheer beauty of the imagery, Welsh pursues a darker metaphor, that: 'No area of experience remains untouched by the capitalist process of commodification, the accelerated production and consumption of gadgets, entertainment and lifestyles.'[11] Welsh's tape offers an alternative view of the business world as a cold, mechanistic environment. He creates a wordless, meditative aesthetic that would be anathema to the up-beat promotional aims dominating corporate videos.

PSEUDO-DOCUMENTARIES

Where corporate videos proved an easy target for the parodic and poetic skills of new narrativists and their successors, television documentaries appeared to be more resistant to satirical attack, trading as they do on a journalistic adherence to truth and a putative social conscience. In the 1980s, television documentaries became progressively more sophisticated and the public increasingly dependent on broadcasting for knowledge of the world outside their immediate

environment. Not only were far-flung locations and 'exotic' races now within imaginative reach, but the seedy side of life was also gradually coming into view. Delinquency, teenage pregnancies, drug addiction, unemployment and racial tensions were all the subject of well-meaning documentaries that nonetheless found it hard to suppress a disapproving tone in the universal middle-class, male voice-over that tended to exemplify what Tom Sherman called a 'detached state of interpretive control'. Audiences enjoyed the vicarious thrill that arose when the hegemony of the Queen's English was momentarily fractured by the intrusion of regional dialects. With the majority of viewers still assumed to be middle class, the 'right' people could witness the 'other' people submit to every form of moral and material degradation while nervously aware that 'there but for the grace of God go I'. In spite of a new appetite for social realism and working-class culture in UK broadcasting, many marginalised experiences were either misrepresented or excluded altogether from the small screen. Artists were quick to fill the gap with alternative views, often of their own lives now that autobiographical video was well established in a feminist and broader socialist context. At the same time, they were able to reflect on the evolving television documentary tradition itself.

In *Sick as a Dog* (1989), Ian Bourn disowns his proletarian roots declaring that one of the chief reasons he persisted with his education was to get away from the rough crowd he ran with as a kid. Bourn's pseudo-documentary tells the story of a likely lad from the East End of London whose obsession with dog racing proves to be his downfall. Unlike most documentaries of the time, Bourn is the subject of his own social investigation, albeit thinly disguised as the protagonist 'Terry Childs'. Mixing video sequences with text, super 8 film and

17. Ian Bourn, *Sick as a Dog* (1989), videotape described by the artist as: 'The opening shot (Terry with the stadium as backdrop) and the shot of Terry at his lowest point (i.e. worrying about the "legitimate" life of earning money in order to pay it back in taxes).' Courtesy of the artist.

deadpan confidences to camera, Bourn shares with the viewer his knowledge of greyhound racing including his own theories of how to choose a winner. His short-lived 'crap theory' was based on the conviction that a dog relieving itself just before the race will be lighter and therefore run faster. By the same token, a constipated dog would be 'in no condition to race'. This and many other theories turn out to be just that – crap theories – and Childs descends into debt and alcoholism. The work employs a web of references, from the paternalistic social documentaries of the BBC, through the reassessments of masculinity that followed feminism, to the arguments among experimental artists about the relative value of film and video. As Nick Houghton has pointed out, the work also establishes a slow and meditative pace where much contemporary video was obsessed with the new technological 'toys for the boys', with 'vivid imagery and editing tricks'.[12] However, the dog racing imagery Bourn works with is visually rich and highly evocative of a working-class milieu suggesting an ambivalence on the part of the artist who, in character, tells us that all he ever wanted to do was get away from this world and 'better myself'. Where regional accents in spoken English in the UK instantly establish the speaker's class position, it is easy to collapse Childs with his creator. My own reading sees Bourn compelled to return periodically to his roots in order to retain a sense of identity in his newly elevated role as artist.

One of television's chief strategies in the 1970s and 1980s was to create aspirational, mythological figures in the shape of individual celebrities who crystallise the values and reflect the world-view of the state. Artists countered the star system by creating anti-heroes like Bourn's embattled Terry Childs or anticipated reality TV by elevating 'ordinary' people into video stars – in the American Ilene Segalove's case, her own mother. Working in the late 1970s, Segalove recorded a series of interviews with Mrs Segalove, sometimes developing fictionalised scenarios based on her life. Oscillating between conformity and resistance, the middle-aged woman comments on everything from video art to the entertainment industry while her role as a mother reasserts itself with advice to her daughter to ring cousin Barry because 'he'll give you some names.' Mrs Segalove, in dramatising her own life for her daughter, became a video star, even appearing at the Whitney Museum. (It is worth noting that had Mrs Segalove been a candidate for a currently popular celebrity reality show on UK TV, she would have been excluded on the grounds that she was over 40.)[13]

OUTSIDE BROADCAST

Since the 1960s, the star system, populated by media celebrities enjoying varying degrees of success, increasingly contrived to merge glamour with political figures, no more seamlessly than in the iconic image of President Kennedy

of this account, I will not classify these degraded, off-screen copies as direct appropriation. It wasn't until 1979 that the American video artist Dara Birnbaum was able to use the footage in its original form. Birnbaum got herself a job in a TV post-production unit and began 'liberating' footage of the Winter Olympics as well as episodes of Kojak, various American soap operas and Wonder Woman. From these pirated sequences, she created a series of fast-edited video collages, often accompanied by musical soundtracks from contemporary composers like Rhys Chatham. The unexpected juxtaposition of skater and soap opera, TV cop violence and car advertising laid bare the artificiality of the conventions of broadcast entertainment as well as the interdependence of advertising and television programming. These juxtapositions were, in fact, part of a normal evening's viewing, and like the modernist video-makers before her, Birnbaum left out much of the narrative exposition, increased the pace of editing and made visible the joins that TV narrative, within its own time frame, carefully smoothes out.

As part of a much-trumpeted 'New Wave' of American video, Birnbaum's work was first seen at the ICA in London in 1983 and coincided with a new phenomenon that had crossed the Atlantic from New York and exploded in

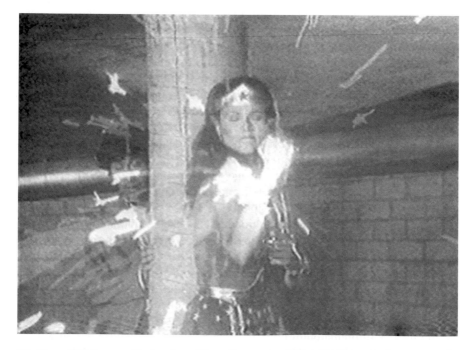

18. Dara Birnbaum, *Technology/Transformation: Wonder Woman* (1978–1979), videotape. Courtesy of the artist and Electronic Arts Intermix (EAI), New York.

London's discotheques and clubs. DJs were beginning to 'scratch' the records they played to create stuttering repetitions that were eventually woven into the music itself, notably in hip-hop music and famously in Paul Hardcastle's song '19' (1985). Reaching no.1 in the charts, '19' was linked to a promotional video that cut together repeating Vietnam war footage, set to a dance beat. The title of the work reflected the average age of soldiers who were sent to fight the red peril in the Far East. Faced with repeating images of explosions and mutilated bodies, it was hard to know whether to weep or get up and dance to the music.

Many artists also drew inspiration from the endless present of found footage film loops as well as the techniques of musical quotation in the work of modern composers from John Cage to Steve Reich. These composers were themselves influenced by the repetitive structures and what Philip Glass called the 'intentionlessness' of non-western music.

Adopting similar techniques of reiteration in *Interlude (Homage to Bug's Bunny)* (1983), Chris Meigh-Andrews re-scanned and looped a fragment of a Bug's Bunny cartoon set on a Spanish galleon. The animated rabbit rushes up and down the stairs and in and out of doors and becomes all the more absurd for the continual repetition of its actions. The artist emphasises the scanning of the eye, camera and cathode ray tube by repeatedly zooming in and out of segments of the image. These camera movements become the focus of interest as the appropriated cartoon is gradually drained of all meaning by dint of pointless reiteration.

Pop exponents exemplified by the Art of Noise were already constructing their music entirely out of digitally sampled sounds and, through artists like Meigh-Andrews, Jez Welsh and Peter Savage, scratch video made its mark in art schools and alternative gallery spaces. In spite of the strands of scratch that drew inspiration from experimental composers, the predominant influence came from the scratched reinventions of pop records developed by DJs like Soul Sonic Force, DJ Shadow and Grand Master Flash who worked in the non-elitist environment of discotheques and nightclubs on both sides of the Atlantic. While artists drew on the new forms of popular music, the music industry appropriated video as its primary promotional vehicle. A new alliance of pop music and video was initiated in the early 1980s closing the gap between art and advertising that narrowed even further in the 1990s. In terms of the UK video art scene in the 1980s, scratch briefly became the current avant-garde. The new generation of working-class identified cultural guerrillas helped themselves to the visual booty, often simultaneously applying their talents to the role of VJ at venues like the Danceteria in New York and the Fridge in Brixton, where Bruno de Florence ran a video lounge.

COPYRIGHT

The fact that scratchists were stealing footage was, to their radical eyes, an added bonus. Flaunting copyright laws was considered to be a political act and complications only arose when scratch video began to enjoy some art-world recognition. In 1985 Channel 4 wanted to broadcast examples of scratch and some works had to be excluded because it was impossible to obtain clearance from the originators of the footage. The right of quotation in print had long been enshrined in law but, as Rod Stoneman discovered, 'when artists enter the public space of broadcasting, they discover that every sound and every image and every storyline is owned.'[16] It would be reasonable to assume that cost was the main deterrent to quoting other programmes, but even the well-resourced satirical show *The Friday Alternative* had to fight a legal battle to establish the right to screen extracts from ITN news bulletins. Although it was expensive to get permission to use news footage, only established broadcasters or producers were granted access. Programme-makers were afraid that they would be debarred from crucial news conferences and media events if they did not tow the party line and re-use the footage with its original intentions intact. As Jon Dovey concluded, 'the control of access to news images itself constitutes a powerful if indirect form of regulation.'[17] The ownership of images was now being contested from within broadcasting, but more critically from outside by Promethean cultural guerrillas. Emboldened by the Marxist principle that property is theft, and armed with the appropriate technologies, scratch artists flagrantly broke the law and plundered the cultural moving image bank. Perhaps the final irony was that in the 1980s, scratch did occasionally make it onto the small screen, but only when commissioning editors like Rod Stoneman persuaded the broadcasters that this was 'only art', and therefore politically harmless.

POLITICAL SCRATCH

For some scratch artists, cultural resistance in the shape of image piracy was not enough. Like earlier generations of political propagandists exemplified by the graphic artist John Heartfield, they wanted to enrich their montages of appropriated sequences with direct political content. Where Heartfield added bleeding axe-blades to the four points of a swastika in a photo montage and Ridley turned footage of goose-stepping storm troopers into a chorus line, artists like Peter Savage, the Duvet Brothers and Gorilla Tapes learned to twist words, distort images and force public figures to say the opposite of what they intended. Sometimes it was enough to reduce them to gibbering monkeys by speeding up the footage or making nonsense of their platitudes with rapid-fire repeat edits. But in *Death Valley Days* (1984), Gorilla Tapes re-assembled diverse off-air clips of Ronald Reagan addressing public meetings and, by using

19. Gorilla Tapes, *The Commander in Chief* from *Death Valley Days* (1984), videotape. Courtesy of Jonathan Dovey.

precision editing, compelled 'The Commander in Chief' to condemn his own country as the 'focus of evil in the modern world'.[18] The origins of the footage are instantly identifiable and the satirical inversion the artists contrived to make Reagan perform works all the better for knowing what he actually meant to say. In this mordant political montage, the authority of news footage is destabilised while certain elements of duplicity and hypocrisy in American foreign policy are exposed. Agitational scratch differed from television-generated parody in that it took up a clear political position representing collective opposition to state policies in general and Margaret Thatcher's and Ronald Reagan's in particular. Although the right to speak might appear to be a guiding principle in current affairs programming, the nature of 'balanced debate' ensures that any dissenting voices like those of Gorilla Tapes tended to be drowned out by state apologists and other left-of-field views. As Jez Welsh has pointed out, shows like the satirical puppet show *Splitting Image* in the UK were encouraged because they confirmed the illusion that in a western democracy freedom of speech is an inalienable right.[19] Television itself was obliged to remain impartial

and show all sides of an argument. Even programmes like *Spitting Image* had to lampoon politicians from all political parties equally and never actively entered any debate.[20]

Some commentators saw political scratch as the populist arm of community video.[21] However, internal contradictions arose when the glamorous aesthetics of the pop video were too thickly overlaid onto political sentiments. Many artists accompanied their video découpages with pulsating disco beats that, like '19', left the viewer wondering whether she should write to her local M.P. or throw a party. However, the barbed attacks that works like *The Commander in Chief* succeeded in launching against the combined forces of party politics and the media constituted evidence that resistance was possible in the midst of the misinformation overload. Gorilla Tapes would appear to confirm McLuhan's view that the role of the artist is to tackle the medium 'with impunity' and, through acute awareness of the media's power to manipulate the senses, resist the mental restructuring forces of technology.

OPTICAL SCRATCH

Like the modernists and structuralists before them, scratch artists used optically disruptive techniques to confound the narrative intentions of the programme-makers from whom they stole. Repetition and abstraction once again played a role in a video art much enhanced by the new palette of visual effects developed by Sony and others. (There was always a slight irony in the fact that video artists were dependent on a multinational corporation to critique a capitalist system.) With analogue editing, it was now possible to separate sound from its picture source and shuffle audio and video at will. The new Quantel technologies offered effects like keying, colourisation, superimposition and fracturing as well as slow motion and the various tricks of later digital image processing such as picture wrapping and animation. Once again a psychedelic element entered UK video art, a mind-expanding, optical play overlaid with a surrealist delight in visual illusions that was also evident in North America and Europe. At times this was raised to the level of visionary inventiveness as in the work of George Barber, Terry Flaxton and Penny Dedman in the UK, Robert Cahen in France and Peter Callas in Australia. At times it descended into a kind of video pattern painting that, in the case of scratch, differed from earlier electronic abstractions only in that the material to be painted, solarised and atomised was once-familiar mass entertainment.

Artists like John Sandborn in the USA and Jez Welsh in the UK achieved a harder brand of abstraction that quickly surpassed the visual disturbances that were so easy to create on film. Using the latest editing techniques in *IOD* (1984), Welsh creates a sensory overload in a vortex of spinning, repeating and flashing video clips, offering a vision of a dystopian digital future in which individuals are at the

mercy of a technology gone mad. In terms of the image, the frenetic looping drains the original television footage of cultural meaning, leaving an optical structure referring only to itself and inducing the *mise en abime* or crisis of meaning that Foucault advocated to undermine conventional forms of knowledge. The courting of incoherence and madness in obsessive-compulsive repetitions pushed over the edge of rational representation any television performers who got caught in the maelstrom. In terms of the televisual experience, the reduction of broadcast content to visual and conceptual delirium made it impossible for the viewer to consume the habitual objects of desire paraded daily on our television screens. The theory was that in denying viewers their quotidian escapist fix, Welsh forced them to consider their own addictions and the passivity of their viewing habits. This is not to say that Welsh and other scratch artists of the period wanted to destroy television – principally, their aim was to expose its artifice. Nevertheless, they clearly enjoyed the visual tricks they devised and relished stirring things up with their new electronic toys. Undeterred by disapproving feminists like myself who might have wanted to spoil their games, artists such as John Scarlett-Davis not only appropriated the narcissistic subjects of postmodern television in lengthy celebrity interviews, but unashamedly exploited the superficial glamour of the star system. Scarlett-Davis, himself a professional promo director, defiantly admitted his postmodern affiliations: 'I'm a sensationalist. I reflect the surface of people who live entirely on the surface of themselves.'[22] If the social critique implied in these works was sometimes compromised by the artists' own seduction by the media, the tapes were nonetheless indicative of the extent to which the younger generation was being formed by the pervasive images of glamour and celebrity that were increasingly permeating both the domestic and the urban environment. They also offered a model of cultural resistance through the re-appropriation of media imagery and its transformation into new artistic forms.

Kim Flitcroft, Sandra Goldbacher and the Duvet Brothers were among the UK artists who maintained a more critical distance from the material they appropriated whilst still celebrating the new formal possibilities of video découpages. Using only the simplest of means, the Duvet Brothers created *Laughing Girls* (1984), a short visual poem on the laughter of women. The tape loops and repeats unidentified footage from the 1940s featuring a row of laughing girls. The wave of convulsive mirth flows back and forth through the women, uniting them into one gleeful, feminine body in a state of emotional release. What made these girls so helpless with laughter is never revealed and questions as to the object of their derision can be variously interpreted, while the work clearly makes reference to the films of Laura Mulvey such as *Thriller* (1979) in which the transgressive power of women's laughter is made manifest. The use of non-verbal expression also theoretically avoids the old dilemma of cultural positioning within language and returns the viewer to the 'unmarked' agency of the body. Working with horror movie footage, Kim Flitcroft and Sandra

Goldbacher similarly implicated the power of the body and brought out the dangerous association of women's sexuality with devil worship. These themes were already inscribed in the original films the artists plundered but, with the shifting of emphasis that scratch could achieve, Flitcroft and Goldbacher were able to reposition the (mostly male) fear of female sexuality as the central theme of the work.

PLAYING COURT JESTER TO THE NETWORKS

To a large extent, artists like Flitcroft, Goldbacher and the Duvet Brothers went a long way towards avoiding one of the pitfalls of re-appropriation, namely the unintentional corroboration of the ideological messages inscribed in the original footage. These can prove surprisingly tenacious and survive the cutting-up process, particularly where the footage is recent and part of the contemporary visual landscape. This is an old problem of representation in counter-cultural practice and also touched new narrativists like Tom Rubnitz and Ann Magnuson as well as feminists, any one of us. Magnuson's clever send-ups of TV divas needed to convincingly replicate the original stereotypes and performance modes to achieve the desired comedic effect. Once again we revisit Lucy Lippard's 'subtle abyss' into which political critiques reiterating the images they are attempting to deconstruct can easily fall. Many scratch artists made no attempt to transform or problematise the stereotypical images of women and ethnic minorities they appropriated. For 1980s feminists, this meant witnessing a resurgence of conventionally eroticised representations of women – representations they had so assiduously avoided before scratch relaunched them, albeit in pieces. This caused a generational rift, with the younger women attempting to break away from the academicism and what they regarded as censorship of female imagery by older feminists who in turn saw all their hard work on the problems of representation rapidly unravelling.

As I suggested in relation to John Scarlett-Davis, scratch video-makers, even when they took up an oppositional stance, often betrayed the same affection for the original that underlies much television comedy. This made it easier for consumer culture to recuperate counter-cultural initiatives. The speed and enthusiasm with which scratch was re-appropriated by pop video and advertising was partly due to its suitability to turning a profit. Scratch techniques amazed the eye where the product or brands in advertisements were said to enchant the ear, smell, taste or touch. Sandra Goldbacher observed that the mainstream contrived to steal 'the speech of experimentalism, emptying it of meaning and using it as a chic throwaway and ultimately exhausted cliché'.[23] As the 1980s gave way to the visually promiscuous postmodern 1990s, it became hard to distinguish scratch from the new relaxed style of 'yoof' television. From the late 1980s, television, music videos and advertisements clearly appropriated the

visual styles of artists and the charge that scratch had been reduced to paying playful homage to the master became hard to dispute. With imitation as the sincerest form of flattery, scratch, like new narrative television parody before it, was recycled by the very institution and attendant ideologies from which it had been stealing. As Barthes observed, 'a code cannot be destroyed, only "played off".'[24] Appropriation had now come full circle.

Scratch's addiction to sparring with broadcast television meant that a certain conceptual looping also compromised its practice. Underlying early scratch video lay the belief that, in the western world, we are subject to information overload and image pollution aggravated by 24-hour, multi-channel broadcasting. But the scratchists' efforts to free themselves from the hegemonic influence of television was hampered by the fact that they were doubly bound by television material, first as viewers and then as artists, dependent on the same visual pollutant as both source material and creative inspiration. There was a danger that they would become as tied to what they were deconstructing as the passive consumer they were trying to re-educate was hooked on the telly. As we have seen, the underlying ambivalence of scratch artists towards their material is a feature of any critical practice in which an artist is both seduced and repelled by what s/he is critiquing. However, scratch's love-hate relationship with television does not constitute grounds for dismissing its achievements. The absorption of image layering, repetition and other scratch techniques into the mainstream has been so total that to contemporary eyes the visual feasts that these artists concocted may look crude and politically ineffectual. However, in the 1980s, it was a shock to see the 'sacred' images of television so abused and the celebration of technology implied in their vertiginous editing, fragmentation and transposition techniques was a challenge to an art world still unwilling to renounce the modernist love affair with traditional art materials. Scratch's populist approach to image making was also a healthy antidote to the conceptual acrobatics of a 1970s avant-garde, steeped in theory.

If anything, scratch signifies the beginnings of a paradigm shift that became more marked in the 1990s. Where the history of art once provided the principal point of reference for contemporary art, the iconography of popular culture, its techniques and aesthetics as well as its proliferating viewing contexts, became increasingly significant in the theory and practice of art. Although the precursors of scratch are clearly identifiable in both experimental film and the cultural collages of 'junk' artists like Kurt Schwitters and Joseph Cornel, not to mention Heartfield and the Cubists before them, television appropriation reflects the relocation of artistic creation to the broader cultural sphere and anticipates the convergence of art and popular culture in the 1990s.

A NOTE ON DEMOCRACY AND DEFYING THE ART MARKET

There is another argument to support the radical credentials of scratch, based on its anticipation of the dramatic developments in telecommunications that transformed the 1990s. Writing in 1986 with notable prescience, Andy Lipman saw scratch as an attempt to create a truly interactive, two-way electronic communication system and envisaged a future 'network resembling the telephone system, where calls, or programmes, or computer software could both be made and received by each individual'.[25] With free access to this inter-net, everyone could become a video artist, individuals creating works that were tailored to their own needs. Not only would this populist electronic art break the monopoly of broadcasting by commandeering its output, but a new interactive cultural democracy would also call into question the elevated status of the artwork as well as the elitist position of the artist. The dependence of the art market on unique objects would be undermined as video artists in general, and scratch artists in particular, regularly produced unlimited editions of their work with little or no scarcity value. This followed the earlier commitment of conceptual art to the dematerialisation of the art object and the replacement of art by life in performance art.

Since the advent of scratch in the 1980s, the utopian vision of a democratised media landscape peopled by creative individuals wielding digital cameras and desktop-editing systems has faded somewhat. I tend to subscribe to Jez Welsh's view that immersion in technology can induce in users 'a controlled state of un-reality' and deflect them from involvement in social initiatives. The image of the teenager or even adult spending hours lost in aimless Internet wanderings suggests that whatever freedom of information and access to the wider world technology offers, it also cuts off the user from social and physical contact with the immediate environment. Whatever the consequences of immersion in technology, it is clear that, for artists, visibility and exhibition context are key to the effectiveness of scratch-style cultural interventions. As with contemporary net art and other forms of oppositional practice, the problem of funding and critical visibility is still as pertinent as it was in the 1980s. Artists working within a political framework are faced with the contradictory need to make a living and remain independent of the regimes that they are committed to oppose. Whatever its internal contradictions and ideological problems around developing a critique whilst maintaining visibility, scratch must take the credit for being the last UK video movement that was allied to a collective social and political consciousness before the 1990s made the selling of the artist the central purpose of art.

7

Video Art on Television

... some people went to galleries, but everyone looked at television.
David Hall

ALTERNATIVES TO TELEVISION

Video artists' antipathy towards television did not obviate the need to disseminate their tapes and with socialist zeal informing much work of the 1970s and early 1980s, artists sought a wide and heterogeneous audience. Where the new narrative and scratch phase of video offered an alternative to the content of television, radical strategies for independent production and distribution were now devised to create a parallel system of access to moving image art.

In both North America and in Europe, artist-run video centres were founded. Electronic Arts Intermix in New York, Montevideo in Holland, Vtape in Toronto, London Video Arts and Fantasy Factory in the UK are examples of collectives that offered cheap equipment hire and post-production facilities. Most also undertook distribution to film and video festivals, alternative, artist-run spaces and art schools.[1] In the UK, the art schools themselves made a substantial contribution to early video culture. They allowed artists to use school facilities at night, offered residencies and employed individuals on a part-time basis to support their practice. Art schools within Reading University, Lanchester Polytechnic and Sheffield Polytechnic ran annual film, video and performance festivals in which students showed alongside practising artists. Over in the USA, artists' work was hosted by educational establishments like Washington University, the School of the Museum of Fine Arts in Boston where Charlotte Moorman made work and Syracuse University where Bill Viola was a student.

An independent distribution network was set up in the burgeoning world of community video. The Raindance Corporation in New York co-ordinated a databank of community tapes and in the UK a group of franchised workshops

was partly funded by the newly formed television station, Channel 4.[2] In the UK, projects like the *Miners' Tapes* (1984) involved artists including Mike Stubbs, Roland Denning and Chris Rushton collaborating with trade unionists and the miners themselves in their struggle to halt the government programme of mine closures. Together, they created a view of the miners' strike that was absent from the mainstream media, which by and large supported the Thatcherite view on the mine closures. ACTT, the television technicians' union, volunteered to document events and these recordings together with those of artists formed the basis of the *Miners' Tapes*. Although fragments appeared on television news bulletins, they were never shown in their entirety. Instead, they were disseminated through the unions and independent distributors and were seen by wide sections of the working population as well as by art audiences. Mike Stubbs, whose own work tackled political issues, found himself with a foot in both camps: 'There was a clear (if artificial) split between those using media to create social change informed by ideology and those wanting to tell stories or experiment with the medium/ia.'[3] The political effectiveness of the *Miners' Tapes* was perhaps limited as Roland Denning suggests: 'Maybe they helped a little with pockets of solidarity, but probably not much in the end.'[4] However, they proved the effectiveness of alternative methods of production and distribution and crystallised the ambitions of artists like Stubbs to combine art and politics in the context of a widely available and democratic video art. Unlike the 'balanced' view of most television documentaries, Stubbs and Denning were able to take a clear position in relation to the miners' plight, bringing their work close to the status of a political act rather than simply carrying out a gathering of news. In addition, the artists were able to experiment with visual styles that were beyond the palette of existing television formats and put them to the service of their own political convictions.

ARTISTS ON (THE MARGINS OF) TELEVISION

In England, as in the USA, there were artists who saw television as a potentially democratic medium, a medium of the masses. They remained optimistic that it would be possible to change the system from the inside if only they could gain access. Beyond large audiences, television offered other inducements to artists. In the 1970s and early 1980s, video was still an expensive medium. For most video artists, it was a struggle to gain access to what Laurie Anderson called the 'million dollar paintbrush'. Before the advent of affordable digital cameras, only television could deploy large production budgets and offer access to high-quality, multi-camera facilities. When Channel 4 was founded in 1982, the largest production grant the Arts Council of England was offering was £6,000. The basic, second-hand series 5 edit suite I bought five years later cost £5,000. An ACE grant didn't go far.

Although many would be quick to deny it, American artists were rather better funded than their British counterparts. They were more successful in gaining access to broadcasting in the USA, although few conquered the major networks. However, in the 1970s, American public service broadcasters opened their doors to artists, as did cable networks, none of which existed in the UK at the time. Since these networks were set up to serve the community directly, any qualms American artists may have had about selling out were dispelled by the educational and democratic principles underlying cable and public access programming. As early as 1969, the public TV station KQED in San Francisco created a National Centre for Experiments in Television and WGBH Boston broadcast a programme of artists' tapes under the title, *The Medium is the Medium*. The work was drawn from an experimental workshop funded by the station and included a contribution from Nam June Paik in which he gave instructions for viewers to close their eyes at certain moments and then to turn off the TV. Paik claimed to be intimidated by television studios: 'Big TV studio always scares me. Many layers of "Machine Time" parallely (sic) running, engulfs my identity.'[5] However, at WGBH he overcame his reticence and was given a free hand to experiment bringing in a number of specially doctored TV sets that would modulate the output of the studio cameras.

Concurrent with Paik's collaboration with WGBH, Gerry Schum created his infamous, but short-lived, *Fernsehgalerie Gerry Schum* on the network WDR, in Cologne. Schum broadcast works by artists from Germany including Rinke and Walther as well as Land Art by the likes of Richard Long and Barry Flanagan, but the work that is best remembered is British artist Keith Arnatt's *Self-Burial* (1969). Over the course of a week, Arnatt broadcast a series of still photographs showing the artist slowly sinking into the ground. These images appeared unannounced while the soundtrack of the interrupted programme continued. Only the image was substituted. Not only did the artist bury himself in the ground, but he also sank his images into a fragment of the broadcasting stream, transforming it, but not entirely obliterating it. Over the seven days, Arnatt both mimicked and disrupted the conventional continuity of a serial that attempts to secure the audience's viewing loyalty through a slowly unfolding narrative.

TELEVISION AND ARTISTS IN THE UK – A RELATIONSHIP OF MUTUAL SUSPICION

Paik's freedom to intervene in the workings of a television studio and the output of television transmitters was not initially shared by video artists working in the UK. Both the BBC and the independent channels were suspicious of the barbed works produced by early practitioners. As Mick Hartney pointed out, 'it soon became clear that access to video was not necessarily the same as access to television.'[6] Broadcasters were unwilling to let artists into their studios and

tamper with their finely tuned equipment. As we saw in Chapter 2, artists had long interrogated the technology through its faults, those moments when televisual realism gives way to image distortion and ambiguity – a nightmare for the highly skilled UK television technicians. The engineers' professional antagonism to 'low-grade' artists' video was echoed by the unions who were afraid that cheap artists' products would threaten their members' jobs. When offered artists' tapes for broadcast, most networks refused on the grounds that even when stabilised through a time-base corrector, the image produced on semi-professional equipment was of such poor quality that it would jam the transmitters. Broadcasters were also developing an anxiety about TV ratings, arguing that artists' work would attract too small and specialised an audience, and could not justify the high cost of studio time. Mark Kidel has suggested that the networks, the 'grammarians of mass communication', were also being protective, fearing that artists would contaminate the dominant codes of entertainment they had created.[7]

Broadcasters' reluctance to open their doors to radical elements was not improved by two infamous television guerrilla actions in 1970. The self-styled 'Yippie' Gerry Rubin, whose Youth International party had organised anti-Vietnam street demonstrations in Chicago, hijacked the David Frost Show with a gang of his friends and his own portable recorder. In a separate incident, feminists threw flour bombs at Bob Hope in response to his offensive jokes as compère of the Miss World competition beamed live to 25 million viewers from the Albert Hall.[8] This was beyond the pale. Television was and, in spite of phone-ins and TV shopping, still is predicated on a one-way flow of information. As Baudrillard pointed out, television speaks 'but in such a way as to exclude any response, anywhere'.[9] Like the anti-war activist Gerry Rubin and the feminists at the Albert Hall, artists' television interventions were designed to rupture the impenetrable surface of broadcasting and elicit creative responses in the viewer or, as David Hall puts it, to 'worry the borders of televisual language and its preconceptions'.[10] In the early 1970s, artists wanted to wake up the habitually comatose viewers of television. For their part, the networks were in the business of pacifying and maintaining the public's appetite for consumer goods. In the UK, at least, video art and television appeared to be locked into irreconcilable differences.

However, a few intrepid practitioners did penetrate the citadel of broadcasting. In 1969, John 'Hoppy' Hopkins founded the experimental video group TVX and initially showed its tapes on a stall in Portobello Market in London. Inspired by the success of North American artists in experimental TV projects and Gerry Schum's broadcasts in Cologne, TVX persuaded BBC2's Late Night Line-Up to use footage they had shot of a police raid on the offices of the art organisation, New Arts Lab. TVX later developed visuals to accompany music tracks for the BBC2 programme Disco 2 but were silenced by the clean-up-TV campaigner

Mary Whitehouse when they included a 'White Panther' clenched fist salute in one of their broadcasts.

David Hall was the first artist to inject pure moving image art into the monolithic presence of UK television entertainment. In 1971, Scottish Television commissioned a series of his 'television interruptions', short black and white episodes, dropped into the schedule unannounced. In Scotland, Hall enjoyed the perhaps unique experience of broadcasting his work unseen by his sponsors. Hall's *7 TV Pieces* included a short work in which a tap appears to fill the TV set with water. This witty illusion heightened awareness of the box as a three dimensional object and one that, in spite of its glass front, could easily spring a leak. Like Arnatt, Hall became the infiltrator who, once embedded in the lion's den, questioned the values of television, indirectly, with conceptual jokes. Hall bypassed the technical drawbacks of early video by shooting his interventions on 16mm film and succeeded in persuading his producers to air the pieces without any contextualising documentary or comment. Like a true guerrilla tactician, he remained anonymous, refusing a credit at the end of the programme. As he commented recently, the doors to television opened to him in 1971 and promptly closed to all artists for the next ten years.

CHANNEL 4 AND BBC2

This situation was alleviated by the occasional documentary like the 1976 survey of artists' video on BBC2's *Arena: Art and Design* programme. It was the first to broadcast Hall's classic *This is a Television Receiver*. However, the situation in the UK changed dramatically when the closed shop of television was broken by the founding of Channel 4 in 1982 under the directorship of Jeremy Isaacs. With a mandate to provide innovative programming in both form and content, the new channel created a dedicated artists' film and video department. It subsidised production workshops across the country, including the artist-run distributor London Video Arts. John Wyver, who worked closely with Channel 4, points out that Canal + in France, PBS in Boston and ZDF in Germany also supported artists' work around that time, but, as Channel 4 commissioning editor Rod Stoneman says, 'in terms of the level of money, airtime and sustained engagement I'd stand by the way I put it in Mike O'Pray's book: *the first decade of Channel 4 constitutes a considerable experiment with experiment – the largest body of avant-garde work shown on network television, encountering its widest audiences, anywhere, ever.*'[11] Channel 4 was certainly unusual in that it commissioned and broadcast an international body of experimental work from mainland Europe and North America as well as films and videos indigenous to the UK. Artists' input may have been modest in terms of their share of the channel's total output, but it was substantial when seen against the obscurity in which artists' video had existed until then. Because of

THE SCULPTURAL APPROACH

A number of artists broadcast works that emphasised the object-ness of the television set, its physical dimensions echoed or subverted in the illusory space suggested by the image. Where David Hall turned the television set into a water tank, the German artist Klaus Blume created a series of surfaces within the screen-frame, equivalent to the internal walls of the television set, but subject to an illogical perspective. In *Touchscreen* (1987) the arrangement of planes in the image is reiterated by the repetitive, syncopated slapping of a hand on each surface culminating in a hefty blow to the screen itself. For a second we take the impact to be real and wonder if the artist is about to break through the glass into our sitting rooms. This reference to television's glass partition, transparent and opaque, illusory and real has been revisited in subsequent video works and was eventually adopted by television itself as a device in programme links and advertisements. In the current Esure car insurance commercial on UK television, an actor taps on the screen as if to tell us he knows we are there and underinsured.

Hall and Blume are rare examples of video artists who have addressed the physicality, the ontological presence, of the television set in broadcast work. Perhaps one of the most potent videos of this nature was a seven-minute piece, made for the *TV Sculptures* series on Channel 4 in 1996 by Anish Kapoor. *Wounds and Other Absent Objects* transforms the television set into a box containing pure colour. A shimmering sun in the middle of the screen slowly metamorphoses from black to orange to blue taking on varying degrees of three-dimensionality and emphasising the sculptural presence of the set itself. Where television meaning is carried principally on the soundtrack, Kapoor eradicates any narrative elements and makes abstract sound as tangible as the colour, returning us to our own physical and emotional response to both elements. In his *TV Sculpture*, Kapoor attempted to change the grazing viewer into a meditative participant in a quasi-spiritual communion with the solid presence of both colour and the television cube that contained it. In an interview, he advised the viewer to 'switch off the lights, turn up the volume, sit back and watch.'

The interview formed part of a mini-documentary prefacing the work. Kapoor was seen in his natural habitat, the sculpture studio. The heavy contextualisation of the work was no doubt deemed necessary for an essentially abstract work. Few purely abstract videos ever made it onto the small screen other than in specialist programmes on animation or abstract cinema. Abstraction and narrative disruptions introduce elements of ambiguity that are fundamentally antithetical to television realism. As we saw in the last chapter, in order to hold the viewer, television must fix meaning so as to avoid ambiguity and counter what Roland Barthes called the 'terror of uncertain signs'. Artists were never allowed to overstrain the narrative expectations of the viewing population.

SURFACE DISTURBANCES

In spite of the contextualising preamble, Kapoor attempted to lure viewers onto a higher plane of colour and space perception. Other artists who made work for television were committed to experimenting with the surface of the televisual image, treating it like a canvas onto which ever-more elaborate visual effects could be deployed. George Snow's *Muybridge Revisited* (1988) combined animation techniques and colour enhancement to create an exuberant homage to the pioneering photographer. David Larcher's *Granny's Is* (1990) built up multiple layers of images to suggest the psychological complexities of his relationship with his grandmother. Perhaps the most accomplished formal experiment on television was the American Dan Reeves' *Obsessive Becoming* (1995), a family odyssey that exploited the recently developed morphing techniques to fuse generations of his relatives' physiognomies into one genus of Reeve.

To a greater or lesser degree, all these works created surface disturbances to the screen image. Before interludes of flying graphics became standard between television programmes, these artists insisted on the two dimensionality of the screen. By contrast, television encourages us to suspend disbelief and perceive a three-dimensional world stretching out behind its display frame whilst ignoring the impossibility of such a space existing inside a small box. Given the scale of the television set in the context of the average lounge, a busy, patterned screen would perhaps return the viewer to the space in which s/he exists, the lively abstraction confirming the set's physical status as a more or less attractive aspect of the decor. In fact, it is now possible to purchase tapes of fire in the displaced hearth, or fish in a bowl that can be played continuously to integrate the television more effectively into the domestic environment. Although they were often innovatory and pleasing to the eye in their optical acrobatics, like scratch before them, these effects-rich artists' videos came close to their commercial counterparts that were themselves beginning to experiment with visual effects. Pop promos were fragmenting, looping and colourising and commercials like the Smirnoff ad were bending reality with the same morphing techniques that Reeves employed.

LANDSCAPE

By the 1980s, UK television had absorbed the image of the English landscape into its vocabulary as a reference to a Romantic tradition that was under threat from the advent of punk and youth cultures that had little use for their parents' pastoral nostalgia. In 1990, Channel 4 screened *The Art of Landscape* every morning for a hundred days. Between 9 a.m. and 1.30 p.m., it was possible to see rural rides through the West Country and wordless bird's eye flights over the Lake District. *The Art of Landscape* quickly moved to cable and, overall,

landscape imagery on television became contained within wildlife documentaries and travel shows or provided backdrops for films and dramas set in rural or exotic locations. When the landscape occasionally formed the subject of a programme, it was always accompanied by over-interpretative commentaries, leading the viewer to fixed readings of the natural or man-made landscapes depicted. For fear of losing the erratic attention of the viewer, a landscape was rarely allowed to present itself to the eye of the beholder unchaperoned.

Since the early days of video art, landscape has been a significant theme in the media artists' portfolio as it had been in that of the painter. Some video-makers, including Mary Lucier and Bill Viola in the USA, turned the camera onto the landscape in the spirit of 1960s environmentalism and used technology to reveal the destruction for which technological advance was largely responsible. Others, like Chris Meigh-Andrews in the UK, created video landscapes in the gallery, drawing out analogies between the flow of natural energies and the flow of electricity through the video apparatus. These works lamented an urban lifestyle that Tom Sherman found 'further removed from a direct relationship with the non-human aspect of the natural world every single day'.[15] Later, artists like the Canadian Stan Douglas configured the landscape as a repository of human history with colonialism as its most shameful episode. In the 1980s, a number of women video artists, including Mary Lucier, Zoe Redman and Helen de Witt, pioneered what they called a 'psychogeographical' approach to landscape.[16] Their intention was to discover means of expression for women that avoided the tainted realm of eroticised body imagery. Landscape was, by and large, gender neutral. By the twenty-first century, nomadism had become a way of life and notions of personal and national identity could be interrogated by way of the landscape people travelled. The video journey for the westerner became a means of discovering unfamiliar landscapes, while recent and second generation migrants retraced ancient and more recent escape routes from troubled third world countries. With its ability to record continuously for up to an hour, video offered a temporal congruence with the extended duration of these pilgrimages and odysseys. Little of such work reached the small screen in the early days although one of the first artists' video broadcast by Channel 4 was Robert Ashley's opera *Perfect Lives (Private Parts)* (1983–1984), directed by the Americans John Sandborn and Mary Perillo. This elegiac road movie sat comfortably within the tradition of the great American open-road narrative, but used the gamut of video effects available at the time to create a visual feast with travelogue.

Channel 4 went on to broadcast a video that diverged substantially from conventional representations of landscapes within televisual narrative structures. *The Reflecting Pool* (1980) remains one of Bill Viola's most potent landscape works and was screened as part of the 1985/88 Illuminations series, *Ghosts in the Machine*. Television now habitually adopts a roving camera

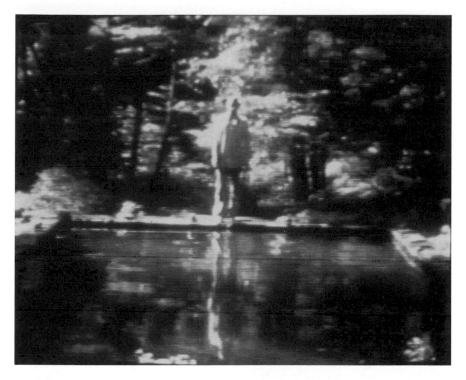

20. Bill Viola, *The Reflecting Pool* (1980), videotape. Courtesy of the artist.

to hold attention and accentuate the voyeuristic pleasures of eavesdropping on others' lives. By contrast, Viola locks the camera into a single position, reflecting the pictorial traditions of landscape painting that employed deep-space perspective anchored to a monocular viewing position. The view he reveals is of a woodland landscape within which a man-made pool sits impassively. Like Kapoor, Viola eschews the ever-present narrative hook of television and the audio track carries only the ambient sounds of the natural environment. Viola deploys silence as a substantial element in the work, revisiting the 'dead air' of broadcasting that no longer exists in an era in which television never sleeps. In this quietly breathing, verdant tableau, a modern day Adam slowly approaches the pool. In his primal nakedness he stands resolutely at the edge for what seems an eternity before taking a giant leap. The leaper is then arrested in mid air, frozen in the landscape and slowly, very slowly dissolves back into the foliage from which he emerged. The pool itself now takes on a magical life of its own, at times reflecting the vanishing man, at times a dark sky, whilst the surrounding pool remains well lit by a midday sun. The slight interferences, the keying of one condition of the landscape into another, the compression

and combination of different time frames, all acknowledge the mediation of both the artist's subjectivity and the apparatus that he uses to bring us this illusory rural view. The figure-ground relationship of traditional representations of space is disturbed by the ripples from the impact with the water that we never see – there is no causal body to make sense of the patterns animating the surface of the pool. In the spirit of the pastoral tradition of landscape painting, the work seems to suggest a harmonious, even spiritual relationship between humanity and nature. Both are subject to the same cycle of dissolution and renewal, a connection we have lost through urban living. It might also point to the indifference of nature to humanity's presence and its ability to outlive our sophisticated yet ever-destructive vanities.

The sense of nature's revenge was more apparent in another landscape work from the USA, broadcast by Channel 4 and Illuminations. The dry and unforgiving landscape of the Pyrenees was the setting for Dan Reeves' lyrical *Sombra y Sombra* (1988). Derelict buildings, discarded shoes and toys are all that remain of a remote community in the foothills of the Pyrenees. Ghostly apparitions waft in and out, while nature reclaims the patches of ground from which men and women once attempted to scratch a living. In common with standard television practice, Reeves reverts to a floating camera to explore the expanding space of the landscape and a voice-over to direct the readings of his drifting images. The heavy tones of the poet Vallejo proclaim 'a point through which a man passed is never empty' and he goes on to repopulate the inhospitable landscape with the stories and memories of the people who once lived there. And yet, we know that soon enough all traces of humanity will have been erased by time and the action of wind, rain and sun. Nothing will remain other than the poet's ability to remember.

Although aspects of these works may have seemed familiar to television audiences, they shifted the landscape from a secondary position as a backdrop to dramas and travelogues into the key expressive element of a work. This enabled artists to reveal something of the way in which the moving image represents and interprets landscape whilst extending the scope of its signifying powers. Within the inversion of background and foreground, these works invited us to speculate, as I have done, on the multiple meanings arising from the landscape.

DEPICTIONS OF THE SELF, STORIES FROM THE OTHER SIDE

Ealier, I made the argument that television's mode of address is one of familiarity, of an artificial one-to-one co-presence with the audience as exemplified by the conspiratorial to-camera confidences of presenters. It is clear that this intimacy is based on a fiction so convincing at times that viewers have been known to take presenters at their word. The consequences of this delusion are

occasionally tragic as in the case of Jill Dando, a UK television presenter who was killed by a crazed fan. There might appear to exist a coincidence between the intimate mode of address employed by broadcasting and certain aspects of video art that, in the 1980s, held by the feminist dictum that the personal is political.[17] However, there were fundamental differences. Feminists located their individual experiences within a critique of Patriarchy. On the other hand, television presenters, newsreaders and chat show hosts never referred to the social or political dimensions of their work. Even now, presenters reveal of themselves only that which is consistent with their constructed public image, sanctioned by the broadcasters. The personality of a TV presenter remains a fiction and the personae of participants, both professional and amateur, are no less bounded by the codes of television behaviour.[18] As Peter Conrad pointed out, 'talk shows are theatres of behaviour, not dialogues.'[19] Presenters and, increasingly, lay participants are required to reflect current ideals of beauty and wisdom and their speech must remain clear, unhesitant and logical or, in the case of agony chat shows, eventually contain their outbursts by submitting to the logic and advice offered by presenters and their 'experts'. Apart from a glove puppet called Emu who famously attacked the British chat show host Michael Parkinson and artist Tracey Emin who made a drunken exit on *Newsnight Review*, the most effective disruption to the fixed smile of the television presenter was the American artist Charlemagne Palestine who, in 1982, shouted unintelligible gibberish on Channel 4's *Ghosts in the Machine*. The presenter, supported by the containing structure of the chat show or game show rules, ensures that no truly disruptive element reaches the viewer and that the programme remains within what Tom Sherman called the 'acceptable levels of Raw Personal Material'. However, presenters sometimes inadvertently allow 'excesses' which are false and carefully staged, including the controlled outbursts that add a frisson of danger to reality shows like *Jerry Springer*.[20]

Documentaries must also hold the dangerous ambiguities of reality at bay and maintain a distance between the viewer and those attempting to tell their stories. Here the 'Formica-bland'[21] presenter is once again pressed into service or replaced by an attractive expert in the field who either leads the camera from key site to key witness or interprets the footage as a pervasive voice-over. Further, it is the presenter's role to deflect the identity of the real mediating agents behind the camera: the directors, producers and their paymasters. Although there have been many groundbreaking documentaries on UK television in recent years, there is a tendency to defuse the power of witness by routinely atomising the testaments of individuals. No one individual is allowed to speak for more than a few seconds. Narrative fragments from a number of individuals are mixed up and regurgitated as palatable entertainments that express the world-view of the programme-makers and reduce the on-screen witnesses to little more than likeable scientific specimens. As a result of the fragmentation of testaments,

it is often hard to remember any one individual at the end of a television documentary. Frequently, an opportunity for empathetic communication is lost while an authorised view of history is reinforced.

In contrast, artists' mediation of either their own testaments or those of their subjects is declared through their authorship. Although traditions of avant-garde art and the context of an evening's broadcast inevitably impress pre-set meanings on a work, artists' videos that addressed identity and self-representation suffered no further mediation on their way to the small screen at the height of the Channel 4's experimental phase. There was variation in the extent to which these works succeeded in bridging the gap between artist and viewer and negotiating the hidden censorship of broadcasters, but a few examples from Channel 4 are useful in considering these questions.

Zoe Redman's *Passion Ration* (1984) was shown as part of Channel 4's *Video 1, 2 and 3* series. The piece was introduced by the artist herself, explaining how video might offer women artists a less over-determined medium in which to find a voice. The work that followed was part poem, part lament about a one-sided love affair. Redman's voice, ironic and vulnerable, dominates the soundtrack and is accompanied by spare visuals – half glimpsed images of a fair-haired woman dressing in shafts of light that penetrate the gloom of a darkened room. We never discover her identity nor whether the story of a lover's indifference is hers or the artist's. Perhaps we are looking at the heartless lover in question. The subtle ambiguities of the work go against the grain of narrative expectations governing broadcast television. There is no resolution, explanation or promise of further episodes to resolve the affair. Nor does the work conform to the language of a commercial break. Nothing is being sold, other than the ambition of the artist to communicate her experience. Her subjectivity finds a mode of expression that is still tentative, a proposition rather than a categorical statement. Although unattributed, the story she tells remains whole, her voice is uninterrupted by other points of view or contextualised by an authoritative voice-over. It is an experience that is mediated only by the creative imagination of the artist and the limitations of an audience whose own vision is marked by what the US artist Bill Viola called 'a seven-channel childhood', and which, in the UK, would have been a three-channel equivalent.

A different approach was taken by Vivienne Dick, whose video *New York Conversations* (1990) was screened by Channel 4 as part of the *Dazzling Image* series. Shot in the streets and apartments of New York, the conversations shift from individual to individual with no apparent connection between them other than the fact that they all live and work in the city. Nan Goldin discusses her drug rehabilitation, a pregnant lab worker describes the process of artificial insemination and a gay man wishes he could come out to his Ukrainian family. The artist offers no overall thesis, no personal opinion on what we might take to be her friends' lives. They simply speak for themselves. We are confronted

with what John Ellis called the 'brute force of witness' eliciting an emotional rather than intellectual response.[22]

The nervousness of the channel in relation to these unmediated, disjointed vignettes was evident in their decision to front the *Dazzling Image* series with personalities like Dr Anthony Clare and Fay Weldon. Clare went a long way to undermining the work when he announced that Louise Forshaw's *Eleven Years* (1990) 'almost renders words redundant' and then proceeded eloquently to diagnose the artist's experience of rape, and subsequent eleven-year ambiguities towards her body, thereby directing us to normalised interpretations of her imagery. His final insult was to quote the artist herself, removing her words from the context in which she had so carefully placed them. The ensuing tape, full of problematic images of Forshaw's naked body, struggled to maintain its power, part of which derived from a sense of the complicity of our gaze, almost as invasive as the men who attacked her. By telling us what to think, Clare eased the anxiety and confusion we felt looking at the fragility of the flesh we vicariously consumed and others had violated.

Some artists showcased on Channel 4 managed to present a personal or political reality by using a conventional documentary format. The hope here, as with much community and what was then termed 'agit-prop' video, was to use accessible narrative conventions as a strategy of persuasion. The women's camp at Greenham produced a number of works including Tina Keane's *In Our Hands, Greenham* (1984), a poetic video diary she made while picketing the American nuclear base. However, it was Kidron and Richardson's *Carry Greenham Home* (1984) that first reached our screens. This slow-moving documentary seemed to strain at the limits of television's tolerance of duration and offered no determining voice-over or interviewer to explain away the women's protest. In fact, the only interviewer who appeared was Frances Coverdale who was then working for the BBC and was attempting to film a report while the Greenham women danced and chanted around her, drowning out her reportage. As Rod Stoneman pointed out, television was slower in those days, but *Carry Greenham Home* occupied something over an hour of airtime, and allowed the women of Greenham, so often portrayed as eccentrics or hysterics, to state their case. We can believe Stoneman when he tells us that most of the political work that was broadcast by Channel 4 was not a threat to the status quo. As he said, 'if power was really challenged then quite formidable problems could be encountered.'[23] It is also possible that dissenting voices were muted by the same balancing of views between artists' tapes that current affairs were obliged to implement; in the case of early Channel 4, the balance operated across the schedule as opposed to within individual programmes. However, in those few years in the 1980s when Channel 4 was open to what Stoneman describes as 'strongly enunciated perspectives', an astonishingly rich body of counter-cultural work reached a national audience. For a time, Stuart Marshall found British television

so amenable to politically motivated programming that he abandoned his role as an artist and devoted his later years to making documentaries around gay politics. Marshall, in common with other artists like Isaac Julien, Ivan Unwin and Maureen Blackwood and later Keith Piper, combined the narrative conventions of television drama-documentary with visual experimentation and took advantage of a radical, if short-lived, moment of accessibility in UK television history.

ALLEGORICAL NARRATIVES, WORDLESS DRAMA

Redman and Forshaw attempted a direct exposition of their subjective experience and political artists embraced the conventions of television narrative in order to raise the consciousness of a national audience. Other artists responded to finding themselves embedded in a word-dominated medium by joining Kapoor and Viola in falling silent or by scrambling narrative conventions. Others again introduced fantasy and allegory. Strategies ranged from the virtual stasis and visual poetics of the former Yugoslavian artists Breda Beban and Hrvoje Horvatic to the whimsically sadistic soap operas of the American Cecilia Conduit; tales of male stalking and female violence in the suburbs.

A less threatening scenario was played out in the dreamlike domestic landscapes of the UK artist Graham Young. In the early 1980s, he made *Accidents in the Home,* a series of tapes of which *no. 17: Gas Fires* (1984) was broadcast by Channel 4. The work concentrates on a man sitting silently in his sitting room gazing into the gas fire while the rousing chords of Bavarian popular music fill the soundtrack. Nothing much happens. We see his electric fan, the TV in the corner, a house plant and a small wind-up aeroplane that he sets off into the room. The piece ends with a clash of Teutonic cymbals coinciding with the small plane freezing in mid flight in front of the fire. The timing in this work is near perfect, the meaning as deep or as wide as the viewer cares to make it. The overall impression Young creates is of a brooding silence fractured by explosive musical jollity emanating from his imagination, a record player, a Bavarian folk festival taking place under his window – we never discover where that other place is. The room in which we sit is replicated by Young's lounge, his solitary dreaming akin to our own. We are thrown back to the essential isolation of the television spectator, perhaps not so much in the guise of passive couch potato, but nonetheless cut off from social engagement, deprived of the potential to take action, removed from life itself.

A group of European video artists in the 1980s also found a wider public through Channel 4 in work that introduced a charged sense of relationship into the silent drama exemplified by Young. Robert Cahen's magical *Juste le Temps* (1983) recreates the Hollywood scenario of strangers on a train. A beautiful young woman is lost in a reverie as she travels through the French countryside in the dying light of a late summer's day. A man in a dark trench coat and

21. Graham Young, *Accidents in the Home no. 17: Gas Fires* (1984). Courtesy of the artist and LUX, London.

hat finds his way to her compartment and the scene is set. The pace is slow, the colour saturation is enhanced and the landscape seen through the carriage window dissolves into layers of smoky abstractions. The scene develops no further, no narrative interrupts the dreamlike quality of the journey and no destination is reached. Time passes and we travel the same time-space as the characters on-screen. The Belgian artist André Colinet suggested a narrative of sorts between his characters, but again with no dialogue to support a clear reading of motive and outcome. In *A Kiss to Build a Dream On* (1987) three characters, a woman and two men, are trapped in a domestic setting in a kind of looped eternal triangle whereby each tries to make loving advances to the other, but is rejected only to reject, in turn, the next partner's overtures. These works reflect the more performative and literary tradition of European video in the 1980s and, as Anne Marie Duguet pointed out, in Colinet's work we see a 'reworking of the central codes of theatre... and theatricality.[24] In the context of British television, *A Kiss to Build a Dream On* makes reference to the tradition of the kitchen sink drama, well established in the UK since the 1960s.

THE FUNDERS

The tendency to cushion artists' video with talking heads stems from what broadcasters assume audiences can tolerate. Many commentators, like Anna Ridley and Anne Marie Duguet, have observed that broadcasters regularly underestimated their audiences' intelligence. Viewers were quite capable of understanding 'difficult' work, they said. In spite of the radical programming that he achieved in his time at Channel 4, Rod Stoneman maintains that the 'distraction culture' could not accept explicit sex, explicit politics or ambiguity. He added that it rarely accepted durational work, which is central to many artists' practice. When I was a member of the Arts Council of England (ACE) panel convened to select ACE/Channel 4 co-funded commissions in the mid 1980s, I witnessed certain pieces being dismissed as 'unbroadcastable'. They were mostly durational films and videos, but occasionally included works that were considered too radical. Chris Meigh-Andrews wanted to publish instructions for a home installation in the *Radio Times*. Viewers would be told to dim the lights and place a wine glass at a given height and distance from the screen. When the image of the naked artist swimming back and forth across the screen was broadcast, the viewer would look through the wine glass and see him captured there like an aquatic Tom Thumb. Another artist wanted to persuade all four channels across the BBC and the independents, to broadcast different views of an event simultaneously so that the viewer could vision-mix from their home remote controls. Both these intriguing ideas were deemed 'unrealistic' and turned down.

It is clear that although British television briefly opened its doors to artists in the 1980s, the work was censored and not just by the broadcasters and co-funders. David Curtis has observed that many artists appeared to be self-censoring their work and with unprecedented injections of cash, tended to up the production values of their tapes in response to what they imagined the broadcasters expected. This resulted in 'a certain blandness' in the commissioned work.[28] From my position on the funding panel at ACE, I observed a parallel tendency for artists to anticipate broadcasters' preferences by submitting conventional shooting scripts that proposed mildly experimental narrative works involving plenty of foreign travel. At a practical level, for those of us who were lucky enough to receive television funding, it meant the difference between creating a handful of self-financed works every few years and a regular output with access to adequate facilities. The relatively modest sum of money I received from Channel 4 in 1984 supported my work for three years.

THE COMMERCIAL INTERESTS

Television sponsorship of a few artists' practices was clearly beneficial to those individuals. It is in its formal influences that television has had the greatest

impact on artists' video. Almost everyone absorbed both the style and content of broadcasting, either positively or negatively and, in the case of scratch, television provided artists with their raw material. The language of television pre-existed video art and would always be the touchstone against which all artists' efforts would be read. In the 1990s, popular culture was to become an important referent for art practice in general but, in the 1980s, when a clear philosophical divide existed between video art and television, working alliances were already being forged.

There are examples of commercial organisations courting artists who first came to their notice on Channel 4. In common with many scratch artists, certain video-makers wore two hats and put their innovative ideas to more lucrative use by making commercials. Rybczynski's *Tango* was mimicked by an Ariston ad, and the film-makers Tony Hill and Tim Macmillan, both responsible for devising ingenious visual techniques, either worked directly with advertisers or had their ideas appropriated by them.[29] Both in-house television graphics departments and software manufacturers regularly employed art school graduates and were undoubtedly aware of what artists were doing with video.[30]

VIDEO ART'S IMPACT ON TELEVISION

During and after the brief marriage of Channel 4 and experimentation, the language of television clearly evolved in a direction that incorporated many of the linguistic innovations devised by artists as well as those that were self-generated. Mick Hartney has pointed out that commercial television in the 1950s was itself innovative. Radical writers and directors like Dennis Potter, Harold Pinter, Ken Russell and Ken Loach were given license to experiment. As I have argued, scratch video may have inspired commercials and title sequences to freely collage and layer found footage and process it with increasingly sophisticated electronic effects. Station idents are often masterpieces of wordless conceptual conceits that also draw on the imaginative flights of surrealism. The current *Wildlife on 2* introductory sequence features a kingfisher diving through a landscape and into water in which a television sits, displaying the same stretch of river. The kingfisher appears to dive right into the set and out again – like the best conceptual trickster. The new tendency to liberate the camera from the tripod and the use of a fractured and repetitive style of storytelling in television drama owes much to the experimental work of new narrativists. I recently heard the former scratch supremo, George Barber, observe how often commercials and television idents use a flowing or spinning image design that was so irresistible to scratchists. In broadcasting it has the effect of hypnotising the viewer into a pleasurable acceptance of continuity disruption and the disturbing content of news programmes. John Ellis has observed that television employs the entire repertoire of graphic supplements to harness the unruly 'raw data' of news,

sport and other live events and transform it into a coherent account of social reality: 'Wars become maps, the economy becomes graphs, crimes become diagrams, political arguments become graphical conflict and government press releases become elegantly presented bullet points.'[31] I could add that, like the Paintbox experiments of scratch and other video colourists, television has discovered the psychological effects of saturated colour. Many programme links employ rich reds and greens to distract the viewers with 'televisuality', optical effects during the syntactical gaps in the TV schedule. These days, commercials and TV idents look so like 'video art' intervals in the programming that the BBC has felt compelled to keep up and mimic the style and repetitive familiarity of commercial breaks. They endlessly preview future programming, the new digital radio channels and the various learning opportunities offered by BBC Worldwide and the Open University. It may be overstating the case to claim that the acceleration in image turnover on television is due to the rapid-fire editing that scratch artists initiated – the frantic competition for viewers was probably a greater spur to up the pace of visual pleasures on television. It was perhaps artists like George Barber, whose optical pace was slower, whose delight in the technology and the patterns he could create more overt, that most influenced the broadcasters.

Here, I am convinced by my own arguments, but there are still disagreements surrounding the degree of influence artists' video wielded over the form and direction of mainstream broadcasting. John Wyver has acknowledged that, 'certain design elements of television took elements of scratch and some other artists' work', but added that, in terms of impact, 'this was very marginal.'[32] Wyver would ascribe the stylistic shifts in broadcasting to the broader inventiveness of television in the 1980s, which was then 'a rich and stimulating environment'. Rod Stoneman is more willing to attribute a significant role to artists whose input created what he called 'a homeopathic effect'. Over time, a small dose of art has made a proportionally larger impact on televisual grammar. However, as I have rehearsed several times in this book, television appropriated only the surface impressions of video. Conceptual jokes, video-graphics and fractured storylines no longer have the power to disrupt conventional perceptions once they are tied to television narratives or the commercial imperatives of advertisements and music videos. As Rob Perée reminds us, in these contexts experimentation is driven by marketing goals, which are 'in keeping with the commercial principles of television'.[33] They are more likely to serve the purpose of providing instant 'product' identification of programme or channel for Ellis' 'grazing viewer' than to subvert televisual conventions and their concomitant ideologies. Perhaps it was naïve of artists to imagine that formal strategies on their own would revolutionise television. Rod Stoneman puts it succinctly when he says, 'it is clear that you can do anything with cameras and with sound and still have it as part of a distracting, consumable, distant spectacle.'[34]

Broadcasters appropriated not only the optical tricks that video artists devised, but also the insistence on the personal voice of the artist, which it reinvented as reality TV. Unlike the socially grounded diaristic work of artists, reality TV divorces individuals from the historical, social and political realities that may have created the predicaments they are encouraged to confess. Subjects are guided to identify causes in themselves and find solutions by an effort of will rather than through conjoined political activism with others in the same situation. Framed by the culture of self-improvement, the personal is no longer political, but simply personal, unconnected to the social domain and the suffering of others. The responsibility of the individual is paramount and the role of the state in determining the individual's lot in life is obscured.

The promotion of individualism underlies even the most explicit broadcasts on the UK's Channel 5 where displaying people who like to have sex wearing teddy bear outfits seems to have become the norm. Sensationalism and a thirst for surface novelty is not the same thing as radical television. It does nothing to change the spectator position nor does it open up a two-way exchange of information. In fact, it conceals a deep-rooted conservatism, the notorious 'dumbing down' that now suffocates the content of contemporary broadcasting. As long as viewers are kept fixated to the surface of eccentric behaviour, they will not ask the deeper questions.

Where the personal has undergone a process of re-domestication in the confines of reality TV and sensationalism in late night sexposés, video art's appropriative strategies have been transformed into television's own nostalgia. With constant re-runs, makings-of, and other programmes about programmes, television has emerged as the epitome of postmodern reflexivity. As David Curtis pointed out, 'television has become just what David Hall always said it was, an object, but now it is a historic object firmly stuck in the past as much as the steam engine is.'[35]

The process of re-appropriation and commodification I have described has taken place gradually over the years. It is clear that the television experimentalism represented by the early years of Channel 4 was indeed a golden age and is now long gone. Instead, we have a proliferation of channels, video game interfaces, cable and digital stations and, of course, the Internet. As John Wyver pointed out, the terrestrial channels have responded to the new challenge of competition by 'retreating aggressively to a middle-ground'. As a result, 'their engagement with innovation (grounded in a social or cultural practice) has all but disappeared.'[36] Television is no longer open to the work of video artists. As early as 1994, Rick Lander was lamenting that, 'any Tom, Dick or Harry can get their 15 minutes of exposure these days, the only people who can't get into television are artists.'[37] Experimental work still occasionally appears on the small screen, but as John Wyver observed, 'even if the fragile flowers of "art" can push their way into the schedule, and they do in Alt.TV, on occasion, or in

other spots on BBC4, they are so marginalised not only by scheduling but also by lack of "buzz", that they are almost irrelevant.'[38]

It would seem that television, in a constant state of narcissistic rewind and superficial search for novelty, has annexed the stylistic innovations of artists and neutralised the formal and political questioning implied in their work. As it excluded artists from the schedule, television removed those cultural irritants or, as Lyotard puts it, those who aim to create in the viewer 'a feeling of disturbance, in the hope that this disturbance will be followed by reflection'.[39] Once the dream of transforming the domestic living room into a reflective space had receded, artists who had enthusiastically participated in the limited opportunities of broadcasting returned to the traditional locus of meditation: the gallery. Although many artists had shown in marginal spaces all along, in the 1990s the commercial galleries and museums began to open their doors to video and the form this work took was what David Hall would argue it had always been – sculpture.

8

Video Sculpture

Video was too much a point in the space. Remember, the convention of the time was monitor and not video projection. Video was too much SCULPTURE.

Vito Acconci

THE PUBLIC/DOMESTIC CONVERGENCE

In 1959, Nam June Paik and Wolf Vostell incorporated modified and partly demolished television sets into their 'happenings', thus beginning the transition of television from home entertainment and information display system to gallery artefact. The signal transmitted to the 'box', however distorted by the artist, was generated by the broadcasting corporations. It wasn't until the mid 1960s that the monitor was born, an adapted television set that could exhibit an external signal from a video player or camera. The artist could now use the flickering 'fourth wall' as a sculptural object as well as a monitor to artistic activity and creative imagination.

Although the monitor had become a conduit of artistic expression, it remained inherently associated with broadcasting and the reception of televisual material in the domestic environment. The supplementary aura of domesticity or what David Hall called the 'inevitable presence' of television persists as long as video is shown on a monitor. Steve Hawley attributes the low status of early monitor-based video art to its domestic associations: 'When people saw those screens in the gallery, they just thought about the domestic, they thought about having their tea.'[1] The intersection of public art and the private realm was not new and had been well established by the time artists began to relocate TV sets to galleries. Early in the twentieth century, Duchamps' infamous urinal triggered an entire industry of art based on found objects. By the 1970s, feminists had introduced personal experience into the public space of art and, in *Semiotics*

of the Kitchen (1975), Martha Rosler made the link between the domestic as it is portrayed on television and the experience of real women trapped in domesticity.[2] As a whole, video art made a three-way connection from artistic expression, to the private sphere and on to televisual culture in the shape of entertainment, with marketing and current affairs constantly flowing through the permeable boundaries of the home.

Many artists emphasised the monitor's domestic origins by recreating home interiors in the gallery. In 1974, Nam June Paik placed a small Buddha in front of a monitor that was connected to a camera relaying the image of the Buddha back to itself. *TV Buddha* ironically combined eastern meditation with America's growing addiction to the television set and made a sideways reference to western narcissism and the commodity culture. The domestic in the art and the art of the domestic was extended to social commentary in *What Do You Think Happened to Liz?* (1980), by the UK artist Alex Meigh. Her video of teenage girls struggling with adult sexuality was shown in an ersatz sitting room that the artist created, complete with wallpaper, carpets, couch and telly. In 1994, the American, Tony Oursler also made observations of a young woman in a domestic setting. He mounted a small monitor on a table facing a prettily upholstered dressing table and chair. With *Judy* as its title, the work suggested the anxious moment of comparison that a girl lives every day when she looks in the mirror and compares what she sees with the ideal images of beauty paraded daily across her television screen.

The domesticity of the television set was most cleverly reiterated at the dawn of video art, when the image of a fire was used in a broadcast by the Dutch artist Jan Dibbets. In *TV as a Fireplace* (1969), he turned the home television set back into the domestic hearth it had displaced, an idea that was taken up later in the work of Susan Hiller among others and, as we have seen, was also exploited commercially. I have described a few examples of the domestic environment explored in monitor-based video sculpture. The compulsion to turn the gallery into a home is also evident in the concept of the video lounge. The now obligatory adjunct to any media festival offers visitors a comfortable chair facing their own set where they can browse through art the way they hop the channels at home. In the video lounge art is thoroughly domesticated.

THE CONVERGENCE OF VIEWING CONDITIONS

Once in the gallery space, the monitor reproduces aspects of the domestic viewing condition whilst introducing those of conventional art gallery spectatorship, often including the discomfort of viewing lengthy works with little or no seating. As we saw in the last chapter, television spectatorship is based on intimacy, a sense of co-presence of the image and an idle spectator, dipping in and out of programmes and occasionally becoming absorbed. Watching the

box is frequently a family affair interrupted by discussions, telephone calls and the usual comings and goings of family members. In the gallery, the grazing is still a feature of the spectatorship, but the church-like devotional attention that would normally be accorded sculpture discourages vocal comment and human interaction. The social dimension is lost as the television or monitor, now elevated to the status of art and stripped of its usual entourage of nick-knacks and domestic lights, takes on the aesthetic pretensions of sculpture. It no longer invites intimacy, but engenders reverence and a more distant appreciation of concept and form. Early works by Paik and Hall used televisions tuned to different stations as a way of indicating the extent to which the home – and art – are infiltrated by popular culture and its attendant ideologies. Once cast as video sculpture, the mass entertainment of the original is now overlaid by the painterly patterns it creates and the high cultural aspirations of the gallery. These two modes of speech remain in tension, but the domestic heritage of the box is rarely eradicated by its new role as art object.

ANTHROPOMORPHISM, THE HUMAN SCALE

> Video is a face-to-face space.
>
> **Vito Acconci**

The familiarity of the monitor is of course dependent on its domestic scale existing in relation to the physical dimensions of the viewer. An encounter with the box triggers a fundamental perceptual process that is activated when an individual comes across an object or another human being. Within a fraction of a second, the viewer makes a comparison between self and the object and establishes whether it is bigger or smaller, and, in the case of another human being, weaker, stronger or potentially desirable. In this respect, the object of the video monitor always implicates the body of the spectator. The technology itself contains a human attribute. Bill Viola has observed that unlike film, video records the image on the same strip of tape as the soundtrack thereby maintaining perfect synchronisation of sound and image. Like human perception, in video 'we don't get images without sound'.[3]

Peggy Gale relates the anthropomorphism of the monitor to its ability to emit light and embody the image rather than project it onto a distant surface as in the case of film. This sense of embodiment is heightened on television by the one-to-one, direct address of newsreaders and chat show hosts. The status of the television set as another one of us, as a kind of electronic transitional object in our own image became the central theme for a number of artists, the best known being Nam June Paik with his *Family of Robot* (1986). Each 'robot' is made from early television sets of different sizes, clad in a range of

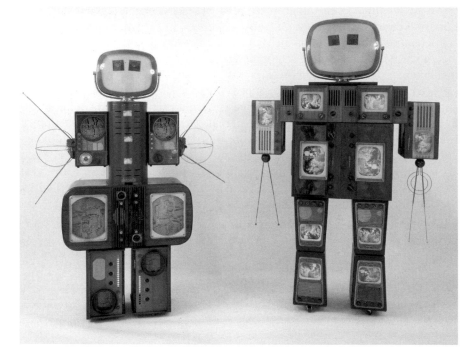

22. Nam June Paik, *Family of Robot: Mother and Father* (1986), video sculpture, 80 x 61.5 x 21 inches. Photographer: Cal Kowal. Courtesy of the artist and Carl Solway Gallery, Cincinnati, Ohio.

wood veneers. Big, medium-sized and child-sized robots are arranged in ironic family groupings, their screens animated by different television programmes currently on air. With the cellist Charlotte Morman, Paik took the bodily reference to a literal and somewhat uncomfortable conclusion by covering the performer's naked breasts with small monitors while she played the cello in the performance, *TV Bra for Living Sculpture* (1969). Although Paik's stated aim was the humanising of technology, Mormon found herself confined by the commodification of her sexuality-as-medium, a bad video joke that militated against her demonstrable skill as a musician. Occasionally, the television set itself has been constituted as an anthropomorphic, inhabited prison. I have already discussed Mick Hartney's *State of Division* (1979), which depicts the artist in the classic head and shoulders shot, swinging in and out of the frame like a newsreader that is never allowed to go home. Hartney confides to camera his feelings of entrapment precipitated by the expectations he projects onto the audience he can't see. Hartney's head is perfectly equivalent in scale to our own and proportional to the box that contains it. Trapped in electronic space,

the artist as an illusion alludes to our spectatorship, to the physical dimensions of the monitor and speaks directly of the social pressures that demand in him rigid patterns of behaviour.

Other artists have deployed the body across a number of monitors, sometimes reiterating the cruciform configuration used by Paik. In the case of *Fragments of an Archetype* (1980), Catherine Ikam adopts a formation that replicates Leonardo da Vinci's famous *Vitruvian Man*. However, the figure in Ikam's installation does not entirely fit the monitors. Parts are missing. The resulting fragmentation of body imagery recurs down the generations. In the UK, Marty St. James and Anne Wilson created *Portrait of Shobana Jeyasingh* (1991). The body of the dancer is fractured across fourteen monitors in another loose cruciform arrangement. The various body parts travel around the installation, ranging from extreme close-ups to wide shots that reveal Jeyasingh's movements in their entirety. As Sean Cubitt observed, the work interrogates 'the idea of television ever furnishing a total, complete, coherent world'.[4] Neither is television capable of representing a unified individual. The dancer's body in *Portrait of Shobana Jeyasingh* shatters into a kaleidoscopic play of corporeal surfaces, disjointed and contingent like vision itself. The viewer is returned to the workings and limitations of the human perceptual system. Trying to put the shattered dancer back together again creates awareness of the extent to which perception is a function of the imagination.

In a gallery space, as at home, the body of the viewer is also implicated by the optimum viewing distance and position demanded by the television set. Even when forced to lie on one's back to view a ceilingful of Paik's monitors, the viewer-set relationship is fixed and delineates our optical range. Too far away and the television image becomes a flickering light; too close and it breaks up into scan lines. Artists including Stan Douglas and Atom Egoyan have disrupted this rule of engagement and forced the viewer too close to the image or, like Joan Jonas, isolated the set beyond the optical range of the viewer. For all but today's wide screen TVs, the ideal viewing distance for a monitor roughly approximates the distance between two human beings in the act of conversation.

LIGHT BOX

Like a lamp, the television box emits light in the home and similarly illuminates the gallery space, where it is often the only source of light. The English composer Brian Eno used a number of concealed monitors showing only plain colour signals to cast tinted lights onto a minimalist wooden construction. In both her performances and her video work, Laurie Anderson has turned her head into a metaphorical television set by putting into her mouth a red light that illuminates both the inside and outside of her body as she speaks. In the UK, Melanie Smith and Edward Stewart took the idea one step further in their single

monitor work, *In Camera* (1999). By means of the simple device of situating the camera inside a mouth, the gallery space is only illuminated when the mouth opens and registers light. The picture plunges back into darkness when the mouth closes again. The total blackness that engulfs the gallery is analogous to the black screen and inert black box to which the monitor reverts once the signal is cut. The sense of loss that always follows switching off the television may tap into more profound anxieties about annihilation and death or indeed the apocalyptic implications of no signal being broadcast from the BBC.

BUILDING BLOCKS

I would be inclined to agree with David Hall's contention that a video displayed on a monitor is already and always a sculpture. Clearly the object-ness of the monitor can be emphasised or de-emphasised depending on the treatment or condition of the casing, its location and the lighting conditions. With the suspension of disbelief and the draw of the flickering image, the box is quickly forgotten if it is unremarkable. However, a video installation remains sculptural and maintains a tension between the ontological dimensions of the work and the illusory spaces suggested by the video image. With the technology forming a prominent part of the display, the means of production of televisual illusionism are always visible and act as a Brechtian distantiation technique or a declaration of art's own constructed nature. At the same time, monitor-based installations invoke all the traditional concerns of sculpture and activate the inherited aesthetic appreciation of form and mass, surface and depth, symmetry and grandeur.

From the beginning, the box of the monitor formed the basic unit of video sculpture. It provided a building block that could be used singly or multiplied as in the work of Paik and St. James and Wilson. The installations then became not only sculptural but also monumental as in the case of Paik who deployed 384 upturned monitors in his 1982 *Tricolour Video*. It was, by all accounts, an impressive display, but maintained the irony of being constructed from domestic objects straying into art from the world of entertainment. As I have mentioned, many of Paik's installations emphasised their three-dimensionality by reducing the video image to a collage of off-air material that, once multiplied, quickly receded into abstract patterning. In the UK, David Hall went a step further by denying the viewer even the ironic display of scratched political broadcasts and turned the monitors to the wall. In *The Situation Envisaged: The Rite II* (1989), a monolithic partition of fifteen televisions, all turned away, closed off a corner of the gallery. Each TV was tuned to a different off-air channel, creating a polyphonic medley of televisual discourses. It was possible to hear the televisions and see the light they cast onto the wall, but their images were not in view. Between each stack of

televisions, a narrow crack allowed the spectators to see a fragment of a video image playing on a single monitor facing outwards. The denial of televisual pleasure and the revelation of those blunt parts of the technology that we usually ignore, gave an object lesson in deconstruction. In addition, the work used the imposition of sculptural scale to allude to the magnitude of televisual cultural influence on contemporary life.

Where Hall constructed solid walls of monitors emphasising their weight and strength, UK compatriot Tina Keane contrived to render monitors weightless. Poised high above the spectator, *A Bouquet* (1984) consisted of a bunched arrangement of monitors, their wires gathered like the strings of balloons, trailing down onto the gallery floor. Images of the Greenham Common Peace Camp drifted across the monitor screens, turning the video bouquet into a tribute to the 'Women at the Wire' whilst emphasising the physical presence of the monitors by defying gravity.

VIDEOWALL

Hall's notional video walls soon became a reality when Videowall technology made it possible to spread a single image across a bank of monitors. This technology was already being used in shopping malls, trade fairs and sports events, but in 1989 the UK artist Steve Littman installed a Videowall at the *Video Positive* festival in Liverpool. Not only was it now possible to create an oversized monitor but also to programme the computer that controlled the Videowall and route certain images to prescribed blocks of monitors. The images could be repeated and enlarged or sections could be augmented by as much as x 200. Most of the UK artists who made work for the wall created landscapes. Kate Meynell used images of the moon and the sea, Judith Goddard the shimmering surfaces of the river Thames while Stephen Partridge created a vertiginous work based on footage of flying over a Scottish landscape in a light aircraft. The effect of the magnification brought video close to the immersive experience of film and yet the constant shifting of images across monitors, the repetitions and alterations in scale created a self-reflexivity consistent with video art's own conceptual precepts. The Videowall also produced a hypnotic and seductive sensory experience. As Littman observed, the viewers never forgot the grid of monitors or 'the dynamics of the camera and Videowall technology' but the works also 'created a sense of flow and counterflow'.[5]

In 1989, Dara Birnbaum used the same technology to create an equally transporting work for the Rio Shopping Complex in Atlanta, Georgia. The flows she portrayed were as much a function of the technology as of the oscillations between past and present, live and pre-recorded in the video footage. She exploited the Videowall's ability to combine off-air broadcast material and her own pre-recorded footage of the landscape that once flourished where the

shopping centre now stands. She added another element, a live camera that froze silhouettes of passers-by into templates that then became the key into which the 'natural' landscape imagery was inserted among the news flashes.[6]

Videowalls proved to be an expensive display platform for artists and although they remain a familiar sight in shopping malls, the technology has been largely superseded by video projection. However, I would agree with Steve Littman that the technology offered interesting opportunities not least for its ability to combine the technological and sculptural specificity of the video monitor with the phenomenological, optical strengths of film.

MIND THE GAP

Where Hall and Paik stacked television monitors into solid walls, and Littman and Birnbaum closed the gaps between them to create a unified field of pulsating video imagery, other artists became more interested in the gaps that could open up between monitors to create both a physical and conceptual space through which the viewer could wander. In *Video Ping Pong* (1974) Ernst Caramelle set two monitors at either end of a ping-pong table. The images showed two players batting a ball back and forth in perfect synch. The trajectory between one and the other was left for the viewer to extrapolate from the gap between the monitors. In so doing, spectators became aware of their own powers of deduction and imagination. In the UK, Kevin Atherton similarly charged the space between two monitors by co-ordinating two sequences of the artist arguing with himself, one combatant in each monitor. Chris Meigh-Andrews created streams and fountains in which the water appeared to flow between and through stacked monitors. In common with much contemporary sculpture, these works operated in the negative space surrounding objects whilst activating the internal space of the imagination and creating awareness of the processes whereby viewers fill in the gaps.

HIDING AND BALANCING THE BOX

Although artists like Meigh-Andrews and Caramelle revealed the sculptural properties of monitors, many others took great pains to conceal the box that supported the magical surface they wanted to exploit. Mary Lucier set monitors into walls, Tony Oursler concealed one in an oil drum and I buried both the monitor and player at the bottom of a well. Although these works might be seen to be re-enforcing the illusionism of television, the dimensions of the monitor determined the structures into which they were partially concealed and the game of pretending that they weren't video screens, but windows (Birnbaum), water (Elwes) or other-worldly presences (Oursler) was so transparent as to reassert the physical presence of that which was hidden.

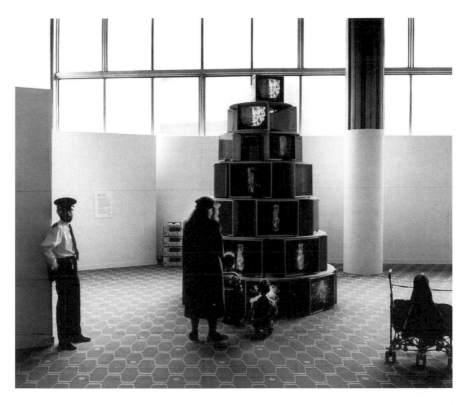

23. Chris Meigh-Andrews, *Eau d'Artifice* (1991), video installation. Courtesy of the artist.

Even when the television or monitor is on full display, it is not always centre stage and is frequently balanced or dominated by other objects introduced into the installation. In Canada, Vera Frenkel's *Transit Bar* (1994) featured migrating individuals who spoke from monitors set around a fully functioning bar with the artist herself frequently present to serve drinks. Working between the Netherlands and the UK, Stansfield and Hooykaas created video installations that included photography, metal, stones and layers of sand in actual and metaphorical meditations on light as it illuminates matter and the landscapes of mind and memory. Many other artists set monitors into especially adapted architectural features – columns, arches and stairways. It was perhaps Dieter Roths' installation *Table Ruin* at Documenta 7 that demonstrated the greatest determination to put the television back in its place. A small black and white monitor was the only coherent element in the chaos of the colourful junk room-cum-museum to which he added throughout his life. Perhaps this no longer qualifies as a video installation because the TV occupies in the gallery a similar

status to that which it enjoys in the home – just one of the items of everyday life. I found that the initial impact of the overall sculptural construction was quickly absorbed and attention soon migrated to the blinking screen in the midst of inert materials. The spectre of broadcast culture, itself a web of political and commercial texts, is always in play.

VIDEO PERFORMANCE

As a material object and a cultural phenomenon, video in the early 1960s was quickly taken up by performance artists and featured in the explosion of inter-disciplinary collaborations that transformed the landscape of fine art. Many worked with closed-circuit video systems as an adjunct to the live presence of the artist, offering a mediated representation as a contrast to what was before our eyes. Some decried and others celebrated the new technological age. As I have already mentioned, Steina Vasulka suggested a deeper material fusion of flesh, electricity and 'cold' hardware in elaborate sound and video systems that integrated her own actions with the behaviour of the technology.

In works by Bruce Nauman, Les Levine and David Hall, the live element of the work was extended to include the visitors to a gallery. This was achieved through live-relay video systems with a built-in time lag. Images of individuals appeared on monitors a few seconds after they had passed the camera, or with a camera situated behind their heads, they saw only their back view as they approached the monitor. Through transmission and more extensive cabling, gallery visitors were able to communicate with others in far-flung parts of the building. The viewer was now literally part of the picture and with the extension of time and the contraction of space, these closed-circuit works anticipated videophones and the Internet. Looking forward to the 1990s, artists like Susan Collins developed long-distance art works occurring simultaneously in different parts of the UK, linked via the Internet. Perhaps here the connections being suggested come closer to the use of video in surveillance than in the home. As long as the image received was displayed on a monitor, its physical dimensions and televisual affiliations always framed the initial response of those who encountered the work within discourses of fine art sculpture.

BREAKING OUT OF THE BOX

It was perhaps inevitable that with the modernist heritage informing early video, artists would find it hard to resist dismantling the box itself. This represented the first step in what has been termed the flight from the monitor, often characterised as the image and the video artist escaping the confines of the monitor to greater expressive freedom. Artists like Gary Hill stripped monitors of the casing that had once disguised them as furniture and revealed their

naked electronic innards. These anatomical monitors reflected the fragmented bodies that were displayed on the screens, themselves denuded of the cultural indicators of clothes. Further technological vandalism was committed by the performance group Ant Farm who ran a car through a wall of television sets. Others shot at, dropped, or burned televisions in gestures of defiance against the hegemony of broadcasting. Finally, the monitor was discarded when the technology moved on towards the end of the 1980s and video projection became a viable exhibition format. The video monitor that had so often stood in for the human head was effectively decapitated and lost its anthropomorphism as its 'face' was scaled-up and reconfigured as a cinema screen. The critical distance we acquired with the three-dimensionality of the box was lost and replaced by the spectacular, immersive experience of the cinema, sometimes enhanced by comfortable seating.

The ontological experience of the box may have vanished, but it was replaced by the physical dimensions of the projected beam of light. This was already an object of fascination for experimental film artists like Malcolm le Grice, Steve Farrer and Nicky Hamlyn who played 'on the contrast between the sculptural/ mechanical presence of the projection, the film strip and the projected image itself'.[7] The most famous sculptural film was Anthony McCall's *Line Describing a Cone* (1972). The film itself consists of a point of light drawing a circle, but the beam that carries the image is made concrete by smoke, incense and particles of dust catching the light as they swirl through the space. Together, the circular projection hitting the wall and its physical trajectory across the space, create the cone of the title.

In the days when smoking was allowed in cinemas, the projection beam was made solid as the smoke passed through it. It acted as one of the haptic markers, the physical fixing points that militate against the loss of body consciousness that we experience when we give ourselves up to the spectacle of film. In more recent times, Tony Oursler has used the momentary substance of smoke to render the air tangible, describe space and act as a carrier of a projected image. Staged at night in London's Soho Square, *The Influence Machine* (2000) consisted of video-projected apparitions materialising and dematerialising in clouds of 'smoke' generated by dry ice machines. The faces and voices of inventors associated with the surrounding area loomed up through the billowing smoke and melted away as the synthetic clouds dispersed. These fragile impressions evoked the spirit of human endeavour and simultaneously reminded us of the mutability of consciousness, the transient nature of life itself. In 2002, a variation on the theme appeared at the Beck's Futures exhibition at the Institute of Contemporary Art in London. Using a similar technique to Oursler's, David Cotterell projected into dry ice footage of Magritte's famous painting *Time Transfixed* (1938) in which a steam engine appears to be emerging from a fireplace. Cotterell's cloud-born engine rushes towards the viewer, becoming

progressively larger as both the film image and the approaching cloud amplify the image. It is an alarming experience. An unfounded sense of suffocation by smoke is combined with the eerie impression that the train, loud in the ears and pressing on the eye is about to run everyone over. This is the reported experience of primitive peoples' first encounter with the legerdemain of film. Also in the UK, Matt Collishaw explored the tricks of the eye by projecting video onto the swirling mass of a snowstorm souvenir and Charlie Murphy made liquid solid by beaming the image down onto a gleaming pool of what looked like milk.

In all these works, the projection is treated as a three-dimensional entity that carries the image, defines the viewers' bodies and, in finding a terminal surface on which to rest, delineates the dimensions of the space in which it is contained. The fragility of the image and the sense of a ghostly presence in Oursler and Cotterell's work has an element of the séance, as though making connections to the spirit world that we will ourselves inhabit all too soon. The reaching across time to encounter the shadows of what is no longer there becomes a paradigm for the technology itself – the ability of video to connect two simultaneously present realities via live-relay.

THE ACTIVE VIEWER, INTERACTIVITY AND OTHER MYTHS

The emergence of the video image from its cuboid container was hailed as a new beginning. It coincided with a rapid increase in resolution of the projected image and, in the 1990s, a deepening involvement of commercial galleries in moving image art. At the same time the concept of the engaged viewer came to dominate cultural theory and was assumed to inform most installation works whether they involved video or not. Barthes' active viewer, busily creating the meaning of a moving image work, was often invoked on the grounds that it was now possible to walk around objects or interrupt projections with our bodies.

When video installation was monitor-based, viewers were indeed free to walk around and among the sets or could observe them from above or below. However, the privilege of multiple points of view was hardly new. It had been a fundamental principle of sculpture since time immemorial. It was perfectly possible to enjoy multiple views of, say, a fascist sculpture from the Third Reich in the same way one might a radical, late-twentieth-century, intertextual assemblage. It isn't the walking that makes a viewer active. The notion of interactivity was supported by the rapid development of computer-operated delivery systems. Gallery audiences could now press buttons to make images appear and disappear. They could turn pages, trigger sounds and switch lights on and off, just as they can at the Launchpad in London's Science Museum where interactivity exists for purely didactic purposes. Artists like Gary Hill and Simon Biggs used sensors to allow the viewer to activate projected video

images. In Hill's *Tall Ships* (1992), ghostly individuals hovered in a darkened space and, once set in motion by a spectator, appeared to approach and simply stare. The sense of participation in this uncanny work was soon diluted by the arrival of other spectators and it became impossible to know who had triggered what. A plethora of such works was made in the 1990s, few as arresting as *Tall Ships*. Ian Hunt was perhaps a little harsh when, in 1996, he observed that a fascination with the tricks of interactivity can 'get at a kind of credulity and stupidity in the viewer that is even more stupid than that of the film-goer'.[8] However, it is true that many interactive artists were content to create fairground attractions or scaled-up video games that turned the viewer into a performing monkey and did little to engage the imagination.

In the course of the 1990s, film-makers invented their own brand of interactivity and made much of the fact that video or film transferred to video and projected onto a gallery wall not only liberated the image from the monitor, but also freed the spectator from a fixed position in the cinema. The gallery was now transformed into a newly radicalised 'cinematic' space. As I have pointed out, the option to perambulate already existed in traditional sculpture and monitor-based video installation. It is certainly true that an object changes depending on the point of view. However, the projected image remains more or less constant when cast onto the wall of an empty gallery. The viewer learns little by moving a few inches or even a couple of feet in either direction. Once the viewer has played with her own shadow in the beam of light and gone up close to dissolve the image into abstraction, s/he usually settles into the ideal viewing position equivalent to where s/he would have sat in the cinema. The point of view of the original camera/artist does not change as the viewer moves around the gallery space. Euclidian perspective is maintained. Video-film, projected directly onto a gallery wall, has also been credited with a paradigm shift based on the notion that a dematerialisation of the art object, a downgrading of the artefact from three to two dimensions harks back to the radical edge of 1970s conceptualism.[9] In my view the television set, by virtue of its combined domestic and popular cultural status, will always struggle to occupy a stable position as 'high' artefact, as sculpture. When it comes to a TV, there is little to be downgraded. In fact, dispensing with the television and replacing it with pure cinemascope illusionism elevates video and film to a kind of electronic mural painting in the grand manner, enveloped in the silence of the rarefied quasi-cathedrals of art that both commercial and public galleries have turned into. The ritualised, communal, proletarian experience – the eating, drinking, smoking and necking that accompanied the theatrical display of cinema – is also lost.

Further claims to radical spectatorship have been made in relation to artists like Sam Taylor-Wood who have multiplied projection screens across several walls. In such work, the viewer has been recast as a walking vision mixer,

active now because s/he can choose which screen to focus on. But again, auto-editing already existed in art. A room at the Royal Academy Summer Show is crammed full of still pictures, the display a composite of often divergent points of view and, refreshingly, not all by the same artist. Here, the visitor to the exhibition enjoys exactly the same editorial control s/he has at a Sam Taylor-Wood video show. The real difference is perhaps between cinema and the multiple, wrap-around video images that make it impossible to grasp the work as a whole. A movie at the theatre is apprehended as a temporal, flat object, commonly experienced at one sitting, from beginning to end. In a multi-screen installation, as in life, one is always left with the feeling that something more interesting is happening behind or just around the corner, on another screen. The predicament of choice fatigue is a contemporary phenomenon and leads to mild distress and a permanent sense of unfulfilled desire that is exploited by the consumer culture.

Raymond Bellour has argued that multiple screens used by artists like Taylor-Wood replicate the physical arrangement of cameras and sets in a studio as well as the fractured narratives of Hollywood. Although these previous incarnations of the imaging process are always implicated in film, they are also deliberately concealed in favour of cinematic realism on which much of this projected work still depends. According to Tom Sherman, the projected video is removed from its architectural roots when it is excised from the box of the monitor. It becomes what he calls 'video without edges', frameless and weightless.[10]

Perhaps Bellour's parallelism works better when artists create correspondences or dissonances between the geography of a depicted space and the actual space of the gallery. The Wilson twins in the UK have used drifting mirror-image sequences of interiors to create discordance between what we understand to be the space we occupy and the optical impressions created by the video projections. The perceptual discrepancy causes nausea and a disruption of balance and we are left with a sense that what we took to be solid walls are drifting, unstable surfaces. Spectatorship adrift, perception à la dérive.

Other artists like Michael Snow, Stan Douglas and Bill Viola have concretised the image by projecting it onto a free-standing or floating screen, sometimes, as in the case of Douglas, projecting onto both sides simultaneously. In Viola's *Slowly Turning Narrative* (1992) a revolving screen fills the space animated by images of a fairground carousel projected from one end of the space and a man's face projected from the other. The screen turns like a huge revolving door and since one side is mirrored, viewers are periodically confronted with their own image trying to keep up so as not to get knocked over. Once again, the physical structure of the projection space is disrupted and the projection itself takes on sculptural dimensions whilst it is simultaneously distorted and fractured by the light bouncing around the gallery space. I read this work as a chilling allusion to the separation of reality from the image that occurs in

modern computer-guided bombing techniques. Just as the revolving screen will hit the viewer if s/he becomes too absorbed in virtual, screen reality, someone on the ground is going to die as the gunner plays his lethal video games.

RETURN TO THE MONITOR AND THE OPTIMAL VIEWING POSITION

As I have argued, a television or monitor, like a screen, establishes an optimal viewing position by virtue of the realist image playing across its screen. This is analogous to traditional sculpture that similarly aims to focus attention and 'diminish the endless perceptual field'.[11] As David Hall has remarked, the ideal viewing position for a Giacometti sculpture returns us to where the artist once stood in relation to his model, which, in Giacometti's case, was said to have been a fixed distance. If we move away from his circular route around the model, we allow the environment to distort his vision and the direct connection with the artist is broken. The work becomes part of an installation and subject to its placing in relation to other objects and the lighting conditions in the immediate environment.

The Canadian artist Stan Douglas devised a multiple video projection that both re-established and disrupted the optimal viewing position by the clever use of sound. *Evening* (1994) consists of three large video projections depicting newsreaders all speaking at once. In front of each newsreader hangs a glass dome that concentrates the sound. If the viewer stands under a dome, the sound of the corresponding newsreader becomes decipherable. Although the speaker is now comprehensible, the monumental image of the newscaster is too close and its constituent scan lines become visible, producing a discontinuity in the narrative and a rupture of the sound and image synchronisation. Outside the domes, the cacophony of voices assumes a palpable presence punctuated by the points of coherence under the domes. The viewer's physical location within the space thus becomes critical to the reading of the work in contrast with much projected work, which fails to problematise the spectator position.

An apparent return to the three dimensions of the monitor with its attendant implications of domesticity and mass communication is evident in the many contemporary works that regularly incorporate monitors. It might be that the low status of early monitor-bound video has been rescued by galleries embracing moving image as the default medium of the new century. Video's standing as high art assured, it is now safe for the monitor to re-enter the gallery. At London's Hayward Gallery, Ann-Sofi Sidén's exhibition *Warte Mal!* (2002) included the obligatory projections, but combined them with a direct, existential confrontation with the object of a monitor. A row of transparent booths contained individual seats and monitors from which former eastern bloc prostitutes described their lives. The traditional medium of self-exposure

24. Ann-Sofi Siden,
Warte Mal! (2002).
Courtesy of the artist
and the Hayward
Gallery, London.

was aptly combined with a pseudo-confessional arrangement of monitors, once again producing a sense of television's anthropomorphism. The implicated viewer, visible to others in the act of voyeuristic consumption, had the illusion that the television/confessional contained the person of the speaker and enjoyed the apparent co-presence of attractive, tragic girls.

The anthropomorphism of the monitor was perhaps not powerful enough for Tony Oursler. Working small, he has returned to a rather disturbing domesticity of the video image. In common with Paik, he has used video technology to recreate the contours of the body and simulate a human presence. Where Paik built up monitor-colossi, Oursler projects grimacing or weeping faces onto dolls or smooth objects. By reducing and distorting the human scale he generates bizarre, malformed creatures, closer to the homunculi of nightmares than reassuring images of another being, just like us. Other artists, like Mark Wallinger and Chantal Ackerman, have returned the image to the monitor,

creating a more distant experience of the image and its simulations. Wallinger reproduces the physical and class remoteness of royalty in repeated sequences of the Queen's coach driving down the Mall while Ackerman arranges monitors in rows in such a way that the viewer moves along in parallel with the tracking shots depicted on the screen. For Ackerman the anthropomorphism of video exists in the viewer's mimicry of the camera and camera operator's journey.

Any use of the monitor in galleries is inevitably tinged with nostalgia as yet another technology heads for obsolescence. With the advent of plasma screens, artists like Bill Viola have collapsed the box and returned the image to two dimensions. In his slow-moving plasma-portraits, Viola is less concerned with reviving the cinematic than with annexing the pictorial traditions of Renaissance painting. Where the play between the two and three dimensions of monitors (surface versus depth) would appear to be lost, the domestic screen remains 'a site of exchange, a creator of illusion, a channel of information'.[12] The monitor/television in its condition as a temporarily illuminated box, whether cuboid or virtually flat, maintains its links to its domestic origins and continually worries the semiotic edge of popular culture. The monitor's mongrel identity draws on a potent though sometimes neglected area of inquiry for contemporary artists who have been tempted away by the technological advances of the 1990s and the demand for spectacle in an expanding art industry.

9

The 1990s and the New Millennium

To refuse to fix meaning is, in the end, to refuse God and his hypostases – reason, science, law.

Roland Barthes

The path from marginal to central is, more often than not, merely a matter of moving work from one context to another.

Julian Stallabrass

BACKGROUND

Throughout the 1970s and 1980s, the slow attrition of 'Master Narratives' such as capitalism, religion and scientific progress caused a loss of faith in traditional belief systems including communism, which Rybczynski called 'the last big idea'. Political theorists, cultural commentators and artists attacked the ideological and ethical standards by which westerners had lived their lives. They showed them to be both corruptible and a product of social, political and cultural institutions as well as the relationships of power they enshrined. In the spiritual gap that opened up, 'advanced' democracies were offered the balm of consumerism and the dream of wealth in a culture of profit, status and celebrity. As western imperialism grew and the power of the multinationals deepened, old points of reference became increasingly unstable, including the church, the family and parliamentary democracy. Even state-run television lost its monopolistic authority with the proliferation of channels and communication systems. The new ideology of consumerism continued to bolster old favourites like the nuclear family and heterosexuality, but now also canonised home ownership, the market economy, money, youth, beauty, and the pursuit of

instant gratification. By the end of the 1980s, any residual belief in the agency of the individual and the power of collective action went the same way as the old faiths and oppositional practices in video diminished. Collectives broke up, economic necessity forcing many into commercial fields while a few successfully maintained their practice, but shed their old political allegiances. In spite of valiant pockets of resistance, political engagement was replaced by Thatcher-Reaganite individualism and the lure of commercial success.

THE COMMERCIAL ALLIANCE AND THE YBAS

Where any view of money exists, art cannot be carried on.

Blake

Towards the end of the 1980s, the intersection of art and commerce became more complex. Increasing numbers of artists worked across both fields and art students demanded a business-oriented education to equip them for careers in the rapidly expanding fields of media and advertising, promotional video, fashion and popular music.[1] For those who continued to explore video in a fine art arena, a steady stream of artist-run spaces came and went. Those state-funded galleries that showed video installation in the early 1980s maintained their patronage and international film and video festivals like Video Positive in Liverpool and the Worldwide Video Festival in Amsterdam continued to flourish. As I have mentioned, television in the UK effectively closed its doors to artists after a flurry of interest and expanded its programming of reality TV, game shows and other forms of light entertainment.

However, everything changed when a short-lived economic boom enriched the late 1980s and the 'young British artist' phenomenon hit the UK art world. A younger generation of street-wise artists exploded onto the scene with a sharp instinct for self-promotion and, this time, with a strong representation of women. Gillian Wearing, Sam Taylor-Wood, Douglas Gordon, Tracey Emin et al staged their own exhibitions and found their entrepreneurial ambitions rewarded when the advertising tycoon Charles Saatchi began to invest heavily in their work. Other commercial galleries followed suit and the large public institutions that had previously acted as arbiters of taste, now endorsed what commercial investors were promoting.

It is not altogether clear why commercial galleries suddenly embraced what they had generally steered clear of – video being ephemeral in form, infinitely reproducible and effectively uncollectible. David Hall holds the view that the improvement in picture quality and the ability to project to cinematic proportions satisfied American needs in particular for video art 'writ large'. It might be that the 1990s propensity to recycle popular culture made it more accessible to a wider, non-specialist audience. It could simply have been that, in the face of

recession, video art was cheap. Jez Welsh takes another view and points to the physical dimensions of video in its installation form. Introducing a sculptural element means that 'the artist pulls off the trick of encasing the immaterial in material form.'[2] The dematerialised object of art was now reconstituted and could be bought and sold like any other commodity. It is possible that galleries eventually conceded that video as the medium of choice for the younger generation was in the ascendant and as a result video began winning Turner prizes in the UK. With video as the new material of art, galleries bought a stake in the business, as they have subsequently been obliged to do with Internet art. Not only did the art object regain its status as the art market picked up, but the artist, him or herself, also became a marketable commodity. Figures like Tracey Emin and Damien Hirst joined the celebrity culture and became household names while their galleries effectively controlled their output.[3] Art patronage of video was not new – over the years, Paik and Viola have been supported by both public and private funds. However, in the UK, video had operated often deliberately outside the gallery system making this new phase of prominence and commercial success a break from the more socialist affiliations of early video artists.

Video now played a central role in the expanding art world of the 1990s. The yBa generation, raised on television, used video naturally and unselfconsciously – and uncritically. Video had always been a marginalised practice and the yBas legitimised the medium as part of their portfolio of talents while showing scant interest in its intrinsic properties. Within a postmodern aesthetic, they played with its conventions with little inclination to critique its ideological ties to the mass media. Popular culture as it is manifest on television and in the music industry was no longer seen as the enemy, but as an integral part of the creative imagination. The loss of the oppositional relationship with the mainstream permitted the introjection of iconic media images that were then made available to artistic reformulation. However, it also defined the limits of individual identity and tied artists to what Kathleen Pirrie Adams characterised as 'wrestling with the icon, continually: and with their full body weight'.[4] This could be a full-time occupation.

The physical and psychical engagement with the ideals of popular culture meant that film, television, fashion and popular music became more significant to the yBa generation than the history of art in general and video art in particular, for which most professed an apparent ignorance. YBas displayed what Phil Hayward called a 'sublime indifference' to the debates and achievements of video history either in the UK or internationally. When video history was cited in any discussion of their work, it was usually restricted to references to a few prominent male American artists, namely Bill Viola and Gary Hill, with a brief nod to Nam June Paik. Perhaps this is not surprising because the new promoters of art and video in the UK were governed by commercial interests

and it isn't easy to market something that is not new. As Brian O'Doherty said in 1986, 'visual art does not progress by having a good memory.' YBa video art showed how easy it is to record over the past.

Without any oppositional stress, the commercialisation of video art in the 1990s led to what Peter Kardia called a 'collectivisation of consciousness', which, he noted, was also a feature of fascist art. This was by no means a blanket phenomenon, but where video drew heavily on uniform popular cultural images there was a danger of blandly reflecting the status quo – a danger that had dogged earlier scratch video and television parody. This is particularly evident in contemporary work by artists like Candice Breitz or Douglas Gordon in which appropriated footage from film and television is apparently deconstructed through repetition, but fails to transform the original while uncritically reiterating its ideological messages. As video was promoted to an expanding and increasingly commercialised mainstream, it lost much of its conceptual bite, but gained in aesthetic impact with an increase in scale and picture resolution. Video art as a counter-cultural practice was tamed first by television in the re-appropriation of its forms and subsequently by the transformation of one of its contexts, the art gallery, into an ever-expanding business empire that nominated video as the ideal medium on which to display its wares.

THE CULTURAL THEORY

Paradoxically, the new celebrity of individual video artists such as Sam Taylor-Wood and Gillian Wearing coincided with a hardening philosophical construction of the self as both culturally mediated and fragmented. While scientists were increasingly emphasising the role of genes in human development, Jacques Derrida's post-structuralist theories once again placed the self firmly in the grip of language. As a vehicle of communication and a carrier of meaning, language was now characterised as unstable and permeable. The self, it was said, could only be understood through language and so became 'unknowable' in any definitive sense. The relationship of the image to reality became yet more tenuous as the other great French theorist Jean Baudrillard extended Derrida's understanding of language to the media and spectacle. Mediatised images of apparent reality are in fact simulations whose primary *raison d'être* is their relationship to other representations in the image-chain, which is itself subject to the twin objectives of profit and status. In the 1990s the sign and its place in the semiotic constellations replaced the old relationship between image and reality. The sign now took precedence over the lived experience it feigned to represent. As Rosetta Brookes put it, 'when the event in its reproduced form becomes socially more important than its original form, then the original has to direct itself to its reproduction.'[5] Many artists illustrated this post-structuralist

vision of web-like linguistic forms by creating labyrinthine, 'rhizomatic' artworks, often with the help of computers.

If an artistic image is merely a simulation in a network of simulations of an event staged for effect, it has no basis in reality and need not be bound by the ethics and laws governing direct action and other forms of representation. This type of reasoning led many artists to grant themselves a licence to recycle the most sensationalist images already in circulation. One example of this process is evident in Johan Grimonperez's *Dial H-I-S-T-O-R-Y* (1997) in which he sets news footage of airplane hijackings to popular songs. Chris Darke has interpreted this work as revealing the 'murderous reciprocity of the media/ terrorist relationship'.[6] This may well be so, but my own understanding of the tape from a screening I attended in Canada is that the artist bought into the mythology of the terrorist as hero – or, in the case of Leila Khaled, as folk heroine. Whatever incisive reflection on the media may be represented by the work, it also insults the reality of the woman whose son lay dying in her arms following a terrorist attack on an airport. She didn't have what Susan Sontag recently described as 'the luxury of patronising reality'.[7] The same could be said for the participants in Santiago Sierra's photographic works that document his employment of migrant workers and Eastern European prostitutes in pointless activities. The artist may be signalling their plight from the safety of a gallery and an international reputation, but for the individuals he exploited to make his point or indeed the mother whose grief Grimonperez is so happy to recycle, the images represent a reality that will live with them the rest of their days.

The cynical postmodern play of signs in the 1990s was underpinned by a kind of nihilistic pessimism, what Jake Chapman called a 'degenerate sublime' that was used to mock the establishment for its archaic conventions and discredited notions of progress. Although burnished to commercial art perfection, the image itself had become so devalued as a political agent that any notion of oppositional practice was dismissed as 'anthropological' and unsustainable. How could one offer a critique of society based on reports of individual experiences or marginalised subjectivities when the very notion of authenticity, so long enshrined in video recording, was called into question? Amelia Jones attacked earlier feminists, including me, for our naïve assumption that it was possible to explore femininity outside the mediations of culture and language as they play out across the image of woman, either live or pre-recorded. Peggy Phelan argued that a kind of radical invisibility was more effective than the precarious business of negotiating an irretrievably marked body or what she called 'the ideology of the visible'. Between postmodernist permissiveness and a recycled Marxist feminist attack on the image, video as deconstructive critique, revelatory or counter-cultural practice was no longer seen to be legitimate. Video was now impotent as a catalyst for change.

TELLING IT LIKE IT ISN'T

The video portrait admits defeat: the human escapes.

Sean Cubitt

Discredited as the medium of truth, video in the 1990s was more often discussed for what it couldn't do than for what it actually achieved. Sam Taylor-Wood's video *Killing Time* (1994) was interpreted by Mike O'Pray as a work that 'subverts portraiture as a mode of revelation'.[8] The installation is based on four of Taylor-Wood's friends miming casually to the soaring arias of Richard Strauss' *Electra*. The mimers make no pretence to any real or imagined relationship with the music and when not mouthing the libretto, they intermittently fidget, smoke, bite their nails or look around disconsolately. The banality of their performance and the unlikelihood that these individuals could aspire to the heights of grand opera have the effect of making tragic their adolescent torpor as well as rendering absurd the excesses of operatic shrieking. Somewhat influenced by Richard Avedon and Peggy Phelan, O'Pray argues that all self-revelation is a kind of performance and acts as a means of concealment as much as of exposition. Taylor-Wood would appear to be interested in what O'Pray calls the leakages, the flaws in the performance that offer clues to the true feelings of the performer. So, Taylor-Wood is pursuing 'truth' after all. She assumes that the non-performances will reveal something of the performers' subjectivities and creates a video portrait of sorts, however mediated.

Unlike Marshall and the new narrativists before her, Taylor-Wood does not believe that transformation might result from the interrogation of culture and how the individual came to be formed. As she says, 'why offer hope when in many instances there isn't any hope. I'm showing things how they are.'[9] Taylor-Wood is undoubtedly right to suggest that video art is unlikely to help people trapped in inner-city poverty, for instance, even when it is made by someone as prominent as herself. However, underlying her comment there appears to be an apathy or sense of resignation to the inevitable alienation of the individual within western culture dominated by the omnipresence of lens-based reproductive media.

As a balance to Taylor-Wood's sense of political impotence in the 1990s, the notion of performativity arose in both photography and video, positing self-revelation and gesture – an acting out across the surface of the body – as dynamic forms of self-definition. The creation of meaning in art now shifted from the 'active' viewer back to the subject of the work who was seen to form the image with the complicity of the image-maker, frequently one and the same person, as in the case of Cindy Sherman. She could play any part, inhabit any persona, no one being more authentic than any other. Her true identity, if there was one, was made up of a hybridised, shifting amalgam of them all. The performative

with its implications of self-invention seems to suggest a core equality that is not, in fact, upheld by social or physical reality. Poverty cannot turn to wealth by pretending and mutton can only very imperfectly impersonate lamb. Peter Gidal reminds us how notions of difference once justified social inequality and now, he says, sameness is fulfilling the same role. 'The "performative",' he writes, 'gives one – and everyone equally – an identity that isn't oppressed because it's all just a masquerade anyway. Sameness as a concept to sell us yet again the lie of democracy in social and personal-psychological terms.'[10]

Unable or unwilling to declare a subjectivity or a social position separate from the catalogue of pre-existing representations, individuals now experienced themselves as an amorphous cluster of aspirational influences and consumer desires. It is this internal fragmentation and almost symbiotic relationship with popular culture that has maintained a strong parodic strain in video into the 1990s. In spite of the theoreticians declaring the project doomed from the outset, the yBa generation were as committed to describing the chains that bind as were their antecedents. Perhaps they were betraying an unconscious hope inherited from the previous generation that naming the tyrant is the first step towards loosening its grip.

PARODY, AGAIN – WRESTLING WITH THE ICONS

In common with 1980s feminists, a need to externalise the internal struggle with cultural ideals manifests widely in women's video in the 1990s both inside and outside the yBa group. Such work often incorporated the aesthetic of the pop song and adopted it as the basic temporal unit, the tape lasting precisely as long as the music. In *I'm Not The Girl Who Misses Much*, (1996), Pipilotti Rist covers the John Lennon song and ineptly, but provocatively, performs it to camera adding another layer of interference in the original by fast-forwarding and rewinding the footage. The image breaks up, abstracts then reforms in a playful digital time game. The distance in years between herself and Lennon, the gap between her flawed performance and the original, the parodic performance of a 1960s go-go dancer and the technological collapse of video realism all point to the imperfect absorption of culture by the individual. This imperfection suggests a kernel of resistance that puts paid to the arguments of semiotic essentialists who see nothing but the workings of language and culture in the make-up of the individual.

Rist is unusual in her willingness to tamper with the realism of the image and *I'm Not The Girl Who Misses Much* is reminiscent of David Hall's classic *This is a Television Receiver* (1976) that similarly deconstructed an iconic media image. No such optical interference exists in Gillian Wearing's *Dancing in Peckham* (1995) in which the artist bops away in a shopping centre much to the bemusement of passers-by. Her dance is balanced precariously between self-

25. Pipilotti Rist, *I'm Not The Girl Who Misses Much* (1996), still of single channel videotape, 5'. Courtesy of the artist, Hauser & Wirth, Zurich, London and Luhring Augustine, New York.

expression and the TV show *Top of the Pops*, a space that Russell Ferguson has identified as existing 'between the parameters that define our social normality and the notional point of unmediated expression'.[11] The ambiguity of the work may contain the crisis of contemporary subjectivity but, without the critical context, it has a tendency to default to the model of one-dimensional sexual display that has been established by *Top of the Pops* and elevated to the level of soft pornography in music videos. In the late 1990s, the American performer Ann McGuire made a series of black and white tapes that dig a little deeper. The works centre on the artist singing versions of sentimental songs, spot-lit on a lonely stage. Although true, her singing constantly veers away from the established formula and seems to skirt the edges of hysteria, drug addiction and madness that were always simmering under the performances of iconic figures like Judy Garland and Billie Holiday. The struggle for self-expression within the mimetic confines of the musical vernacular is what gives these works their tension. Where earlier feminists wore the masquerade like a costume, with an essential self beneath waiting to be liberated, women in the 1990s externalised what was already part of them, namely those elements of the culture that have come to embody their aspirations but which rub up against unnamed energies and desires that call from outside the perimeter fence of the monoculture.

The illusion of mastery that dressing up and impersonation have always promised girls is perfectly encapsulated by the videos of Jane and Louise Wilson, a UK duo who have replicated the editing and performance style of the 1970s TV series, *The Avengers*. In *Normopaths* (1995) the girls are seen crashing through doors and leaping up stairways in pursuit of some imaginary law-breaker. The work is all ironic performance and no narrative and, once transposed to the gallery or fine art context, revisits the formal devices that would, in its original broadcast format, act in a supporting role to the storyline. In the Wilson sisters' case, this stripping away of the narrative to reveal the gestural infrastructure of the series could be read in the context of celebratory feminism, a kind of updated mirror phase projecting a desire to endorse and aspire to the power of the crime-busting Emma Peel. However, there is a certain mannerism involved in the recycling of a popular cultural icon, itself a form of dramatic hyperbole. As David Hall commented, work based on circular, postmodern reiterations are 'critical in their content, but they are not really critical of display'.[12] The internal play of imagery in an otherwise secure deployment of realism suggests the same reverence for the original that scratchists betrayed and casts the 1990s artist less as an oppositional cultural irritant than as an unproblematic product of society, albeit a creative one. The mute mimicry of a female heroine also has a tendency to refute the power of female speech – in that it omits those sharp comments Diana Rigg delivered with such precision. Instead she is re-presented primarily as an eroticised body, whereas sexy athletics were only part of the repertoire of Rigg's original performances.

In the 1990s, the postmodern parody knowingly recycled the ever-present images of popular culture and also, sometimes unconsciously, those of earlier performance art and even the traditions of painting and sculpture. In Cheryl Donegan's *Make Dream* (1993), the artist mimics the films that were made of Jackson Pollock at work and executes her own action paintings. As she paints, her movements evoke the energetic gyrations of the modern music video performer, combining the phallic mythology of Pollock with the sexual provocation of the go-go dancer. Yael Feldman's *Je reviens bientot* (1995) once again revisits the popular song, this time as a counterpoint to the image of a woman sporting a bleeding nose, dripping paint from her body. Cecilia Parsberg extended the painterly theme by spitting colour at the camera, while Cheryl Donegan drank ravenously from a punctured milk container and Stephanie Smith kissed red lipstick all over a woman's body. Michael Curran also favoured a soundtrack dominated by a popular song, this time the ballad *Sentimental Journey* (his version, 1995) and juxtaposed it with his own image. Sporting a black eye from the night before, the artist is seen calmly shaving in the mirror while the beat goes on. These corporeal videos alluded to the repetitive performances of early conceptual video-makers and performance artists like William Wegman, Vito Acconci, Gina Pane and Bruce Nauman whilst embracing

26. Harrison and Wood, *Six Boxes* (1997), videotape. Courtesy of the artists and the UK/Canadian Film and Video Exchange.

the abject and the visceral, as well as the primitivist aspects of action painting. In the UK, Harrison and Wood produced a series of cleverly choreographed physical performances to camera that managed to parody slapstick comedy as well as 1970s performance art exemplified by the exaggerated posturing of the performance groups Nice Style and Station House Opera not to mention the cool lines of modernist sculpture best achieved by Donald Judd. In works like *Device* and *Cross-Over (I Miss You)* (1996), minimalist boxes, stairs and walls are a foil to the absurd physical endeavours that sometimes create an illusion of weightlessness or entrapment and at other times contrive to transform the artists into ungainly puppets in a slow sculptural dance. Harrison and Wood's sculptural references are rare in contemporary work and the main contribution of artists emerging in the 1990s was their bold reworkings of popular culture, music videos particularly, with performance conventions that were becoming such a potent influence on teenage style, behaviour and ambition. Donegan in the USA and Smith in the UK also took on the rhetoric of pornography with its relative gender positioning that involved one selling and the other 'buying into a

woman faking it'.[13] Like other parodic phases of video, these works were mixed in their ability to subvert the original and, like the promos and advertisements from which they drew, many of them had undeservedly short shelf lives.

FILM IN THE GALLERY

With television having reverted to a closed shop, many of these satirical video artists depended on the old avant-garde distribution networks to disseminate their work and only a few, like the Wilson twins, managed to forge alliances with mainstream galleries. Once the galleries opened up, practitioners whose central commitment was to film were first through the door. They quickly realised that with traditional sources of funding drying up and commercial films increasingly difficult to get off the ground, galleries offered a new form of alternative cinema. At the same time, the Arts Council of England and other public funders had budgets to spend on experimental moving image. Established artist-film-makers like Isaac Julien and Mark Lucas, yBa newcomers like Sam Taylor-Wood and Gillian Wearing and artists like Matthew Barney and Kutlug Ataman, whose natural home was in the commercial sector, all took advantage of the new willingness of galleries to embrace the moving image.

Galleries may have regarded their involvement with film as a radical departure, but many artists and theorists proclaimed the death of cinema and recast the gallery as a kind of cinematic tomb, a 'repository for the splinters and debris of cinema'.[14] The demise and ghostly resurrection of film seems to have been triggered by the proliferation of moving image delivery systems – digital games, video, surveillance, multiple television channels and the Internet. Although people still go to the movies, film theorists have now consigned 'Cinema' to a pre-digital past. The digital now marks a threshold before which we are likely to be watching a cast of dead people, spectral Hollywood icons magically preserved and reanimated on celluloid. This association with the past, with death itself, is not yet a feature of video. With a shorter history, video only acts as an embalmer of our youthful faces. And yet, it is video technology that has allowed film to be archived, stilled, and analysed frame-by-frame as in Douglas Gordon's *24 Hour Psycho* (1995). Transferred to video, Hitchcock's masterpiece is slowed to 24 hours, to virtual stasis, the condition from which it started – the stillness of the individual celluloid frame being what Laura Mulvey has called, 'film's best kept secret'.[15] Gordon claims that the suspended animation of *Psycho* reveals the 'unconscious' of the film, a level of meaning of which Hitchcock was unaware. This might correspond to Barthes' notion of the 'obtuse' or supplementary meaning of a film that has no narrative propulsion, seeks no closures, but elicits a more visceral, emotional response in the viewer. This can be the curve of a brow, timbre of a voice, subtlety of a gesture, a beautiful or ugly face that, together with the

intended meaning of the image, creates a polysemous reading. Sometimes these meanings are contradictory and co-exist 'saying the opposite without giving up the contrary'.[16] My own view has always been that in *24 Hour Psycho*, the obtuse 'unconscious' meaning was simply Hitchcock's own skills revealed. As he worked closely with his editor frame by frame, he would have known exactly what subtexts were seeping out of the *mise en scène*. Gordon's contribution is to have allowed us more time to appreciate the film's subtle interrelationship of narrative and image in the context of our collective knowledge of *Psycho*'s now mythic storyline.

24 Hour Psycho is an example of a contemporary fetishisation of Hollywood in general and Hitchcock in particular.[17] Aided by new digital technologies, other film artists are now re-staging emblematic films or key sequences from Hollywood movies. Mark Lewis, a Canadian artist currently working in the UK, has recreated Michael Powell's controversial film, *Peeping Tom* (2000). The original *Peeping Tom* (1960) told the story of a young camera assistant who, in his spare time, murdered women with a camera rigged with a lethal spike. This allowed him to film the terror and gruesome deaths of his victims. In his version, Mark Lewis uses actors to restage sequences that we witnessed being shot by the protagonist in the primary film, but that we never saw. Lewis' 'part-cinema' is a

27. Mark Lewis, *Peeping Tom* (2000), 35mm film (looped), transferred to DVD. Courtesy of the artist.

truncated version of the original. It is both elliptical and circular and depends on its visual richness to achieve the tension and menace for which Powell largely relied on narrative. The results in both Lewis' and Gordon's work are often as magical and unsettling as anything created by Hollywood. Unsettling because the narrative closure of mainstream cinema is denied whilst our scopophilic fascination with the image is indulged. Although there is some investigation of formal conventions following the abstraction of the narrative framework, the attachment to the original has meant that the image is rarely defaced as would have been the practice with earlier experimental film-makers who scratched, painted and colourised found footage. The deconstruction, where there is one, is at the level of cinematic grammar, but not filmic illusionism. As Chris Darke contends, the works appeal to viewers' recollections of the primary film and so constitute a kind of historicism. This differs from the contemporaneity of scratch video in the 1980s, which dealt mainly with broadcast imagery that was currently in circulation.

Cinematic pastiches in the mid to late 1990s reveal the extent to which the creative imagination is colonised by the phantasms of Hollywood film. They are also a form of retreat from the real, a re-immersion in the escapist enchantments of a celluloid dreamland. It is always easier to recycle an elegant, glamorous and illusive past rather than face the uncomfortable realities of the new millennium. As such, the work of artists like Gordon and Lewis have an anthropological or social dimension in that their fascination with Hollywood reflects the preoccupations of an increasingly mediatised and politically disillusioned generation who also nostalgically recycle the sounds and images of the 1950s, 1960s, 1970s and now even the 1980s.

Other film artists in the 1990s used the cinematic idiom in their work, but went beyond the now clichéd 'message' that western identity is formed as much by the silver screen as by family and the state. Michael Maziere, working in the UK, shifts the emphasis back to the power of individual vision and has evolved a lyrical fusion of black and white film clips and original footage. He practises what he calls 'cine-video', a multilayered, intertextual fusion of the personal and the cultural that is also evident in the work of other second-generation experimental film-makers like Nina Danino, John Maybury and Nicky Hamlyn. Filmic references abound in the American Matthew Barney's epic *Cremaster Cycle* (1994–2002) in which staged set pieces evade narrative closure whilst over-compensating with the allure of pure spectacle. Barney rejoices in a kind of baroque mannerism, but like Maziere and Danino, he works principally with his own footage. These artists prove that it is possible to create a new synthesis between the language and world-view of Hollywood and the aesthetic resistance of the individual imagination that is brought to bear on what continually bombards it under the guise of entertainment.

Rather than consigning the ossified remains of cinema to the gallery, artists

such as Matthew Barney and Steve McQueen are seeing the value of their work being shown under cinematic conditions, something experimental film-makers have known all along. The difficulties of holding the attention of visitors to a gallery are partly solved by putting the viewer back in a cinema seat and plunging the auditorium into darkness. The visual field is reduced, distance cues are disabled and concentration on the projected image is virtually guaranteed. Art has always found a place in the cinema, from the days of surrealist film onwards, but early video art was also frequently shown in darkened spaces, grouped into programmed, monitor–based screenings with many of the artists present to enter into live debates with the audience at the end. It was not easy to walk out halfway through especially when subjected to durational works by one's tutors. The UK artist Steve Hawley is all in favour of reinventing the immersive experiences of cinema. Contrary to the views of structuralists in the 1970s, he now regards the cinema as a place of active spectatorship in which the critical faculties remain alive, judging good and bad performances, special effects and storylines based on accumulated knowledge of the cinema. The cinema is a social space, one in which a film is experienced simultaneously with others. It is also a traditional site of subsidiary human activities. As Hawley says, we used to go to the cinema to 'eat, drink, smoke, have sexual experiences and fantasise'.[18] Hawley wants to reinstate what he calls 'non-stop cinema' in which audiences could drop in at any time and settle comfortably with their popcorn while a cycling programme of video-films repeats through the afternoon. Although there would be no coercion involved, non-stop cinema has the potential to re-enchant the cinematic experience sufficiently to entice viewers to while away a day at the cinema, just as we did in the 1960s until all good citizens were instructed to go home by the playing of the national anthem.

THE CONSEQUENCES FOR VIDEO

The incursion of film into the gallery across the 1990s has compounded the displacement of video history that the yBa generation began in the UK. Critics' insistence on film history as the primary conceptual framework for gallery-based moving image art has meant that the links between, for instance, Mark Lewis and the 1980s video-maker Mark Willcox are not discussed and the origins of video as a gallery, broadcast and agitational practice have been suppressed. The knowledge that cinematic language provided the foundation of all moving image art should not mask the fact that a critique of the linguistic and spectatorial specificities of television was a generative impetus for video in the gallery, especially in the UK. Film has its own gallery history, in the UK through the installations of artists like Chris Welsby, Malcolm le Grice and Jill Eatherley. They emphasised the ontology, apparatus and space of film and in 'Expanded Cinema' introduced a crucial element of live performance. The crisis

of the image that film-makers have been experiencing recently seems not to have affected established and recent video-makers. For them, the proliferation of communications formats only enriches the field of potential platforms and strategies of intervention, culminating in Net art where the Marxist-driven desire to bypass a capitalist art market still survives.[19] However antithetical to the participation of artists, television in all its guises remains as powerful a referent as cinema history in the new gallery-based art of the moving image. Outside the UK, Candice Breitz has made works nostalgically based around popular 1980s TV shows and a young breed of 'recombinant' Canadian artists have reinvented scratch video, lifting material directly from current broadcasting. Since more people watch television than visit the movies, these works should be at least as interesting to theorists and commentators as those that relate primarily to Hollywood film.

THE CONVERGENCE OF FILM AND VIDEO

At the turn of the twenty-first century, the distinction between video and film has virtually disappeared now that a technological convergence has taken place in the widespread adoption of digital imaging techniques. As artists, we are now labouring in what Michael Rush calls a post-medium world. Whatever formats an artist shoots on, the work is invariably edited digitally on a computer and displayed by a video projector or monitor. It is just as frequently flattened into plasma screens achieving the resolution of hyper-realist paintings. There are exceptions. In the UK, Tacida Dean deliberately shoots, edits and projects in the gallery with film technology. The apparatus of the projector is a critical if rather museological element in the display of the work. The quality of both the recording and projection of video has improved to such an extent that it is becoming difficult to distinguish it from film. Artists talk about film when they are shooting on video and make what they call videos with filmic proportions and intent. Some, like Gordon, Maziere and Lewis, choose to explore the moving image in relation to its cinematic heritage; others maintain the critical and formal links with early video, casting a deconstructive eye over televisual practices, surveillance, video games and, latterly, the Internet. As video art is itself consigned to cultural history and becomes vulnerable to the nostalgia of commentators like me, I shall end my account by discussing a selection of contemporary works that appear to revisit and in many cases extend the ideologies and formal concerns of the history I have expounded.

POLITICAL ENGAGEMENT

In the last few years there has been a discernible re-awakening of political awareness in video art. This might be attributed to a humanitarian sense of

horror at the ongoing conflicts in the Middle East, on the borders of India and Pakistan, and in the Sudan. Perhaps we will retrospectively identify a turning point in the wake-up call of the scenes of devastation in New York of September 11th, 2001 and the subsequent, bewildering American interventions in Afghanistan. It could well be that the cynical manipulation of UK and US opinion leading up to the GW2 has also rekindled the flame of protest in younger hearts and minds for whom uncensored, divergent information is now readily available on the Internet. Perhaps the energetic protests of the anti-globalisation movement have shown that dissenting voices still can, with determination, make themselves heard.

The return of socially marked content could also be a manifestation of the economic cycles of art. The fine art industry, in line with the wider market forces governing fashion, music and entertainment, trades on the new and is subject to cyclical changes that depend on a certain cultural amnesia as well as the circulation and constant renewal of consumer desire. As time has threatened the yBa phenomenon with obsolescence, it becomes clear that the culture industry needs to be fed with something new. The young invariably desecrate what was sacred to the old. Where the 1990s were largely dedicated to lifestyle tribalism, aesthetic cynicism and commercial success, so we might expect the new kids on the block to embrace a wider sense of community and cultural diversity and also reject the profit-driven structures of the art market. I may be wrong but, ironically, market forces could well thrust socially connected artists into the cultural limelight.

The new political sensibility in art quite logically enlists video as a witnessing medium. Video permits the recording of extended testaments and suits the urgency of speech that was characteristic of agit-prop video in the 1960s. As I mentioned in Chapter 8, Ann-Sofi Siden primarily used video in her London exhibition *Warte Mal! Prostitution after the Velvet Revolution* (2002). In essence, the work is a social document that records the lives of women for whom the Velvet Revolution has brought poverty and the painful option of cross-border prostitution in towns like Dubi in Czechoslovakia. In 2003, Kutlug Ataman also showed a series of extended video interviews with marginalised individuals from his native Turkey, including an elderly theatre diva, a terrorist, a political refugee and a transvestite prostitute. My own work in recent years has been based on extensive interviews with both French and English members of the wartime SAS in an attempt to unravel the story of my father's war.

Where video was the primary medium of witness for these works, the Croatian artist Sanja Iveković, employed video as one among many tools in an investigative process. *Searching for my Mother's Number* (2002) catalogues the artist's search for information in an attempt to piece together the story of her mother's incarceration in Auschwitz. As well as video, the work includes reference books, period photographs and other information laid out on tables

as in a museum or library. Unlike Ataman and Siden, Iveković works from a declared position, in this case that of a daughter searching out her mother's history. A situated point of view also informs Amar Kanwar's *A Season Outside* (1997–2002). Shot along the borders of India and Pakistan, Kanwar's film is a beautifully observed documentary and a personal odyssey. The artist's voice-over describes his search for understanding of the historical conflict between the two countries that forced his family to flee. He laments the failure of reason to prevent violence between an established nation and 'a community forced to take up arms in defence of its identity'.

It is legitimate to ask how these works differ from British television documentaries that have, at different times, interrogated similar issues, sometimes to great effect. Of course, a more insidious type of sensationalist 'freak show' documentary fills our screens on an almost nightly basis, chronicling the careers of mass-murderers, Nazi henchmen as well as prurient and intrusive investigations into the lives of sex workers. Leaving aside the question of sensationalism, which can be a temptation to us all, the first difference is that unlike a television programme that is consumed in private, videos like those of Ataman and Siden, expose viewers to public scrutiny. In *Warte Mal!*, for instance, spectators are watched watching the girls by their fellow gallery-goers. For me, it was not always a comfortable experience.

I would argue that when a work pivots on a declared position in which the artist enters the frame with his or her motives implicated in the work, a kind of narrative equity is established that avoids the objectification of the subjects under observation. In the case of Ann-Sofi Siden, and perhaps Iveković, we might apply Griselda Pollock's argument that a woman artist setting up a dialogue with other women constitutes a 'moment of feminism' transcending the barriers of class and privilege.[20] With a subject such as prostitution, defined by fixed power relations and charged with sexual desire, it is hard to undermine the recuperative powers of the consuming gaze and the egalitarian 'moment of feminism' might well get lost. But these extended individual testaments still constitute a very different approach to an equivalent work on television. As I have argued, television documentaries' tendency to atomise witnesses' narratives results in a loss of their identity and we struggle to remember any one individual with whom to develop an empathetic relationship. All that remains at the end of the programme is the undeclared world-view of the producers and their bosses. Overall, artists allow their subjects to speak uninterrupted, sometimes, as in the case of Ataman, for several hours. The problem that arises in a gallery context is that there is no obligation to commit to the duration. The free-roaming viewer whose spectatorship is to a large extent determined by the short attention span produced by a cultural diet of multiple TV channels, unwittingly replicates the fracturing of individual identities by cruising between images, sampling the juicy bits and editing out what may be too demanding.

However, the work does create the opportunity to stay with an on-screen subject and when the subject is also the artist, then the spectator is offered what Tom Sherman calls 'a point of view closer to the ground, more like one's own perception'. From here, Dan Reeves' memories of Vietnam and Amar Kanwar's experiences of partition in India, both familiar to us in the form of television news, can be 'revisited, or kept alive, or measured for change'. Sherman also makes the point that artists' work can show up the inconsistencies and distortions in the news and in sanctioned television documentaries.[21] Once engaged with the work, the viewer can establish a critical distance from ideologically marked accounts or at least consider an alternative. Julian Stallabrass has suggested that the presence of the artist's subjectivity, the physical space the work occupies and the commitment the viewer makes in wandering its geography all help to make the message more tangible, more real. In contrast to the homogenising effect of information gleaned at a glance from television, visitors to a gallery may find themselves 'grasping a situation imaginatively that before they had only understood intellectually'.[22]

It is the speculative nature of contemporary social video and its apparent ideological neutrality that distinguishes it from earlier political video. Many of the issues we saw in the earlier tapes, at least in the UK, were made in the context of national campaigns addressing employment, health, including abortion, housing, gay and women's rights and discriminatory practices of every kind. Now, the majority of artists work independently of any social initiative, any organised campaign. They nonetheless address the issues of the age and often acknowledge the inherent contradictions of political work. Whatever their strategy, the video-films of these artists turn away from the cultural introspection and latent narcissism of postmodernism and once again attempt to confront the real.

A SENSE OF PLACE, OF HISTORY AND PERSONAL VISION

Political awareness in moving image has been transformed from a clear voice of protest supporting specified campaigns to a speculative sense of place and history with individuals constituted as migrating identities, constantly moving outward and away from their points of origin. Edward Said has suggested that 'modern culture is in the large part the work of exiles, émigrés, refugees.'[23] These displaced individuals are frequently drawn back to their countries of origin, seeking out the borders they first crossed, which are now emblematic sites of diasporic experience as well as symbols of the tension and conflict that they left behind. Armed with the technology, skills and often the ideologies of another culture, they try to construct a viable identity between the sometimes conflicting point of origin and the ultimate destination. As Mark Nash has suggested, there has been a complex 'reworking (of) the colonial archive'.[24] Many

artists seek evidence of past events and transmit them within the witnessing mode of documentary while others take a less didactic approach, reinvesting a landscape or place with the force of aesthetic vision forged between two cultures and charged by individual experience.

Shirin Neshat has turned the moving image into an almost ritualistic experience with her mesmeric black and white installations based on the songs, rituals and social traditions of the Islamic culture into which she was born. *Tooba* (2002) is a simple two-screen projection in which an old woman is seen standing, barefaced and impassive, with her back to a large tree isolated in a walled enclosure. On the opposite screen, groups of men chant in a circle, then emerge from the desiccated landscape and converge on the enclosure like ants. The fate of the woman remains unclear as the men and then other women and children begin to climb over the wall. The allegorical roots of the work remain obscure, but the tension between woman and man, between Islamic censure and western freedoms as well as the more ancient powers of Islamic poetry, written mostly by women, have been recurring themes in Neshat's work and infuse this compelling

28. Shirin Neshat, *Tooba* (2002). Courtesy of the artist and Barbara Gladstone Gallery, New York.

installation.[25] Tabea Metzel, writing in the Documenta 11 catalogue, suggests that the double screen format can symbolise the duality of the work and 'the emotional condition of a woman caught between two worlds'. A similar sense of cultural hybridity is evident in *The White Station* (1999), a single-screen work by the Iranian Seifollah Samadian. Shot in Tehran, *White Station* is a spare, virtually black and white film that observes a female figure dressed in the regulation black chador waiting at a bus stop by a prison-like building, enfolded in a bleak winter landscape. Like a small Lowry figure, the woman walks to and fro, buffeted by the swirling snow. Very little happens. An occasional vehicle passes, another dark figure approaches and walks away and a crow fidgets on the bare branch of a tree. The woman, huddled under her umbrella, waits for a bus that never comes. The sense of confinement within the designated role of femininity under the post-revolutionary regime is reinforced by the cruel extremes of the elements penetrating her winter clothes. Her waiting is the hiatus of women who have been forced to return to the oppression of an earlier age. She is not just waiting for a bus – she is waiting for change.

A return to the site of political events or a place representing the ongoing oppression of a race or conflict between races was already well established in the 1990s in the video installations of the Irish artist Willie Doherty. The cities and lanes of rural Northern Ireland form the backdrop to journeys that are tense with the anticipation of violence. A suspicious shape by the roadside, an obstacle across the track, night-time surveillance of the city all leave the viewer unsure as to the nature of the subject position being depicted – victim or aggressor, social commentator or poet of city lights and the Celtic landscape. The work rides on common knowledge of the 'troubles' in Northern Ireland, but it also opens up levels of projection and imaginative understanding which dry news reports fail to illuminate.

UK artist Steve McQueen uses a similar blend of aestheticisation and social observation in his single-screen projection *Western Deep* (2002). The work is as much an exploration of the textural quality of magnified and processed imagery as it is an exposé of the appalling working conditions South African gold miners endure. Unlike the 1970s coal miners' tapes in the UK, *Western Deep* includes no facts or figures, no interviews or newsreel footage. Viewer, miner and artist are linked by a common physical experience of time enveloped in a claustrophobic darkness and the oppressive bombardment of amplified sounds from drills, lifts and the infernal machinery of underground mines. Sound is also an important feature of Zarina Bhimji's single-screen work *Out of Blue* (2002). The sublime landscape of Uganda comes alive to the sounds of animal and insect life interspersed with the isolated voices of the inhabitants and snatches of radio broadcasts announcing the expulsion of Ugandan Asians in 1971. Lingering shots of derelict buildings hint at the violence that erupted in the recent past. As in Doherty's Ireland, the African landscape becomes a

repository of memory and a possible setting for further conflict. For the present it is seen in repose, as if surprised in a moment of contemplation of its own natural beauty. Cast adrift in another's visionary universe the viewer questions both the thematics of the work and the certainties by which we habitually attempt to construct bounded identities in the shifting territories of what has been termed a post-colonial world.[26]

The non-western work that has most moved me in recent years has included the series of tapes made by the Inuit artist Zacharias Kunuk in collaboration with video-maker Norman Cohn. Working throughout the 1990s, Kunuk recorded 13 'dramas' in which the Inuit people re-enact their own history and traditional way of life. Kunuk found video the natural medium for these performed records

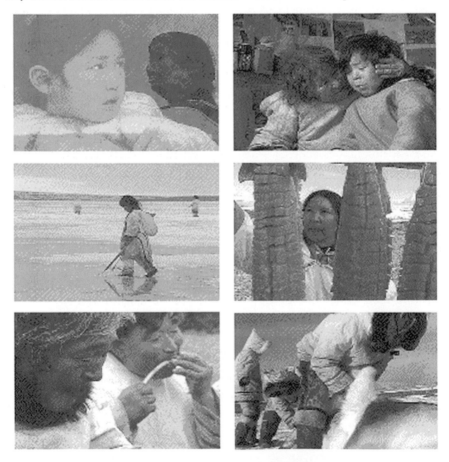

29. Zacharias Kunuk, *Nunavut (Our Land)* (1994–1995), videotape. © Igloolik Isuma Productions.

because his people 'never made books... we kept records in our heads. The history has been saved through our songs.'[27] Video's ability to run parallel with real Inuit time was also useful when it came to recording the patience it takes to catch a seal by a breathing hole, the complexity of family interactions successfully defusing conflict and the duration of long sledge rides through the arctic landscape in search of good hunting. More than any, these works propose an alternative aesthetic and cultural model to what Kunuk describes as 'the Shakespearian drama of conflict' that still dominates the work of many western video-film-makers. Far from attempting an escape from what Nadja Rottner calls a mono-perspectival approach to image-making, through 'a degree zero that has no apparent meaning, syntax or narration',[28] Kunuk situates his work in an explicit culture, history and landscape. He allows the subjects of his work to determine the story they tell within a kind of radical specificity and, through duration, evades being constituted as 'other' to the western monoculture Rottner decries.

Politically connected video, then as now, walks a moral maze. Nowadays it is, in part, compromised by its newly found fame in the elitist environment of art emporia and art fairs across the western world. It is always plagued by problems of exoticism and special pleading and risks being complicit in the containment and diffusion of difference. At times, it has been accused of re-exploiting the misery of others for personal success in an international art market. As I have argued, socially conscious video in the West has lost its connections to political activism, to actual social movements whose aims it shared in the 1960s and 1970s. It can no longer follow the admonishments of 'Third Cinema' to avoid simply 'illustrating, documenting or passively establishing a situation'. It would be hard now to attempt the alternative, 'to intervene in the situation as an element providing thrust and rectification'.[29] New political video operates in a different way. It evokes rather than preaches, emotes rather than shocks and acknowledges the complexities and conflicts of multicultural identities in the modern world. It has introduced aesthetic sensibilities and forms that enrich the canon and, finally, it has devised ways of reviving a contingent humanism as an antidote to the impasse of postmodern cynicism.

AUTHENTICITY AT THE EXTREMES

When viewed from a structuralist position, doubt could still be cast on the validity of political work even when it is based on stories from the Third World. As we have seen, the reliability of lived experience as a guide to reality has been under attack by theorists since the 1960s. One solution to the loss of authenticity has been the exploration of extreme experience, a place to which the mediating agency of culture supposedly cannot follow. Much influenced by the writings of Georges Bataille and driven by a desire to cast off the shackles of

acculturation, artists have explored the limits of endurance, pain and sexuality as well as 'mind expanding' drugs. Bataille would have it that in such moments of abjection or bliss, a common humanity is experienced that goes beyond the confines of the individual bounded by social convention. Here, one would hope to experience Barthes' notion of *jouissance*, that ecstatic slipping and sliding across meaning that precipitates a shattering of cultural identity and the loss of ego. The 'Aktionist' performance artists of 1960s Vienna were the first to harness the abject and used shock tactics, ritualised humiliation, self-mutilation and an orgy of bodily fluids to induce a cathartic disruption of bourgeois conditioning in the audience. Many of these performances were recorded in the films of Kurt Kren and influenced the next two generations of live artists, including Gina Pane in the USA, Marina Abramović in former Yugoslavia, Stuart Brisley in the UK and Nigel Rolfe in Ireland – all of whose performances were recorded on videotape. Video artists realised that the image itself could induce a similar emotional disruption in the viewer and, in the 1990s, Julie Kuzminska created vertiginous visual acrobatics and rock-laden soundtracks to complement the extreme performances of the French circus performers, Archaos. Kuzminska found in Archaos a beauty, a violence and what she called a 'spiritual chaos' that offered freedom in its acknowledgement of the essential futility of human existence. In *Dead Mother* (1995) the performance artist Franco B added fear and loathing to these nihilistic tendencies. Images of self-laceration and blood-spitting combine with a harsh electronic soundtrack and sequences of the artist's lips sewn together to suggest a deeply conflicted relationship with his mother, not to mention his own psyche. The addition of digital effects to this self-inflicted physical abuse created a decorative dimension and, curiously, recast Franco B's actions as the helpless rage of childhood dressed up in an act of adult purification through horror.

Self-mutilation was taken to an extreme by the French performance and video artist Orlan who, in the 1990s, underwent a succession of operations under local anaesthetic. The image of the artist was beamed live from the operating theatre while she kept up a running commentary. Meanwhile, the surgeon went about transforming her into ideal images of feminine beauty enshrined in the history of art. Like many performance artists, Orlan regards her body, not as a temple, but as an art object, a material to be moulded and marked like wood or bronze. Orlan has stated that where women's bodies are inscribed by culture, she creates her own language of the flesh through her actions and thereby stimulates debate in the wider community. The intention of her 'carnal art' is to 'demonstrate the vanity and madness of trying to adhere to certain standards of beauty'.[30] However, she also celebrates advances in medicine that have opened up the body to the human gaze and overturned centuries of pain and suffering. As Orlan frequently proclaims, *'Vive la Morphine!'* The artist believes there are certain extreme images that render video technology transparent. They bypass

the distancing effects of video's imperfections and short-circuit the mediating force of language and acculturation. Eyes are turned into 'black holes' that swallow up the images and cannot prevent them from hitting where it hurts, below the belt of representation. Marina Abramović has expressed a similar desire to circumvent the limitations of language through an exploration of the body in extremis: 'I want to lead people to a point where rational thinking fails,' she declares, 'where the brain has to give up.'[31] For Abramović, it is only through the body that we can experience authentic experience: 'It is real, I can feel it, I can touch it, I can cut it.'

If Orlan and Abramović are right and opening the body is one of the images that is so inassimilable to the rational mind that we instinctively close our eyes, then Mona Hatoum has left us gaping in fascinated horror by exposing the inside of her body to the camera.[32] However, it is Annie Sprinkle who transcends the older feminist struggles with the body politic by breaking the final taboo and allowing others to violate the boundaries of her body, entering her with their own. In *Sluts and Goddesses* (1994) Sprinkle's topic is sex. Being an established sex worker, she knows the subject well. Hers is not the elliptical gesturing towards sexual acts that we considered in Donegan's tapes – Sprinkle deals with the real thing. The depiction of sex in artists' moving image is nothing new. Back in 1964, Carolee Schneemann's magnificent film *Fuses* established the desiring female subject by showing the artist happily, Hippily copulating under the dispassionate gaze of her cat. Annie Sprinkle does something different. *Sluts and Goddesses* comes across like an afternoon TV show from the 1950s, full of good advice to those of us who are 'homemakers'. Instead of recipes for apple pie, Sprinkle's cosy counsel addresses the problems of women's pleasure illustrated by explicit sexual material of a masturbatory and Sapphic nature culminating in Sprinkle's impressive five-minute multiple-orgasm. In contrast to late-night Channel 5 eroticism in the UK, Sprinkle explodes accepted codes of 'tasteful' heterosexual eroticism in her tour de force of female pleasuring. Whether she and the other artists achieve a moment of authenticity is debatable, but *Sluts and Goddesses* certainly evades capture by language. To my mind, it is unclassifiable.

THE NEW FORMALISTS

Now that we have settled into our new century, there are signs that, as well as a certain political sensibility, abstraction and a spare minimalism are re-entering the plastic arts. Although narrative is fundamental to the moving image, a more formal strain of video was maintained throughout the 1990s by artists like the Irish video-maker Nick Stewart whose 1996 *Familiar Image* consists of measured sequences recycling static, found photographic portraits for which he offers no biographical details. In later work, employing slow motion, Stewart recorded individuals moving trance-like through the films of spray under Niagara

30. Portrait of Annie Sprinkle, from the cover of *Sluts and Goddesses*, Video Workshop (1994). Art Director: Leslie Barany. Photographer: Amy Ardrey. Courtesy of Annie Sprinkle.

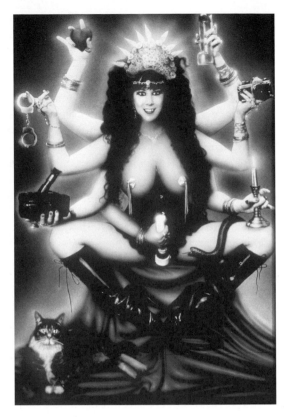

Falls. Like Bill Viola, Stewart harnessed naturally occurring features of the landscape, such as heat and rain, to distort and veil evidence of human life. The technology that both reveals and conceals is always implicated in these works as well as the fugitive nature of human existence. The impulse metaphorically to smear the lens and defuse the image is evident in the recent work of UK artist Dryden Goodwin. He displays the old interest in the characteristics of the medium whether he is working in film, video or drawing. Reviving the rapid-editing techniques of scratch in his videotape *Hold* (1996), Goodwin constructs a scratched version of what he sees when he wanders the metropolis, surreptitiously observing its inhabitants. Working on the edge of perception, *Hold* devises a febrile video impressionism in which individuals flicker briefly into life before being extinguished by the next in line. The resulting optical effect is curiously immersive however much we are aware of the technological tricks that created this formal, digital tapestry of ghostly urban dwellers.

The lost youth of the inner city has long held a fascination for the US artist, Larry King. Like Goodwin, he subjects what would otherwise be documentary footage of teenage boys to the abstracting effect of video manipulation, but this time by going back to the old technique of re-scanning and zooming into a section of a television screen. In *Nate, G-Street Live* (1992), an individual boy is picked out from a group appearing on a New York public access TV programme. His adolescent awkwardness and fragile sense of identity are accentuated as his image struggles to take form through the fractured surface of the degraded video image. The Canadian Stan Douglas has also revived a modernist interest in the technology by slowly pulling apart the two electronic fields of a projected image. In *Pursuit, Fear, Catastrophe: Ruskin, B.C.* (1993), an image of the dramatic Vancouver coastline splits into its two constituent (odd- and even-lined) fields. Like drifting double vision, the image divides while voices from different parts of the installation urgently whisper stories of Canada's colonial past. In common with Mary Lucier's sun video-drawing, the work exploits an electronic fault line to reflect on the nature of technology, the fractured and incomplete history of the location whilst paying tribute to the grandeur of the Canadian landscape.

With the advent of digital technologies, editing has become much faster and more accurate than it was in the days of scratch. Christian Marclay has developed 'Plunderphonics', a form of sampling that creates musical compositions entirely made up of existing material. In Germany, artistic duo Kurt Hentschläger and Ulf Langheinrich have created what they call 'Granular Synthesis'. This is a method of combining 'grains' of appropriated sounds with images of individuals and reconstituting them as unholy abstractions in which people are made to behave more like machines than human beings. American artists such as Jennifer and Kevin McCoy have reinvented Dara Birnbaum's television appropriations by restaging and abstracting well-known tele-filmic genres. As I have mentioned, Candice Breitz has revived the UK scratch aesthetic in her repeat-edited fragments of *Dallas* and other iconic TV series from the 1980s. Breitz also isolates key moments in 'women's films' juxtaposed with sequences of the artist miming to the same soundtrack. Breitz sees herself as an active consumer, simultaneously 'pop-guzzler' and 'pop hacker' who once again attempts to harness the power of the mainstream. Earlier, I have referred to a younger generation of Canadian artists who purloin imagery from television and the Internet and mould it into what Tom Sherman has dubbed a 'recombinant' art. They regard their version of scratch and appropriation as a way of displacing the tired identity politics of their elders. Scrambled and scratched into virtuoso techno-Pollocks, the works of Tasman Richardson, Jubal Brown and Leslie Peters refuse the established narrative traditions of Canadian video. Not only that, but they also dismiss the older generation's preoccupation with theory. 'I don't care to know about postmodern theory,

the juxtaposition of images or the social underpinnings of cultural symbols,' writes Richardson in a statement issued by Vtape in Toronto. These young 'recombinants' play with the technology, and, like the earlier conceptualists, mess with its functions. For Woody Vasulka, technological interference was part of a search for enlightenment and, as he says, it was 'the deficiency of the system that told you something'. However, the recombinants justify their visceral optical de-compositions with a throwaway anarchist philosophy that 'celebrates the beauty and purity of the on-going nature of true revolution'.[33] Whatever Brown professes and whether the revolution is taking place in the image or in his own activities, he and his colleagues are also accomplished formalists. They are contemporary video painters who manipulate mass media imagery and digital technology with great skill. They use off-air material like any other colour in their palette of electronic abstraction.

Beyond the pure computer experiments of video graphics, it is rare nowadays to find artists investigating the workings of the technology itself. The Vasulkas, now living in the USA, continue their research into the electronic signal, 'the organising principle of the image', in the optimistic hope of finding a code that 'is not contaminated by human ideas and ideologies and psychology'.[34] Chris Meigh-Andrews in the UK takes a more pragmatic view, believing that 'however far into the wires and components you go' the 'technology embodies the intention of the designer and the culture that the machinery comes out of is built into the technology'.[35] Throughout the 1990s, his work demonstrated a similar fascination with the technology, but the social and psychological dimensions were never lost and were underscored by a certain visual poetry and a gentle irony. In his installation *Perpetual Motion* (1994), a monitor is powered by a wind generator, itself activated by a large standing fan, in turn powered by the mains. The image on the monitor is of a kite apparently buffeted by the wind from the fan. The impossibility of the material relationship between fan and kite indicates the cultural dimension of televisual illusionism whilst the causal circle that the installation sets up is analogous to the flow of energies in nature. The work also conjures up the flow of ideas and information traversing the media and passing through and between individuals. Finally, in spite of its 'cheat' of using the mains to generate wind power, it makes a plea for renewable sources of energy and a more harmonious relationship with the natural world.

LANGUAGE AND THE SELF

In the last decade, artists have used video to represent a positive view of technology as an integral part of the natural world (Meigh-Andrews), as an escape into a 'utopian disengagement' from culture (Vasulka), as pure image (Stewart) or as rampant anarchy (Brown). On the other hand, many would

agree with Steve Hawley who believes that 'video's main attribute is its ability to dramatise dialogue, disseminate information and act out debates.'[36] In the 1990s, Hawley developed his earlier investigations into language and its relationship to identity, through dialogic videos, notably in *Language Lessons* (1994) made in collaboration with Tony Steyger. As I described in Chapter 4, the work takes the form of a documentary about invented languages like Esperanto and, in the case of Volapuk, a system of communication adopted by only a handful of people worldwide. The alienating experience of being subject to the powers of a language that is not one's own makes a brief appearance in a memorable sequence in John Maybury's *Remembrance of Things Fast* (1996). He has Tilda Swinton deliver a digitally fragmented monologue based on the memory of being in hospital and undergoing brain investigations. There, she is subject to the obfuscating language and alienating institutional practices of the medical profession. As well as implicitly critiquing the medicalisation of human life, Maybury indicates the physiological dimension, the delicate relationship of grey matter to the proper functioning of language. Maybury's tape speaks of the fragility of our mortal coil and that part of it which supports language whereas Hawley links language to the democratic aspirations of those who believe the world would find harmony if we all spoke with one tongue.

Displaced or disrupted speech is the basis of Gillian Wearing's *2 into 1* (1997). In a kind of video ventriloquism, a mother mouths the pre-recorded words of her two sons, whilst they mime to her own descriptions of what it is like to bring up two forceful boys. The 'speaking in tongues' or transposition of words is comical at first, but it soon brings into sharp relief the dysfunctional relationship between the mother and her offspring. The sharp observation of these miniature machos lording it over their mother makes this work a natural inheritor of feminist traditions in video. Like the work of artists such as Martha Rosler and Mona Hatoum, *2 into 1* witnesses the seepage of patriarchal ideologies into the domestic realm and family relationships, to the extent that sons can oppress their own mothers without compunction. The legacy of feminism is evident here and is said to operate at an unconscious level in many women's videos from the 1990s. However, the transposition of voices in *2 into 1* implicates the mother as well as the sons. Where do these boys learn their attitudes? From the evidence of Wearing's tape, at least in part, from their mother's inability to assert herself in the home, which then begs the question, how did she learn to be a doormat? And so on. Where earlier feminist work might have cast the man as the natural enemy, Stephanie Smith and Edward Stewart suggest a delicately balanced interdependence underscored by the mutual threat of violence. In *Mouth to Mouth* (1996) Stewart is seen submerged in a bath while Smith kneels beside him, periodically plunging her head in to give her partner a mouth-to-mouth supply of air. The decision to keep him alive rather than let him drown is not presented as a certain outcome. This work is

31. Gillian Wearing, *2 into 1* (1997), video broadcast on Channel 4. Courtesy of Interim Art, London.

part of a continuing investigation of masculine and feminine interaction through the filter of the artists' own relationship. It is a direct descendent of *Breathing in, Breathing out* (1977), a very similar video by Abramović and Ulay in which the artists are locked into a continuous kiss of life, breathing into each other with the resulting depletion of oxygen being a threat to them both. According to Abramović, they saw their union as total, 'creating something not myself or his-self but THAT-SELF'.[37] Unlike Abramović and Ulay, Smith and Stewart are no longer working within the context of a visible feminist movement that might have cast them along the lines of a strict patriarchal power relation, an imbalance that Abramović was actively seeking to rectify. Wearing, Smith and Stewart belong to a postmodern era in which the old oppositions are no longer felt to be sustainable in theory or in life.

CHANCE IS A FINE THING

In the 1990s, Wearing scrambled voices and identities, Smith and Stewart recast the war of the sexes on more equal terms and narrative itself was once again subverted, this time by another technological advance. Artists like Stan Douglas

and Adam Chodzko began to use computers to introduce random elements to abstruse narratives, a chance technique that was already well established in avant-garde music from John Cage onwards. Douglas has produced highly theatrical scenes that are shuffled to create endless narrative permutations. In the UK, Steve Hawley is also randomising image, sound and subtitle for his forthcoming series of 'non-stop cinema' works. No two visitors to the gallery or movie theatre see the same work. The arbitrary nature of language and its tenuous hold over meaning constitute the overriding themes of such works. Their refusal of linearity in the deployment of narrative themes promotes a less goal-oriented, secure conceptual framework and introduces a more maze-like, aleatory and non-hierarchical approach to storytelling. Chance in art, as in life, throws up the real challenges and surprises.

HIGH-GLOSS AND SOAPS

The influence of dominant forms of cinematic and televisual narrative persists, even when lyrical, fanciful or chance elements are introduced. The experience of life as an extended soap opera is reflected both in the choice of narrative idiom and in the increasing adoption by artists of Hollywood's high-gloss production values. Video-makers like Eija-Lisa Ahtila create pseudo-soaps in which actors perform significant or difficult moments in life, drawn from stories told to the artist by real people. In *The House* (2002) a young woman isolates herself in a woodland cabin and, like Lilian Gish in *The Wind* or Catherine Deneuve in *Repulsion*, she begins to imagine from external sounds that people and objects are about to burst through the walls. Unaccountably, the girl transforms herself into a version of *Peter Pan*'s Wendy and takes flight through the woods. The escape into fantasy might be interpreted as the last resort in a world of manipulated desires. For his part, the Canadian artist Mike Hoolboom describes his work in the 1990s as 'documentaries of the imaginary'. No longer attempting to pursue reality in the medium of truth, his tapes are 'more faithful

32. Stephanie Smith and Edward Stewart, *Mouth to Mouth* (1996), videotape. Courtesy of the artists.

renderings of how I dream, or imagine the world to be, or imagine my place in it'.[38]

If the new task of moving image is to transmit the magic of dreams, then the spectacle of video is now as important as its ability to convey information. Even Bill Viola is polishing his act. Embracing the new high resolution of digital video and plasma screens, he links video to an earlier purveyor of dreams, to the High Renaissance. Appropriating the themes of religious painting, he has been producing a series of videos that deliberately aspire to the condition of painting in their hyperrealist crispness. Cinema and fresco painting combine in video once again to astonish and captivate the jaded eye of the contemporary media junky. Spectacle is the binding agent, a role once played by the Christian beliefs evoked by Viola's work. Gradually, through the 1990s, artists have played down video's traditional role as a medium of witness and concentrated on its power to conjure up an atmosphere, suggest a state of mind and stir the emotions. The individual subjectivity of the artists, their televisual dreams and hallucinations are given a Hollywood makeover with the high resolution of plasma screens and large-scale digital projections. In this respect, video art clearly shares with mainstream film and video the desire to transport and enchant its audiences. In this post-mesmeric age, its visual culture saturated with extreme imagery, it is not an easy task to enthral an audience.

REALITY VIDEO, REALITY TV AND THE INTERNET

When you are bending down looking at somebody's anus,
someone else is looking at yours.

Senegalese saying, quoted in Trinh Minh-ha's *Naked Spaces: Living is Round* (1985)

The return to art history, lost faiths and the imaginary may have been partly prompted by the colonisation of 'the personal' by reality TV. However, many video artists have continued to use social documentary formats based on empirical research among individual members of society. We saw how Ann-Sofi Siden worked with European prostitutes, Kutlug Ataman with transvestites and ageing divas, and myself with veterans of the Second World War. For her part, Eija-Lisa Ahtila has focused on teenage girls, Georgina Starr on people she has never met, while Gillian Wearing took as subjects alcoholic vagrants and anyone who responded to her advert for individuals willing to confess all on tape. Those who 'confessed' shared the same compulsion that reality show subjects have to expose themselves to the nation. They know that they must satisfy broadcasters' insatiable appetite for the salacious and the grotesque and so construct identities and one-dimensional 'life crises' that will bring them their fifteen minutes of fame.[39] Viewers revel in the pleasures of *schadenfreude*

or, as John Stallabrass calls it, 'holidaying in other people's misery'. As I argued in Chapter 7, the subjectivities represented in reality TV are removed from any social or political context. Although a large degree of self-reflexivity is maintained, down to the camera operators periodically being drawn into the fray, what is kept hidden is the programming, funding, commercial and political pressures that govern the style and content of broadcasting. Television as an institution is still veiled in secrecy. Many years ago, Rosalind Krauss accused video artists of retreating into a narcissistic, hermetically sealed world delimited by the closed-circuit, corralling artist, on-screen image and camera. There is little doubt that reality TV does much the same work, but this time manages to separate the mass of individual couch potatoes not only from their own lives but, in the one-dimensionality of the representations they see on the screen, from any deeper understanding of contemporary life.

Video art embracing the personal can just as easily share television's dubious obsession with 'freak show' documentaries and the narcissistic exhibitionism that is as endemic in art as in televisionland. Tracey Emin unashamedly spills her guts in her art as she did famously on a BBC *Newsnight Review* debate in which she drunkenly staggered off the set whilst giving her co-panellists the benefit of her colourful views on art in general and the Turner Prize in particular. Unlike feminists' careful linking of their experiences to a critique of a patriarchal political system, Emin deals in individualised acts of excess. As she happily declared to a television interviewer, 'I wasn't confessing, I was throwing up.' The 1990s did not invent narcissism. Even 1980s feminists could indulge in introspective confessionals, much encouraged by the unblinking stare of the video camera and its ability to record over long periods of time. One might think that any woman's experience aired in public is by extension a political act, especially at times when women have not been able to speak out. Back in the 1980s, Martha Rosler held the view that the personal is not political when 'the attention narrows to the privileged tinkering with, or attention to one's solely private sphere, divorced from any collective struggle or publicly conjoined act and simply names the personal practice as political. For art this can mean doing work that looks like art has always looked, that challenges little, but about which one asserts that it is valid because it was done by a woman.'[40] Contemporary reality television and the individualism of art in the early 1990s contributed to the gushing of purely therapeutic confessionals throughout the culture and did little to change the conditions under which people lived.

The Internet has now become a major repository for these liturgies of neurotic interiority. Individuals set up web cameras in their homes, sometimes one in each room, so that the world can tune in, 24 hours a day, to the banality of their lives.[41] Chris Darke asks perceptively, 'what is video voyeurism after all, but a kind of intimate surveillance?' Contrary to video's traditional claim to offer an encounter with reality, this two-way gaze, this mutual super-vision

constitutes a flight from reality. Both viewer and viewed suffer a 'deflection of consciousness away from the social towards a twilight zone of interactive waking dreams'.[42] It is electronic contact with those spectral presences on the Internet that became the subject of recent work by the Canadian video and performance artist, Tom Sherman. *SUB/EXTROS* and *HALF/LIVES* (2001) are constructed from downloaded footage of unnamed webcam broadcasters. Men and women of all ages and physical types sit, apparently transfixed by their monitors, their faces lit by an unearthly greenish cast emanating from the screen. Sherman adds to the slow-scanning images his own soundtracks consisting of a combined monologue and music track composed in collaboration with Bernhard Loibner. Although intent on long-distance communication, these 'webcamers' seem painfully alone, addictively plugged into an interaction, not so much with another person as with a system of communication that allows the illusion of contact while avoiding the risks of face-to-face human intercourse.

The French artist Patrick Bernier actualises the desire of webcasters to open the intimate spaces of their homes to others. In *Hébergement/Hostings* (2001) he approaches individuals offering a link to their website from his exhibition in exchange for lodgings. In this way, Bernier is 'running through the two-way mirror' of the Internet and physically invading their homes. 'Already a voyeur, I make myself visible', he declares.[43] Having reached the inner sanctum, Bernier

33. Tom Sherman, *SUB/EXTROS* (2001), videotape, 5 min. 30 sec. Music: Bernhard Loibner. Courtesy of the artist.

the artist-interloper reveals those parts of the house that the restricted, keyhole range of the webcam cannot reach. Artists in the UK, like the Wades and Fran Cottell, are also frustrated by the lack of real contact on the Internet and have opened their homes to the public. In the late 1990s and early 2000s, there has been a spate of 'relational' art that involves the public in participatory activities like eating, telephoning or kicking a football around the gallery. I take this as further evidence that artists are combating the fear of actual human contact fuelled by virtual reality, cyber sex and other inventions of the communication age. Back in 1988, another French artist, Pierrick Sorin, made the definitive parody of artists' and webcasters' compulsive exhibitionism. *C'est mignon tout ça* (1988) reveals the artist admiring his own anal caresses by means of a closed-circuit video system whilst dressed in women's black underwear. The widespread navel- or anal-gazing that the work satirises confirms the dissatisfaction and lack of completeness that Sherman and Bernier's Internet subjects also betray. It would appear that with the help of video cameras, many of us are slipping into an exclusive relationship with our own nether regions. The question then arises: how can the twenty-first-century video artist combat both the insidious narcissism of western culture and the undifferentiated information overload to which we are all subjected?

IN PROVISIONAL CONCLUSION

Video began life as a counter-cultural force worrying the edges of both fine art and broadcast television with which it shared a common technology. Over the past forty years, video has moved steadily from a marginal practice to the default medium of twenty-first-century gallery art. Here, the convergence of formats precipitated by the advent of digital technology has brokered a merger between the parallel practices of artists' film and video. With television, fashion, advertising and the pop industry no longer regarded as the enemy, many artists now draw freely from existing cultural genres without feeling the need to develop a critical stance either towards their content or the position they occupy in the marketing structures of a consumer culture. Moving image artists not only plunder popular cultural sources for their art, but they also apply their creativity to commercial fields with many acting as a bridge between the two. With the exponential expansion of the art world in the last decade and institutions like the Tate Modern in London drawing in unprecedented numbers of visitors, awareness of artists' moving image is now widespread. I doubt that there exists an advertising or television executive who hasn't heard of Bill Viola. Video has come a long way from the days when a dozen aficionados of the medium gathered after hours for a screening of 'difficult' work at a smoke-filled Air Gallery in London.

Many of the belief systems and counter-cultural ambitions of the early avant-garde have dissolved into postmodern webs of signification and individual expression. Theoretically, within a plural and pseudo-egalitarian visual culture, no one representation is given more weight than any other, although the actual visibility of artists ranges from rock-star status to virtual obscurity. A free-floating intertextuality has held sway for the last decade against a background of an ever-diminishing, but ubiquitous, monoculture. Promiscuously quoting the canon of popular culture and high art, contemporary image-makers appropriate the original while often reducing the act to stylistic gesturing that is only as good as its novelty value. Within a culture defined by a short attention span and an insatiable desire for the acquisition of property and consumer goods, art struggles to defend its traditional right to address the complex and unfathomable questions of human existence. Seduced by the rewards of venture capitalism or a simple desire to make a living, video artists have bought into the market place represented by the commercial gallery system, whilst simultaneously attempting to create in their work an oasis of calm in what Chris Darke calls the contemporary 'image storm'.

The gallery as well as civic spaces have been turned into moving image installations where an aesthetic of spectacle adapted from Hollywood film has been grafted onto deconstructive methodologies left over from an earlier age. Although many of the radical formal and conceptual innovations of early video art have been absorbed by the mainstream or been lost under the mass amnesia of a commercialised art world, many of their methodologies have survived and are reinvented against a changed social, political and technological landscape. Some artists are disillusioned with what they see as the creative bankruptcy of popular entertainment. In the case of figures like Bill Viola and Daniel Reeves, they are adopting a new asceticism, a contemplative stillness that both counters the 'contemporary excess of meaning and events'[44] and turns the gallery into a modern cathedral of art. People now go to galleries as a refuge from the 'image storm' and for spiritual nourishment on Sundays when they used to go to church.

As we turned into the twenty-first century, a revival of socially engaged art, of a 'relational' art with a global reach, looked to shatter the postmodern ennui of the yBa generation. This new political awareness was only occasionally the product of cultural tourists entering an exotic land and bringing back curiosities for the amusement of a superior nation. To my mind, the most interesting work emerging in our so-called post-colonial world has been the mobilisation of indigenous creative energies whose vision, though inevitably marked by western influences, cannot but change the conceptual framework and, indeed, the form that art will take in the future. In the films and videos of artists like Shirin Neshat and Zacharias Kunuk, political awareness is not seen as an alternative to aesthetic considerations, but as intrinsic to the business of

speaking out. Beauty and horror co-exist in the reports they send back of their experiences in what Germaine Greer has called the 'unsynthesised manifold', in the messy trenches of reality.

Where traditions of video art persist, moving image will always be deployed as the factual medium, whether as evidence of historic and political events or as a personal archive. Tom Sherman warns against the use of video as a catalogue of memory binding together 'the loose ends of our imperfect memories'.[45] The realism of video has a tendency to make us forget how easily it is edited and reworked just as our memories are constructed and reconstructed over time. For those of us in the West, the moving image artist will always be up against the editing of reality in pre-existing forms of television. Video art will, of necessity, maintain a dialogue with video games, picture messaging, the proliferating linguistic practices of the Internet and whatever communication systems the new century throws up. In this context, artists will constantly reflect their times, but they can still act as the 'ghost in the machine', the irritant that questions the power structures and entrenched practices of the image-brokers. In their constant search for innovative imaging techniques, they will extend the boundaries of what is possible with new technologies and communication systems. Tom Sherman has proposed that in the information age, artists could act as 'intelligent agents', guides or ciphers steering viewers through the morass of undigested information that bombards us every day. Artists are endowed with the skill of repositioning the viewer's perceptions and drawing meaning out of the clamour of an increasingly mediatised world. They will always illuminate the 'other' point of view, the blind side, that which is hidden under the manipulations of vested interests dominating the political, industrial and imperial West.

By virtue of their medium, moving image artists will always be in the business of enchantment and wonder. They will systematically pursue beauty even though, in the past, few have admitted to this quest. The aesthetic dimension of moving image has been harnessed as a conductor of meaning from the beginning and its ability to move the emotions will continue to play a part in whatever project artists undertake. Given my background in oppositional video, I would like to think that artists would set aside their disillusionment with party politics and once again contribute to collective endeavours like the anti-capitalist movement, environmental conservation and the international condemnation of American expansionism. However directly or indirectly they address contemporary issues, artists must always ask the difficult, unfashionable and prescient questions. There is a degree of clairvoyance involved, a leap of faith and a mobilisation of that old enemy of postmodern cynicism, the unruly artistic imagination.

Notes

CHAPTER 1: INTRODUCTION – FROM THE MARGINS TO THE MAINSTREAM

1. Throughout this book, I use the term 'televisual' in the sense that it was first employed in the 1970s by Stuart Marshall, namely to denote the language and representational conventions of realism in broadcast television with the implied receptivity, if not passivity of the viewer. I distinguish the term from John Thornton Caldwell's later use of the noun 'televisuality', referring to visually arresting material on television designed to harness the aesthetic sensibilities of the viewer. See Caldwell, *Televisuality: Style, Crisis, and Authority in American Television*, Rutgers University Press, 1995.
2. The Sony Portapak was a bulky portable video recorder that was powered by large, rechargeable batteries and linked to a camera by a power cable. It took video cassettes that allowed twenty minutes of continuous recording time.
3. Paik is widely accepted as a pioneer in the field although antecedents and parallel developments have been identified elsewhere. See for example Edith Decker-Phillips, *Paik Video,* Barrytown Ltd., 1998.
4. Roland Barthes, *Image, Music, Text*, Fontana/Collins, 1977.
5. Peter Kardia, 'Making a Spectacle', *Art Monthly*, no. 193, 1996.
6. It could be argued that artist-run spaces still exist and that contemporary art on the Internet successfully sidesteps the gallery system. A full discussion of this issue is outside the scope of this book, but I will return to other demotic initiatives in chapter 7.
7. It is only recently that American performance tapes have found their way into the prestigious Kramlich collection.
8. See Amelia Jones, 'Presence in Absentia, Experiencing Performance as Documentation', *Art Journal*, Winter 1997.
9. *Postcard* (1984), Air Gallery, London.
10. Douglas Crimp, 'The Photographic Activity in Postmodernism', *Performance Texts and Documents*, Parachute, 1980.
11. Bruno Bettleheim, *The Uses of Enchantment*, Peregrine Books, 1976.

12. Nam June Paik, 'Input-Time and Output-Time', in Ira Schneider and Beryl Korot (eds.), *Video Art: An Anthology*, Harcourt Brace Jovanovich, 1976.
13. Dan Reeves in conversation with Chris Meigh-Andrews, www.meigh-andrews.com.
14. All quotes by Marty St. James taken from 'Video Telepathies', *Filmwaves*, No. 15, 2001.
15. Frank Poper quoting Hervé Fisher in *Art of the Electronic Age*, Thames and Hudson, 1993.
16. See Dan Reeves in conversation with Chris Meigh-Andrews, op. cit.

CHAPTER 2: THE MODERNIST INHERITANCE

1. Stuart Marshall, 'Institutions/Conjunctures/Practice', in *Recent British Video* catalogue, 1983.
2. For a comprehensive account of the deconstructive techniques of structural film-making by artists, see A.L. Rees, *A History of Experimental Film and Video*, BFI Publishing, 1999.
3. For a fuller discussion of Paik's relationship to John Cage, see Edith Decker-Phillips in *Paik Video*, Barrytown Ltd, 1998.
4. Quoted by Edith Decker-Phillips, ibid.
5. Pierre Théberge on Michael Snow, in Schneider and Korot (eds.), *Video Art: An Anthology*, Harcourt Brace Jovanovich, 1976.
6. Richard Serra, in Schneider and Korot (eds.), *Video Art: An Anthology*.
7. See Mick Hartney, *An Incomplete and Highly Contentious Summary of the Early Chronology of Video Art (1959–1976)*, London Video Arts catalogue, 1984.
8. I will consider some exceptions in my discussion of UK scratch video in the 1980s and its reinvention in contemporary Canadian video. See chapter 6.
9. Edith Decker-Phillips, op. cit.

CHAPTER 3: DISRUPTING THE CONTENT

1. David Ross, 'The Personal Attitude', in Schneider and Korot (eds.), *Video Art: An Anthology*, op. cit.
2. Sally Potter, 'On shows', in the catalogue of *About Time, Performance and Installation by 21 Women Artists*, ICA publications, 1980 (unpaginated).
3. Dara Gellman, catalogue entry in *UK/Canadian Video Exchange 2000*, London, Toronto.
4. Rozsika Parker and Griselda Pollock, *Old Mistresses, Women, Art and Ideology*, Routledge & Kegan Paul, 1981.
5. This view held sway for many years partly as a result of Laura Mulvey's influential article 'Visual Pleasure and Narrative Cinema', *Screen*, Vol. 16, 1975, pp. 6–18.
6. Eric Cameron, 'Structural Video in Canada', *Studio International*, 1972.
7. Lucy Lippard, 'The Pleasures and Pains of Rebirth – European Women's Art', in *Feminist Essays on Women's Art*, Dutton Press, 1976.

8. Jayne Parker, *The Undercut Reader*, Wallflower Press, 2002, p.118.
9. See Peggy Phelan, *Unmarked: The Politics of Performance*, Routledge, 1993.
10. See Jean Fisher, 'Reflections on Echo – Sound by women artists in Britain', in Chrissie Iles (ed.), *Signs of the Times* catalogue, Oxford Museum of Modern Art, 1990, pp. 60–7.
11. Vera Frenkel's own description of the work in a correspondence with the author.
12. Vera Frenkel, from the script for 'The Last Screening Room', in Peggy Gale and Lisa Steele (eds.), *Video re/View: The (Best) Source for Critical Writings on Canadian Artists' Video*, Art Metropole and Vtape, 1996.
13. Tamara Krikorian quoted in Julia Knight (ed.), *Diverse Practices: A Critical Reader on British Video Art*, Luton Press/Arts Council of England, 1996, p. 77.

CHAPTER 4: MASCULINITIES

1. In 1977, I was accused of a similarly reductive approach to masculinity when Annie Wright and I spent some time disguised as men. Andre van Niekerk reproached me for my conception of what it means to be a man with this scathing comment: 'Man? Perhaps we should substitute that word for dirty, oily and thoroughly unwholesome, depraved person.'
2. Marilyn Frye quoted by Peggy Phelan in *Unmarked: The Politics of Performance*, Routledge, 1993, p. 101.
3. Peggy Phelan, *Unmarked*, op. cit.
4. Bruce W. Ferguson, 'Colin Campbell: Otherwise Worldly', in Gale and Steele (eds.), *Video re/View*, op. cit.
5. Ibid.
6. Stuart Marshall quoted by Rebecca Dobbs in David Curtis (ed.), *A Directory of British Film & Video Artists*, Arts Council of England publication, 1996.
7. John Greyson, 'Double Agents: Video Art addressing AIDS', in Gale and Steele (eds.), *Video re/View*, op. cit.
8. Negative capability was the characteristic first attributed to male poets like Keats who were seen to have flexible ego boundaries enabling them to take on different identities and sensibilities. It was also a quality that was attributed to women's art in the 1980s.
9. Vito Acconci in conversation with Klaus Biesenbach, *Video Acts: Single Channel Works from the Collections of Pamela and Richard Kramlich and the New Art Trust* catalogue, P.S.1 New York, ICA London, 2003.
10. Tom Ryan, 'Roots of Masculinity', in Andy Metcalf and Martin Humphreys (eds.), *The Sexuality of Men*, Pluto Press, 1985.
11. Ibid.
12. See Linda Nochlin, 'Why Have There Been No Great Women Artists?', in T.B. Hess and E. Baker (eds.), *Art and Sexual Politics*, Collier Macmillan, 1973.
13. Rozsika Parker and Griselda Pollock, *Old Mistresses: Women, Art & Ideology*, Routledge & Kegan Paul, 1981.
14. See chapter 6 for an account of Bourn's work.

CHAPTER 5: LANGUAGE

1. Abigal Child, 'Being a Witness', in Steve Reinke and Tom Taylor (eds.), *Lux, a Decade of Artists' Film and Video*, YYZ Books, 2000.

2. Peggy Phelan, *Unmarked: The Politics of Performance*, Routledge, 1993.

3. See Susan Blackmore, *The Meme Machine*, Oxford University Press, 1999.

4. Terry Eagleton put it like this: 'Each sign in the chain of meaning is somehow scored over or traced through with all others... and to this extent no sign is ever "pure" or fully meaningful.' See *Literary Theory: An Introduction*, Minnesota Press, 1996.

5. See Dale Spender, *Man Made Language*, Routledge & Kegan Paul, 1980.

6. Hélène Cixous, 'The Laugh of the Medusa', in Elaine Marks and Isabelle de Courtivron (eds.), *New French Feminisms*, The Harvester Press, 1981.

7. For a comprehensive account of experimental film in the UK, see A.L. Rees, *A History of Experimental Film & Video*, BFI Publishing, 1999.

8. Peter Gidal, 'There is no other', *Filmwaves*, No. 14, 2001.

9. A.L. Rees, *A History of Experimental Film & Video*, op. cit.

10. Steven Heath, 'Repetition Time – notes around 'structural/materialist film', in Michael O'Pray (ed.), *The British Avant-Garde Film, 1926–1995*, University of Luton Press/Arts Council of England, 1996.

11. Rod Stoneman, 'Incursions and Inclusions: The Avant-Garde on Channel 4, 1983–93', in O'Pray (ed.), *The British Avant-Garde Film*, op. cit.

12. See Nina Danino and others for a comprehensive account of the second wave of independent film in *The Undercut Reader: Critical Writings on Artists' Film & Video*, Wallflower Press, 2003.

13. See Laura Mulvey, 'Film, Feminism and the Avant-Garde', in O'Pray (ed.), *The British Avant-Garde Film*, op. cit.

14. See E. Deidre Pribram (ed.), *Female Spectators: Looking at Film and Television*, Verso, 1988.

15. Performativity in this context refers to qualities of the live encounter between individuals in which language and other forms of interaction offer active participation for all those involved. It also suggests the possibility of expression even through conventional representations.

16. Stuart Marshall, 'Institutions/Conjectures/Practices', *Recent British Video* catalogue, British Council publication, 1983.

17. Ibid.

18. Maggie Warwick, from an unattributed publication.

19. Steve Hawley quoted by Rod Stoneman in Curtis (ed.), *A Directory of British Film & Video Artists*, Luton Press, 1996.

20. '[T]here's no idea of free will – that's ridiculous. This idea of humanism, which was initially about knowledge giving you power and giving you access to freedom.' Gillian Wearing, quoted by Julian Stallabrass in *High Art Lite: British Art in the 1990s*, Verso, 1999.

21. Consequences is a traditional English game in which a series of narratives are devised by a number of participants. Each episode is written by a different person

on pieces of paper, folded as they are passed round so that the previous player's contributions are hidden. The resulting nonsense stories create much hilarity.

22. Joan Key, 'Neuter, on Kiki Smith and Susan Solano', *Make*, No. 76, 1997.
23. Lei Cox, London Electronic Arts catalogue, 1997.
24. Sean Cubitt, *Videography: Video Media as Art and Culture*, Macmillan, 1993.
25. Ibid.
26. Ibid.
27. Baudrillard, in common with Irigaray, Bataille and other cultural theorists, believed that it is in the marginal areas of madness, carnival, ecstasy and pain that the individual can exist and operate outside the confines of culture and society.
28. Vito Acconci in conversation with Klaus Biesenbach, in *Video Acts: Single Channel Works from the Collections of Pamela and Richard Kramlich and the New Art Trust* catalogue, P.S.1 New York, ICA London, 2003.
29. Stuart Marshall, 'Video: from art to independence. A short history of a new technology', in Julia Knight (ed.), *Diverse Practices, a Critical Reader on British Video Art*, Luton Press/Arts Council of England, 1996.
30. For a more detailed account of *With Child*, see Catherine Elwes, *Video Loupe*, KT Press, 2000.
31. Mark Wilcox, *de-construc'tion* broadsheet for 'Subverting Television: a three-part programme of British video art', Arts Council of England, 1984.
32. Ibid.

CHAPTER 6: TELEVISION SPOOFS AND SCRATCH

1. The device was recently revised in London and New York by Sean Foley and Hamish McColl in their stage show, *The Play What I Wrote*, in which a different surprise guest trod the boards each night.
2. See Sigmund Freud, *Jokes and Their Relation to the Unconscious*, Penguin, 1976.
3. John Ellis, *Seeing Things: Television in the Age of Uncertainty*, I.B.Tauris, 2000.
4. Andy Lipman, programme notes in a Channel 4 leaflet accompanying *The Eleventh Hour* series, 1986.
5. In 1938, Orson Welles broadcast an adaptation of H.G. Wells' *War of the Worlds* in the style of a news report. According to popular legend, his performance was so convincing to the American populace that panic broke out amongst those who missed the programme announcement.
6. Breakwell's tape was in fact broadcast, very late at night, on Channel 4's series *The Eleventh Hour* in 1984.
7. Marshall McLuhan, *Understanding Media: The Extensions of Man*, McGraw-Hill, 1964.
8. Ibid.
9. *Deodorant Commercial* was later shown on Channel 4 in the UK.
10. See Caldwell's *Televisuality: Style, Crisis, and Authority in American Television*, Rutgers University Press, 1995.
11. Andreas Kroksnes quoted in *UK/Canadian Film & Video Exchange* catalogue,

London/Toronto, 2003.

12. Nick Houghton on Ian Bourn in Curtis (ed.), *A Directory of British Film & Video Artists*, Arts Council of England, 1996.

13. It was announced in the UK on 5 May 2003 that the ITV reality programme *I'm a Celebrity, Get me out of Here* would no longer consider candidates over 40.

14. Raymond Williams quoted by Andy Lipman, in *Video: The State of the Art*, Channel 4/Comedia, London, 1985.

15. Jeremy Welsh, 'One Nation Under a Will (of Iron), or: The Shiny Toys of Thatcher's Children', in Julia Knight (ed.), *Diverse Practices: A Critical Reader on British Video Art*, Luton Press/Arts Council of England, 1996.

16. Rod Stoneman, commissioning editor at Channel 4 quoted in *The Guardian*, 16 September 1985.

17. For an account of Dovey's attempts to clear Gorilla Tapes' work for broadcast, see Jon Dovey, 'Copyright as Censorship: Notes on Death Valley Days', in Knight (ed.), *Diverse Practices*, op.cit.

18. A similar technique was used recently in a clip circulating on the Internet by Johan Söderberg. Originally made for Kobra, a Swedish Television Programme, *Endless Love* synchronizes the words of the Lionel Ritchie and Diana Ross song to the lip movements of Tony Blair and George Bush. The two leaders' political alliance is given the saccharine treatment as they sing to each other of their mutual, endless love. Back in the 1980s, Gorilla Tapes created a similarly touching love scene between Margaret Thatcher and Ronald Reagan.

19. Before the 2003 Iraq war, Tony Blair was addressing a televised gathering and when a student activist loudly expressed his opposition to the war, Blair smugly pointed out how this kind of intervention would never have been allowed in Iraq just as the student was unceremoniously dragged out of the hall and duly silenced.

20. A contemporary exception might be the UK show *Bremner, Bird and Fortune*, whose questioning of the legitimacy of the Iraq war was consistent before and after the conflict, but it was unfortunate that, once hostilities began, the comedians disappeared from our screens.

21. See Jeremy Welsh, 'One Nation Under a Will (of Iron)', op. cit.

22. John Scarlett-Davis, quoted by Andy Lipman in a Channel 4 leaflet accompanying *The Eleventh Hour* series, 1986.

23. Sandra Goldbacher quoted by Andy Lipman, ibid.

24. Roland Barthes, *Image, Music, Text*, Fontana /Collins, 1977 edition.

25. Andy Lipman, op. cit.

CHAPTER 7: VIDEO ART ON TELEVISION

1. For an eight-year period in the late 1970s, the Arts Council of England funded *Film & Video Artists on Tour*, a scheme in which artists presented their work in art schools across the country.

2. For a clear account of community video in the USA, see Deirdre Boyle, 'A Brief History of American Documentary Video', in Doug Hall and Sally Jo Fifer (eds.),

Illuminating Video: An Essential Guide to Video Art, Aperture/Bay Area Video Coalition, 1990.

3. This brief account of the Miners' Tapes is drawn from Mike Stubbs' unpublished essay, *Objects of Hate – Miners' Strike*, 2003.

4. Roland Denning in correspondence with Mike Stubbs, July 2003.

5. Nam June Paik, 'Video Synthesizer Plus', in *Radical Software*, No. 2, 1970.

6. Mick Hartney, *An Incomplete and Highly Contentious Summary of the Early Chronology of Video Art (1959–1976)*, LVA catalogue, 1984.

7. Mark Kidel, 'Video Art and British TV', *Studio International*, May 1976.

8. For a comprehensive account of television and early experimental video, see Mick Hartney, 'InT/Ventions: Some Instances of Confrontation with British Broadcasting', in Knight (ed.), *Diverse Practices*, Luton Press/Arts Council of England, 1996. Also, Mark Kidel, 'Video Art and British TV' in the same volume.

9. Jean Baudrillard, 'Requiem for the Media', in John Hanhardt (ed.), *Video Culture: A Critical Investigation*, New York, 1987.

10. David Hall, in conversation with the author.

11. Rod Stoneman confirming his views to the author in an email, September 2003. The book he is referring to is Michael O'Pray (ed.), *Avant-Garde Film*, Luton Press/Arts Council of England, 1996.

12. John Ellis, *Seeing Things*, op. cit.

13. Peggy Gale, 'Video Has Captured our Imagination', in Gale and Steele (eds.), *Video re/View*, Art Metropole and Vtape Toronto, 1995.

14. 'Manx' describes an individual from the Isle of Man, off the west coast of England.

15. Tom Sherman, *Before and after the I-Bomb: An Artist in the Information Environment*, The Banff Centre Press, 2002.

16. See Helen de Witt, 'Trans-national traffic – The Road Movie and shifting European identities', *Filmwaves*, No. 16, 2001.

17. See chapter 3 for a fuller discussion of feminist theories of the personal.

18. An ex-student of mine once told me that his friend Dominic Allen, who forged a career as an intrepid television explorer, was unrecognisable on screen to those who knew him as a quiet individual.

19. Peter Conrad, *Television: the Medium and its Manners*, Routledge & Kegan Paul, 1982.

20. In 1999, Stuart Smith conned a Channel 4 documentary film crew into believing that he was a millionaire with a stormy relationship with his daughter, in fact his girlfriend. Their 'reality' ended with a staged fight between 'father' and 'daughter'.

21. Charlie Brooker's *bon mot*, *Guardian Guide*, 19 July 2003.

22. John Ellis, *Seeing Things*, op. cit.

23. Rod Stoneman in conversation with the author, April 2002.

24. Anne Marie Duguet interviewed on *The Eleventh Hour*, Channel 4, 1987.

25. Keying is the now familiar technique for combining two image sources. The weathergirl stands in front of a blue screen and the graphic charts of the country she is referring to are electronically grafted into the blue.

26. See David Hall interviewed by Chris Meigh-Andrews, www.meigh-andrews.com. Obviously, Hall was aware that television itself coloured the way his work was received, but it was precisely the preconceptions of television spectatorship that his work was addressing.

27. David Loxton of WNET, NY, quoted by Rob Perrée, *Into Video Art: The Characteristics of a Medium*, Com Rumore, 1988.

28. David Curtis in conversation with the author, July 2003.

29. To my knowledge, only Gillian Wearing has ever sued an advertising company for plagiarism. In this case, over her device of asking subjects to hold placards on which they have written their thoughts – an idea that, in fact, originated with Bob Dylan.

30. In the 1980s, I used a post-production house in Soho for a video I was making for Channel 4. According to my editor, commercial directors would ask for sneak previews of what I and other Channel 4 commissioned artists had been doing.

31. John Ellis, *Seeing Things*, op. cit.

32. John Wyver in a letter to the author. Wyver was and is the director of Illuminations, a production company that collaborated with Channel 4 to bring international programmes of artists' work to the small screen in the early 1980s and beyond.

33. Rob Perrée, *Into Video Art*, op. cit.

34. Rod Stoneman, in conversation with the author.

35. David Curtis in conversation with the author.

36. John Wyver, letter to the author.

37. Rick Lander, contributing to NFT seminar, *Artists and Broadcast*, 13 December 1994.

38. John Wyver, letter to the author.

39. Jean-François Lyotard, 'Brief Reflections on Popular Culture', in Lisa Appignanesi (ed.), *Postmodernism*, *ICA Documents 4*, ICA London, 1986.

CHAPTER 8: VIDEO SCULPTURE

1. Steve Hawley in conversation with the author, September 2003.

2. See chapter 3 for a fuller description of Rosler's tape.

3. Bill Viola, quoted by Chris Darke, *Light Readings, Film Criticism and Screen Arts*, Wallflower Press, 2000.

4. Sean Cubitt, 'False Perspectives in Virtual Space', *Variant*, Spring 1992.

5. For a full description of the Videowall project in Liverpool, see Steve Littman, 'The Videowall System: an unexplored medium', in Knight (ed.), *Diverse Practices: A Critical Reader on British Video Art*, University of Luton Press/Arts Council of England, 1996.

6. For a full description of the project, see Dara Birnbaum, 'The Rio Experience', in Doug Hall and Sally Jo Fifer (eds.), *Illuminating Video, An Essential Guide to Video Art*, Aperture/BAVC, 1990.

7. Nicky Hamlyn, 'Film, Video, TV', *COIL*, 9/10, 2000.

8. Ian Hunt, 'Vide Video', *Art Monthly*, May 1996.

9. See Chrissie Iles, 'Luminous Structures', *COIL: Journal of Moving Image*, No. 3, 1996.

10. See Tom Sherman, *Before and After the I-Bomb: An Artist in the Information Environment*, The Banff Centre Press, 2002.

11. David Hall in conversation with the author.

12. Jeremy Welsh, *Video Positive* catalogue, Tate Gallery Liverpool, Moviola, 1991.

CHAPTER 9: THE 1990S AND THE NEW MILLENNIUM

1. In Canada, an entire generation of video-makers was 'lost' to the world of commerce. Lisa Steele at Vtape in Toronto has worked hard in the last few years to involve younger artists in Vtape's activities and prevent a further talent-drain to the commercial sector.

2. Jeremy Welsh, 'One Nation Under a Will (of Iron)', op. cit.

3. Tracey Emin once confided to a television interviewer that she never launched into a new creative direction without first consulting her gallerist because 'after all, he has to sell the work.'

4. Kathleen Pirrie Adams, 'Lady in the Lake: fluid forms of self in performance video', *Promise* catalogue, YYZ, Toronto, 1999.

5. Rosetta Brookes, quoted by Rob Perrée in *Into Video Art: The Characteristics of a Medium*, Com Rumore, Amsterdam, 1988.

6. Chris Darke, *Light Readings: Film Criticism and Screen Arts*, Wallflower Press, 2000.

7. Susan Sontag, 'The Telling Shot', *The Guardian*, 1 February 2003.

8. Michael O'Pray, 'The Impossibility of Doing Away with Video Art', in Knight (ed.), *Diverse Practices*, op. cit.

9. Sam Taylor-Wood quoted in Julian Stallabrass, *High Art Lite: British Art in the '90s*, Verso, 1999.

10. Peter Gidal, 'There is no other', *Filmwaves*, January 2001.

11. Russell Ferguson, 'Show your Emotions', in *Gillian Wearing*, Phaidon Press, 1999.

12. David Hall in conversation with Chris Meigh-Andrews, www.meigh-andrews.com.

13. Collier Schorr, 'Openings: Cheryl Donegan', *Artforum*, Summer 1993.

14. Raymond Bellour quoted by Chris Darke, *Light Readings*, op. cit.

15. Laura Mulvey, 'Death 24 times a second: the tension between movement and stillness in the cinema', *COIL*, October 2000.

16. Roland Barthes, *Image, Music, Text*, Fontana/Collins, 1977.

17. *Notorious – Alfred Hitchcock and Contemporary Art* (1999) was an exhibition, staged at the Museum of Modern Art in Oxford that was devoted to artists who reinterpret or recreate Hitchcock's films.

18. Steve Hawley in conversation with the author, September 2003.

19. A discussion of moving image on the Internet is beyond the scope of the present volume. For a good account of artists working with the material and structures of the

Internet, see Noah Wardrip-Fruin and Nick Montford (eds.), *The New Media Reader*, MIT Press, 2003.

20. Griselda Pollock, speaking in a public discussion of *Warte Mal!* at the Hayward gallery in 2002.

21. Tom Sherman quotes all from a letter to the author, 2003.

22. Julian Stallabrass, *High Art Lite: British Art in the 1990s*, Verso, 1999.

23. Edward W. Said, *Reflections on Exile*, Harvard University Press, 2000.

24. Mark Nash, 'Art and Cinema: some critical reflections', in *Documenta 11* catalogue, 2002.

25. See essays by Selene Wendt and Neery Melkonian in the catalogue *Shirin Neshat*, published by Henie Onstad Kunstsenter in association with Riksutstillinger, 2000.

26. With British and American troops controlling the gates of Basra and Baghdad, the notion of post-colonialism, taken literally, seems rather absurd. Perhaps, 'second-colonial age' would be better depending on how far back into history one wants to go.

27. Zacharias Kunuk quoted by Nancy Beale in the *Ottowa Citizen*, 25 May 1994.

28. Nadja Rottner writing on Michael Ashking, *Documenta 11* catalogue, 2002.

29. For an account of politically engaged 'Third Cinema' see, Fernando Solanas and Octavio Getino, 'Is your filmmaking revolutionary?', *Filmwaves*, February 2001.

30. Orlan, 'I Do Not Want To Look Like...', in *Women's Art*, May/June 1995.

31. Marina Abramović in conversation with Doris von Drathen, in Friedrich Meschede (ed.), *Marina Abramović*, Edition Cantz, 1993.

32. For an account of Mona Hatoum's body explorations, see chapter 3.

33. Jubal Brown, *UK/Canadian Video Exchange 2000* catalogue, Toronto and London.

34. Woody and Steina Vasulka in conversation with Christopher Meigh-Andrews, www.meigh-andrews.com/writing.

35. Ibid.

36. Steve Hawley quoted by Andy Lipman in *Video State of the Art*, Channel 4/Comedia, London, 1985.

37. Marina Abramović interviewed by Klaus Biesenbach in *Video Acts: Single Channel Works from the Collections of Pamela and Richard Kramlich and the New Art Trust*, P.S.1 publication, 2003.

38. Mike Hoolboom interviewed by Cameron Bailey in *NOW*, Toronto 14 August 1998.

39. Many, of course, simply fake it and programmes and presenters, including *Kilroy* in the UK, have been hoodwinked. When bone fide participants have demonstrated contradictory impulses or complexities, the broadcasters have ironed them out as the inhabitants of the *Big Brother* house discovered when they watched programmes that bore little resemblance to what they had experienced in the House. See 'Stars and Gripes', *Sunday Times* magazine, 1 April 2001.

40. Martha Rosler speaking at the debate 'Is the Personal Political' at the ICA, London in 1980, the year in which the gallery staged three major exhibitions of women's art. For an account of the events, see Sarah Kent and Jacqueline Morreau (eds.), *Women's Images of Men*, Writers and Readers, 1985.

41. After seven years of being continually monitored on the Internet, the pioneering 'webcamer', Jennicam has been closed down by the payment company because she has been seen naked.
42. Jeremy Welsh, 'One Nation Under a Will (of Iron)', op. cit.
43. Patrick Bernier writing in *Tranz-Tech Festival* catalogue, Vtape, 2001.
44. Nadja Rottner writing in the *Documenta 11* catalogue, 2002.
45. Tom Sherman *Before and After the I-Bomb*, op. cit.

Bibliography

Abramović, Marina in conversation with Doris von Drathen, in Friedrich Meschede (ed.), *Marina Abramović*, Edition Cantz, 1993

Adams, Kathleen Pirrie, 'Lady in the Lake: Fluid forms of self in performance video', *Promise* catalogue, YYZ, Toronto, 1999

Appignanesi, Lisa (ed.), *Postmodernism, ICA Documents 4*, ICA London, 1986

Barthes, Roland, *Image, Music, Text*, Fontana/Collins, 1977

Bernier, Patrick, *Tranz-Tech Festival* catalogue, Vtape, Toronto 2001

Bettleheim, Bruno, *The Uses of Enchantment*, Peregrine Books, 1976

Blackmore, Susan, *The Meme Machine*, Oxford University Press, 1999

Caldwell, John Thornton, *Televisuality: Style, Crisis, and Authority in American Television*, Rutgers University Press, 1995

Cameron, Eric, 'Structural Video in Canada', *Studio International*, 1972

Conrad, Peter, *Television, The Medium and its Manners*, Routledge & Kegan Paul, 1982

Cubitt, Sean, *Videography, Video Media as Art and Culture*, Macmillan, 1993

Cubitt, Sean, 'False Perspectives in Virtual Space', *Variant* Magazine, Spring 1992

Curtis, David (ed.), *A Directory of British Film & Video Artists*, Arts Council of England Publications, 1996

Crimp, Douglas, 'The Photographic Activity in Postmodernism', *Performance Texts and Documents*, Parachute, 1980

Darke, Chris, *Light Readings, Film Criticism and Screen Arts*, Wallflower Press, 2000

Danino, Nina and Michael Maziere (eds.), *The Undercut Reader*, Wallflower Press, 2002

Decker-Phillips, Edith, *Paik Video*, Barrytown Ltd., 1998

de Witt, Helen, *Trans-National Traffic – The Road Movie and Shifting European Identities*, Filmwaves 16, 2001

Eagleton, Terry, *Literary Theory: An Introduction*, Minnesota Press, 1996

Ellis, John, *Seeing Things: Television in the Age of Uncertainty*, I.B.Tauris, 2000

Elwes, Catherine, *Video Loupe*, KT Press, 2000

Ferguson, Russell, 'Show your Emotions', in *Gillian Wearing*, Phaidon Press, 1999

Fisher, Jean, 'Reflections on Echo – Sound by women artists in Britain', in Chrissie Iles (ed.), *Signs of the Times* catalogue, Oxford Museum of Modern Art, 1990

Freud, Sigmund, *Jokes and Their Relation to the Unconscious,* Penguin, 1976

Gale, Peggy and Lisa Steele (eds.), *Video re/View: the (best) source for critical writings on Canadian Artists' Video,* Art Metropole and Vtape, Toronto, 1996

Gellman, Dara, catalogue entry in *UK/Canadian Video Exchange 2000,* London, Toronto

Gidal, Peter, 'There is no other', *Filmwaves,* issue 14, 2001

Hall, Doug and Sally Jo Fifer (eds.), *Illuminating Video, an Essential Guide to Video Art,* Aperture/Bay Area Video Coalition, 1990

Hamlyn, Nicky, 'Film, Video, TV', *Coil,* 9 October 2000

Hartney, Mick, *An Incomplete and Highly Contentious Summary of the Early Chronology of Video Art (1959–1976),* London Video Arts catalogue, 1984

Hanhardt, John (ed.), *Video Culture: A Critical Investigation,* New York, 1987

Hess, T.B. and E. Baker (eds.), *Art and Sexual Politics,* Collier Macmillan, New York, 1973

Hunt, Ian, 'Vide Video', *Art Monthly,* May 1996

Iles, Chrissie, 'Luminous Structures', *Coil: Journal of Moving Image,* Issue 3, 1996

Jones, Amelia, 'Presence In Absentia, Experiencing Performance as Documentation', *Art Journal,* winter 1997

Kardia, Peter, 'Making a Spectacle', *Art Monthly,* No. 193, 1996

Kent, Sarah, and Jacqueline Morreau (eds.), *Women's Images of Men,* Writers and Readers, 1985

Key, Joan, 'Neuter, on Kiki Smith and Susan Solano', *Make,* No. 76, 1997

Kidel, Mark, 'Video Art and British TV', *Studio International,* May 1976

Knight, Julia (ed.), *Diverse Practices, a Critical Reader on British Video Art,* Luton Press/ Arts Council of England, 1996

Lipman, Andy, programme notes in a Channel 4 leaflet accompanying the series *The Eleventh Hour,* 1986

Lipman, Andy, in *Video: The State of the Art,* Channel 4/Comedia, London, 1985

Lippard, Lucy, 'The Pleasures and Pains of Rebirth – European Women's Art,' *Feminist Essays on Women's Art,* Dutton Press, New York, 1976

Marshall, Stuart, 'Institutions/Conjunctures/Practice' in *Recent British Video* catalogue, 1983

McLuhan, Marshall, *Understanding Media: The Extensions of Man,* McGraw-Hill, 1964

Meigh-Andrews, Chris, conversations with Dan Reeves, Catherine Elwes, The Vasulkas and David Hall, www.meigh-andrews.com

Marks, Elaine, and Isabelle de Courtivron (eds.), *New French Feminisms,* The Harvester Press, 1981

Metcalf Andy and Martin Humphreys (eds.), *The Sexuality of Men,* Pluto Press, 1985

Mulvey, Laura, 'Visual Pleasure and Narrative Cinema', *Screen,* Vol. 16, 1975

Mulvey, Laura, *Death 24 times a second: the tension between movement and stillness in the cinema,* COIL, October 2000

Nash, Mark, *Art and Cinema: Some critical reflections,* in Documenta 11 catalogue

O'Pray, Michael (ed.), *The British Avant-Garde Film, 1926–1995,* University of Luton Press/Arts Council of England, 1996

Orlan, 'I Do Not Want To Look Like...', in *Women's Art*, May/June 1995

Paik, Nam June, 'Video Synthesizer Plus', in *Radical Software*, No. 2 1970

Parker, Rozsika and Griselda Pollock, *Old Mistresses, Women, Art and Ideology*, Routledge & Kegan Paul, 1981

Perrée, Rob, *Into Video Art: The Characteristics of a Medium*, Com Rumore, Amsterdam, 1988

Phelan, Peggy, *Unmarked: The Politics of Performance*, Routledge, 1993

Poper, Frank, *Art of the Electronic Age*, Thames and Hudson, 1993

Potter, Sally, 'On shows', in the catalogue of *About Time, Performance and Installation by 21 Women Artists*, ICA publications, 1980

Pribram, E. Deidre (ed.), *Female Spectators: Looking at Film and Television*, Verso, 1988

Rees, A.L., *A History of Experimental Film and Video*, B.F.I Publishing, 1999

Reinke, Steve, and Tom Taylor (eds.), *Lux: A Decade of Artists' Film and Video*, YYZ Books, Toronto, 2000

Said, Edward W., *Reflections on Exile*, Harvard University Press, 2000

Schneider, Ira and Beryl Korot (eds.), *Video Art: An Anthology*, Harcourt Brace Jovanovich, 1976

Schorr, Collier, 'Openings: Cheryl Donegan', *Artforum*, summer 1993

Sherman, Tom, *Before and after the I-Bomb: An Artist in the Information Environment*, The Banff Centre Press, 2002

Solanas, Fernando and Octavio Getino, 'Is your Filmmaking Revolutionary?', *Filmwaves*, February 2001

Sontag, Susan, 'The Telling Shot', *The Guardian*, 1 February 2003

Spender, Dale, *Man Made Language*, Routledge & Kegan Paul, 1980

Stallabrass, Julian, *High Art Lite: British Art in the 1990s*, Verso, 1999

St. James, Marty, 'Video Telepathies', *Filmwaves*, No. 15, 2001

Video Acts: Single Channel Works from the Collections of Pamela and Richard Kramlich and the New Art Trust catalogue, P.S.1 New York, ICA London, 2003

Welsh, Jeremy, *Video Positive* catalogue, Tate Gallery Liverpool, Moviola, 1991

Wendt, Selene and Neery Melkonian, *Shirin Neshat*, Henie Onstad Kunstsenter in association with Riksutstillinger, 2000

Wilcox, Mark, *de-construc'tion*, broadsheet for 'Subverting Television: A three-part programme of British video art', Arts Council of England, 1984

Index and Videography